YORKSHIRE
FROM THE AIR

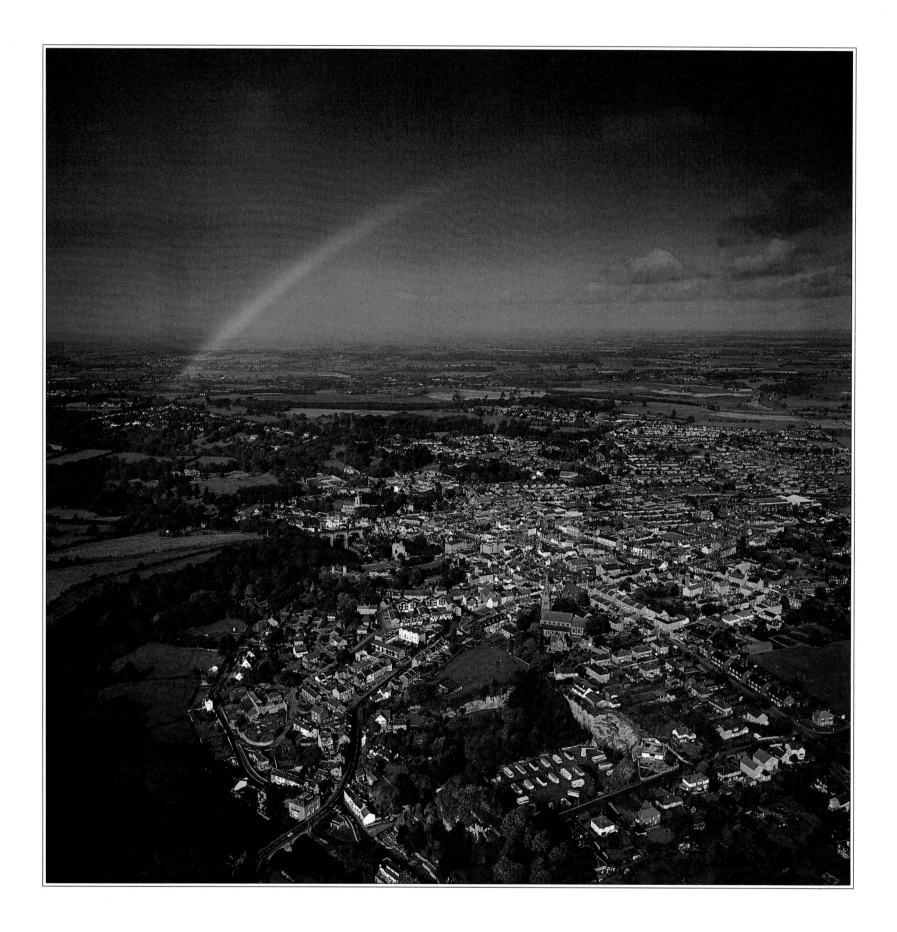

YORKSHIRE
FROM THE AIR

Photographs by Aerofilms

LLYFRAU 'R YNYS

ISLAND BOOKS
PRODUCED FOR S. WEBB & SON
Menai Bridge

LIST OF AERIAL PHOTOGRAPHS

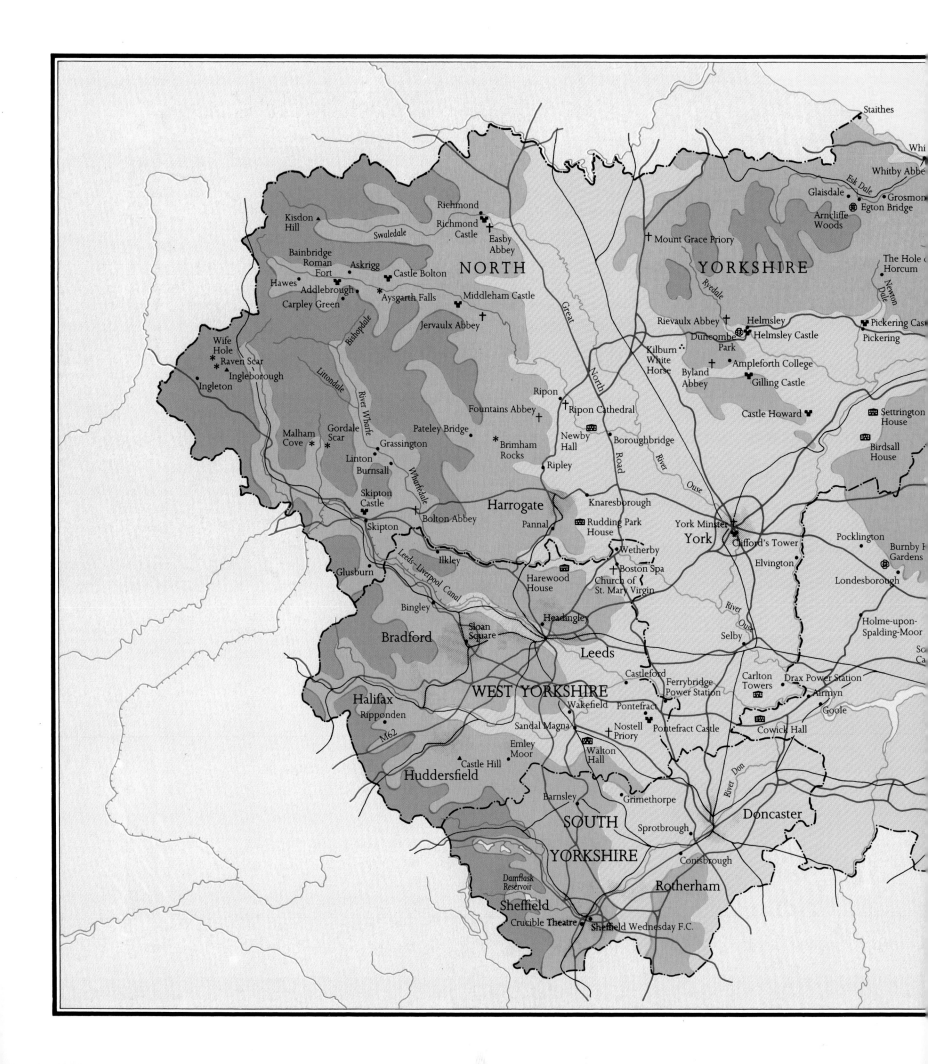

Staithes

Whi

Whitby Abbe

Esk Dale

Glaisdale
Arncliffe
Woods

Grosmo

Egton Bridge

Richmond

Richmond
Castle

Kisdon
Hill

Swaledale

Easby
Abbey

NORTH

Mount Grace Priory

YORKSHIRE

The Hole
Horcum

Bainbridge
Roman
Fort

Askrigg

Castle Bolton

Ryedale

Newton
Dale

Hawes
Addlebrough

Carpley Green

Aysgarth Falls

Middleham Castle

Rievaulx Abbey

Helmsley

Pickering Cas

Duncombe
Park

Helmsley Castle

Pickering

Jervaulx Abbey

Bishopdale

Kilburn
White
Horse

Ampleforth College

Wife
Hole

Raven Scar

Ingleborough

Littondale

River Wharfe

Ripon

Byland
Abbey

Gilling Castle

Ingleton

Fountains Abbey

Ripon Cathedral

Castle Howard

Settrington
House

Malham
Cove

Gordale
Scar

Grassington

Pateley Bridge

Brimham
Rocks

Newby
Hall

Boroughbridge

Birdsall
House

Linton
Burnsall

North Road

River

Skipton
Castle

Wharfedale

Ripley

Knaresborough

York Minster

Pocklington

Burnby H
Gardens

Bolton Abbey

Harrogate

Pannal

Rudding Park
House

York

Clifford's Tower

Elvington

Skipton

Leeds–Liverpool Canal

Ilkley

Wetherby

Londesborough

Glusburn

Harewood
House

Boston Spa
Church of
St. Mary Virgin

River
Ouse

Holme-upon-
Spalding-Moor

Bingley

Headingley

Selby

So
Ca

Bradford

Sloan
Square

WEST YORKSHIRE

Leeds

Castleford

Carlton
Towers

Drax Power Station

Airmyn

Halifax

Ripponden

Ferrybridge
Power Station

Goole

Wakefield

Pontefract

Cowick Hall

M62

Sandal Magna

Nostell
Priory

Pontefract Castle

River
Don

Emley
Moor

Walton
Hall

Castle Hill

Huddersfield

Barnsley

Grimethorpe

Doncaster

SOUTH

Sprotbrough

YORKSHIRE

Conisbrough

Damflask
Reservoir

Rotherham

Sheffield

Crucible Theatre

Sheffield Wednesday F.C.

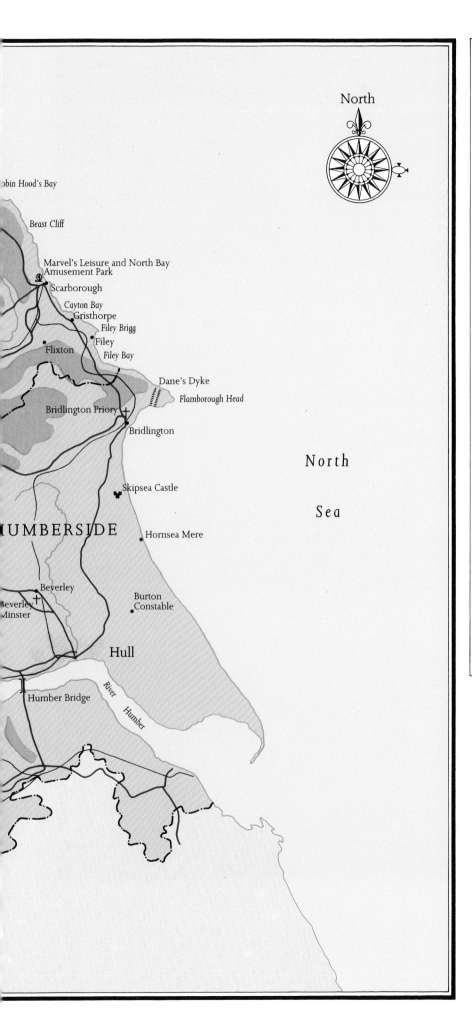

Robin Hood's Bay

Beast Cliff

Marvel's Leisure and North Bay
Amusement Park
Scarborough
Cayton Bay
Gristhorpe
Filey Brigg
Filey
Filey Bay
Flixton

Dane's Dyke
Flamborough Head

Bridlington Priory
Bridlington

Skipsea Castle

HUMBERSIDE

Hornsea Mere

Beverley
Burton
Constable
Beverley
Minster

Hull

Humber Bridge

River Humber

North

Sea

YORKSHIRE

Legend

—·—·—·— County boundary

〜〜〜 River

┬┬┬┬┬ Canal

———— Railway line

━━━━ Road

⬚ City or large town

· Town or village

▦ House

♛ Castle or fort

✝ Abbey, cathedral, church or priory

⊕ Garden or park

∗ Area of natural beauty

🎡 Leisure park

▨ Mountains/moors

▨ Hills

▨ Lowland

Scale

0 5 10 15 20 25 30

Miles

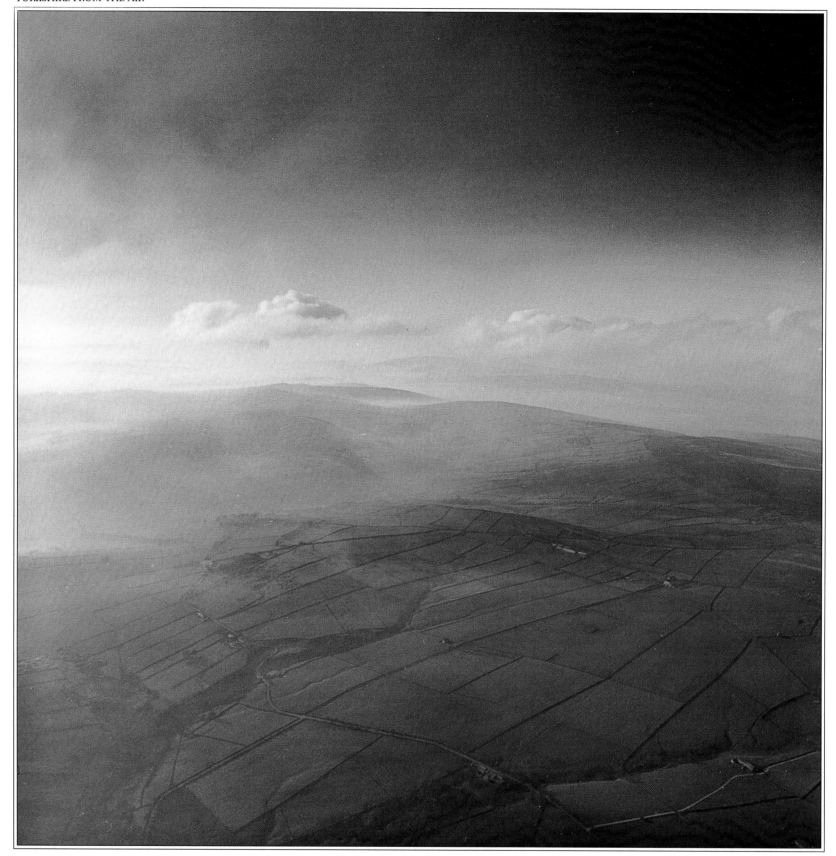

CONONLEY MOOR

*A light mantle of mist makes the expanse of moorland south west of Skipton seem all
the more remote. The photograph is taken from Cononley Moor looking westwards
over Lothersdale. Beyond is the Lancashire border: the hill on the horizon is Pendle.
Cononley was the most southerly of Yorkshire's lead-mining areas; a single vein here
was mined extensively between 1830 and 1876.*

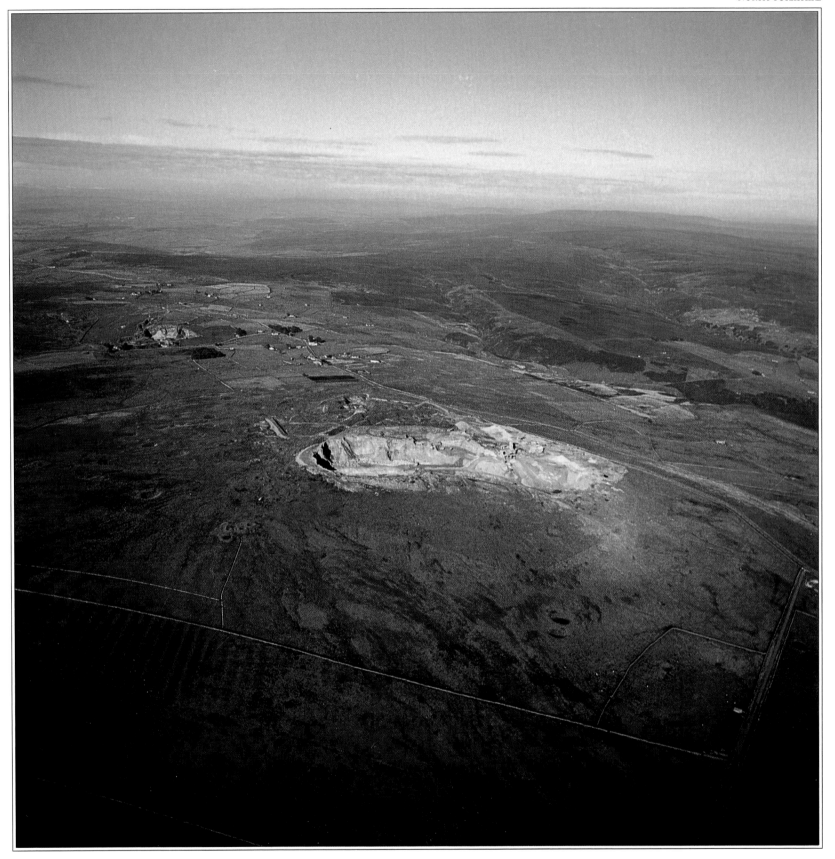

MOORLAND NEAR PATELEY BRIDGE

The moors of Nidderdale near Pateley Bridge are pitted and scarred with mines and
quarries. Lead was mined here by the Brigantes and the Romans; later, ownership of
the mines passed into the hands of the monks of Fountains and Byland and after the
Dissolution of the Monasteries to secular landowners. Here a modern limestone quarry
is surrounded by the remains of earlier lead-mining activity.

9

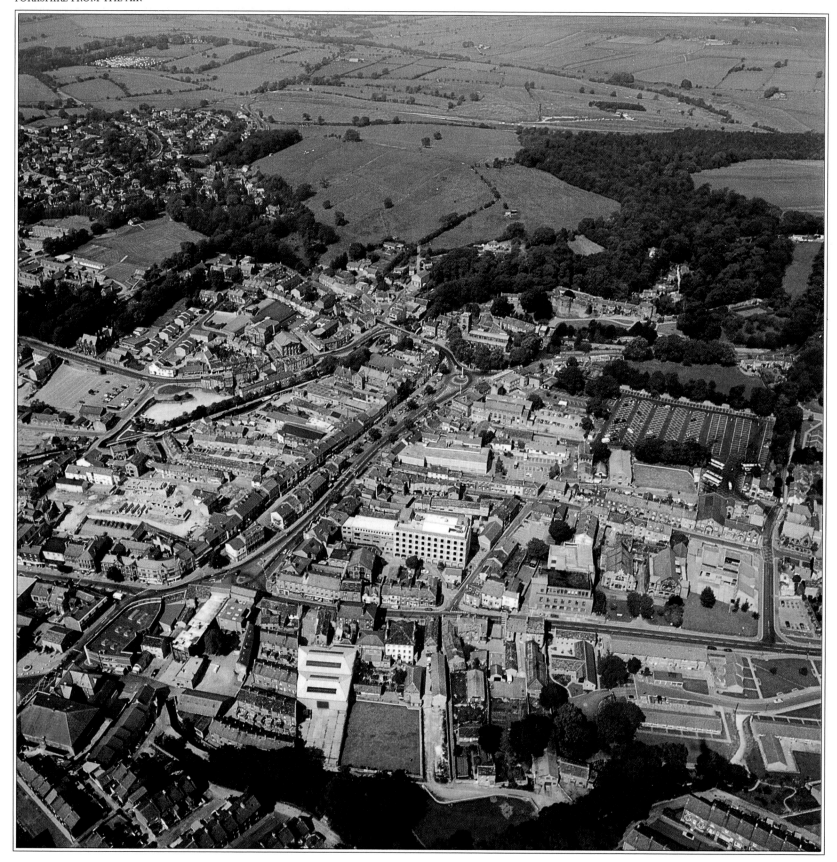

SKIPTON

As Richmond is to the northern dales, Skipton is to the south – the gateway for many
visitors from the population centres of Lancashire and South Yorkshire. The broad,
tree-lined main street leads up to the church of the Holy Trinity; behind this and
slightly to the right can be seen the impressively well-maintained castle. Skipton has
been a busy market town for centuries and produces quantities of cotton thread.

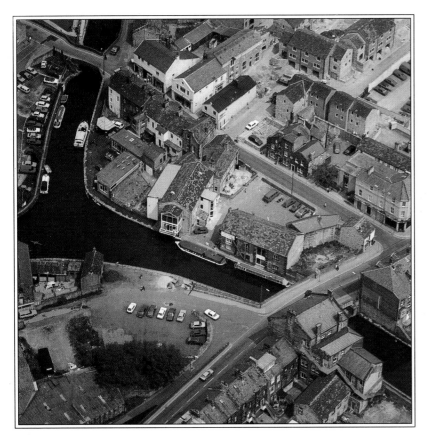
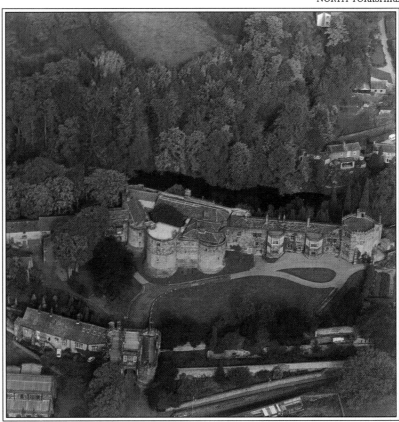

THE LEEDS-LIVERPOOL CANAL AT SKIPTON

In 1770 an *Act of Parliament* authorised the building of a canal between Liverpool
and Leeds and the canal was extended to Skipton in 1774. It added greatly to the
town's prosperity, bringing trade in limestone, fertilisers and food to add to the existing
ones of wool and livestock, and by the early nineteenth century coal to power the mills
as well. However it has not carried any commercial traffic since 1954.

SKIPTON CASTLE

Skipton Castle dates from the eleventh century, but little of the original Norman work
remains. The medieval stronghold of the Clifford family, it became famous during the
Civil War for withstanding a siege by Cromwell's men for three years, but was so
battered in the process that it had to be almost completely rebuilt by Lady Anne
Clifford in 1657. The keep has five towers, three of them circular.

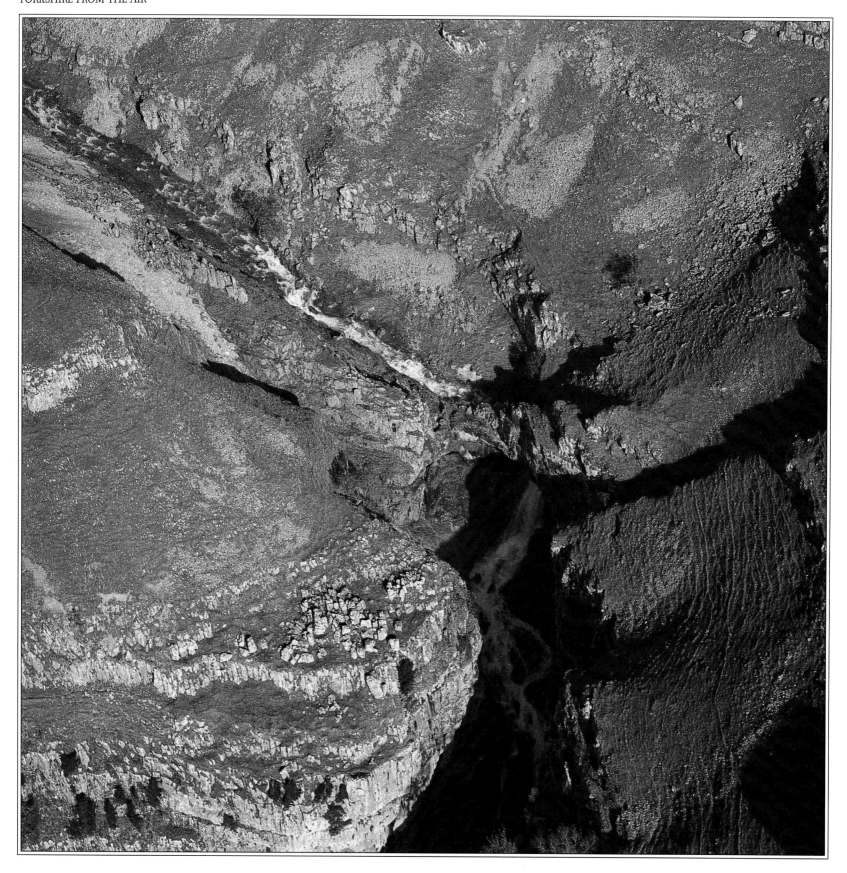

GORDALE SCAR

It is the underlying rock that is responsible for much of the beauty of the Yorkshire
Dales, and nowhere is this more evident than in the dramatic formations thrown up by
the Craven Fault around Malham. This is Great Scar Limestone country, where the
soft stone has been eroded by water over centuries. At Gordale Scar, 1½ miles east of
Malham, a deep limestone gorge has been formed by a collapsed cave.

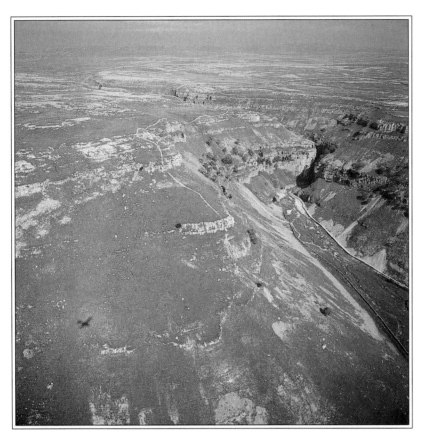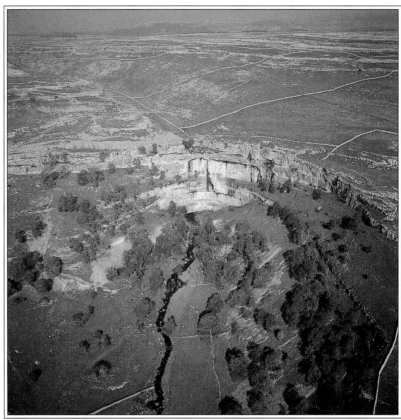

GORDALE SCAR

*Visitors to Gordale climb up the gorge, round a corner and past the fine waterfall
formed by Gordale Beck tumbling down from the limestone pavement above. It is an
impressive sight and has long attracted visitors to the Dales. Wordsworth, who came
here in 1807, wrote of it afterwards: 'Gordale chasm, terrific as the lair
Where the young lions crouch'*

MALHAM COVE

*The great natural amphitheatre of Malham Cove once held a waterfall higher than the
Niagara Falls. From nearby Malham Tarn, a river flowed over the lip of the cove,
whose walls are over 300 feet high; the dry bed of this river can still be seen. Now the
water has found its way through the fissures in the limestone and emerges instead at
the foot of the rocks as Malham Beck. Charles Kingsley came to stay with his friend
Walter Morrison at Malham Tarn House and the scenery of the Great Scar Limestone
is very much a part of The Water Babies. It is said that Kingsley was once asked to
explain the black markings on the face of Malham Cove and replied that they were
left there by the sooty fingers of a little sweep's boy.*

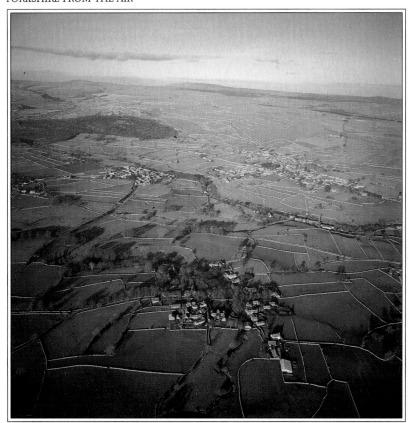 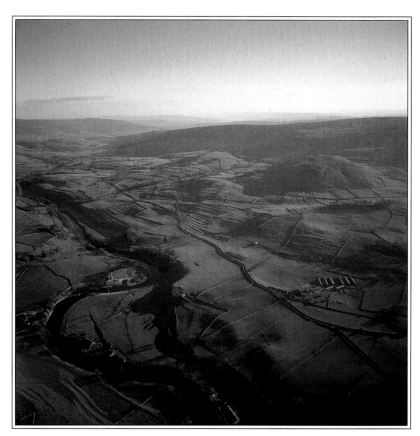

LINTON AND GRASSINGTON

Grassington, on the far bank of the River Wharfe, is one of the oldest inhabited places
in the Dales – nearby can be found evidence of Bronze and Iron Age man, as well as
survivals from the Roman period and Middle Ages. At the top of Grass Wood, the
large wood in the distance, is Fort Gregory, an Iron Age fort; the moors behind the
town were mined for lead in the age of Trajan and again from the seventeenth century
until the exhaustion of the seams at the end of the last century; the remains of three
mills around Linton Falls, on the river between the village of Linton, in the foreground,
and Grassington, behind, are witnesses to the other great industry of the past –
textiles. Today Grassington is a magnet for tourists, making it rather congested in
summer, but the village of Linton remains one of the most attractive in Yorkshire, with
houses grouped among trees round a green and a stream with
stepping-stones and a packhorse bridge.

RIVER WHARFE, GRASSINGTON

Below Grassington, by a meander in the River Wharfe, the lower slopes of the hillsides
provide a striking reminder of yet more of the earlier inhabitants of the dale.
Grassington means 'the pasture farm' in Anglo-Saxon; during the seventh century
Wharfedale was colonised by Anglo-Saxon farmers. Since the bottom of the valleys
were too marshy for cultivation, they created stepped terraces, known as lynchets.

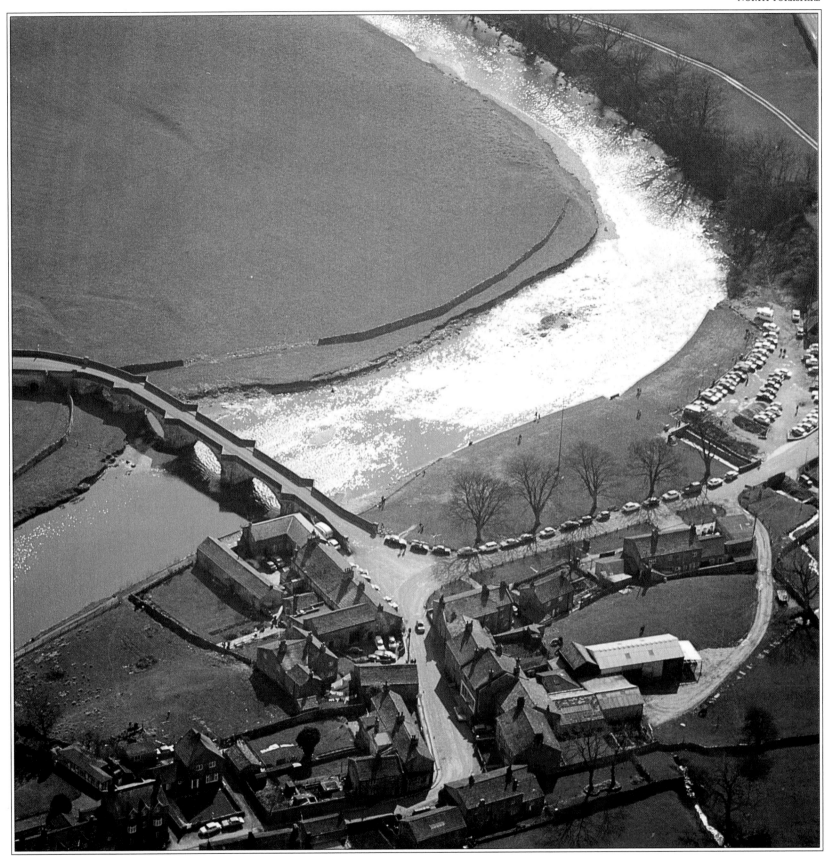

BURNSALL

The river Wharfe glistens peacefully in the summer sunlight beside the attractive
village of Burnsall, which has sensibly made the most of its situation by having a
village green beside the river. The apparent gentleness of the river is deceptive, however
– when it is in spate during the winter months the brown water batters itself against
the beautiful bridge, and its predecessors were often washed away.

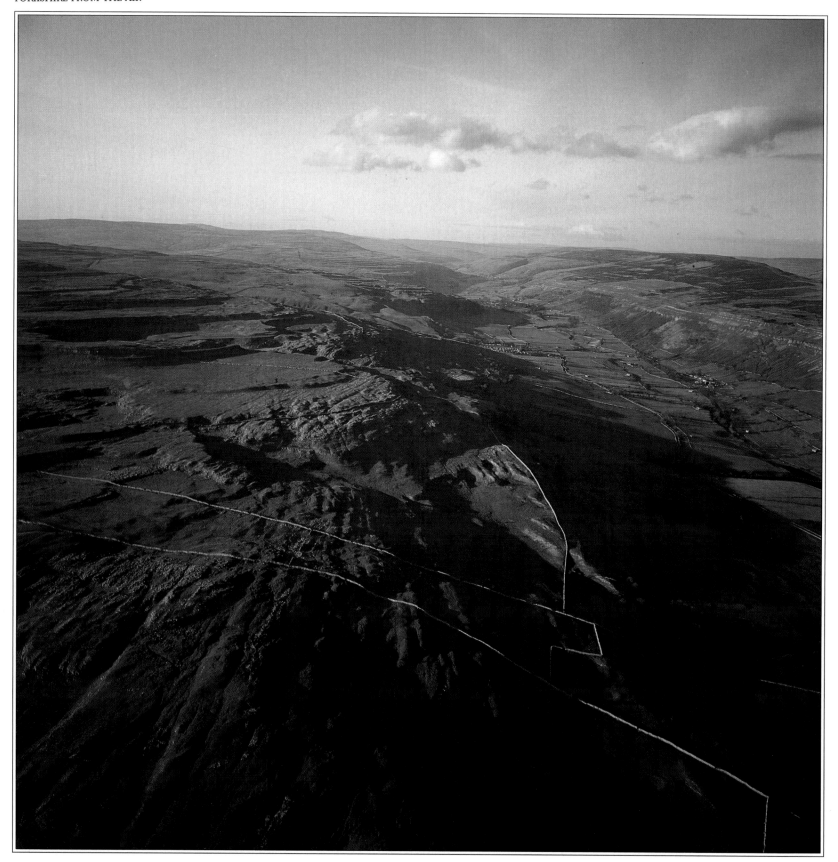

LITTONDALE

Comparatively small and remote, Littondale is one of the most beautiful in the
Pennines. Its emerald, close-cropped turf was the source of the riches of Fountains
Abbey – just to the south, the principal grange for the wool from the monks' Craven
estates was at Kilnsey. In the seventeenth century it was the scene of feuding between
the Clifford family of Skipton, the owners of much of the dale, and Sir John Yorke.

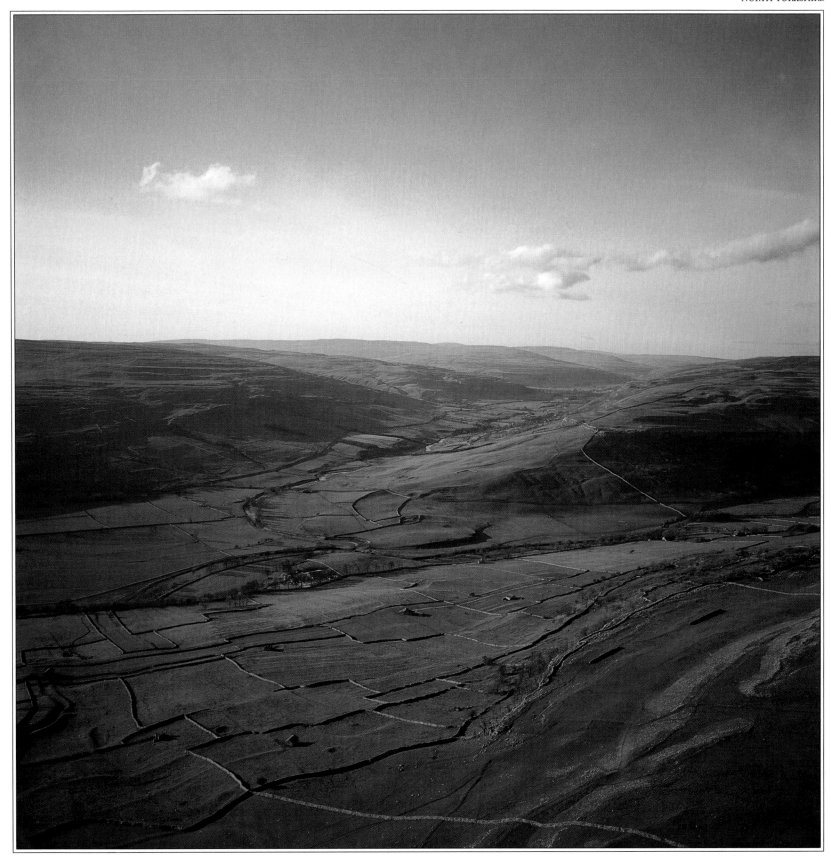

WHARFEDALE – JUNCTION OF RIVERS WHARFE AND SKIRFARE

A long tongue of moorland known as Old Cote Moor finally comes to an end at High
Wind Bank just north of Kilnsey. This allows the River Wharfe, on the right, to be
joined by its tributary, the Skirfare, seen here coming down its dale, Littondale, in the
centre of the picture. Kilnsey marks the eastern limit of the Great Scar Limestone; the
layered rocks of the Yoredale Series succeed it in Littondale and Upper Wharfedale.

17

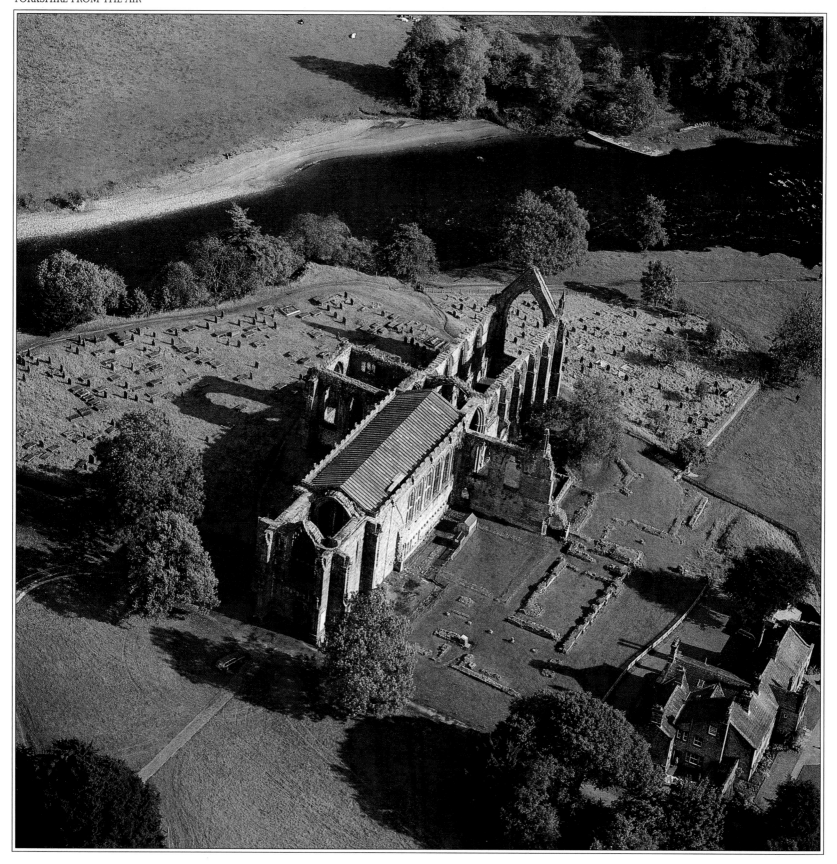

BOLTON ABBEY

This tranquil and beautiful ruin is strictly speaking an Augustinian priory, not an
abbey. Founded in 1154, the priory was suppressed under Henry VIII in 1539, but the
nave was spared and is now used as a parish church. Building here went on right up
to the Dissolution: the last prior, Richard Moon, began work on the great west tower
in the 1520s, unaware that he would never see the completion of the task.

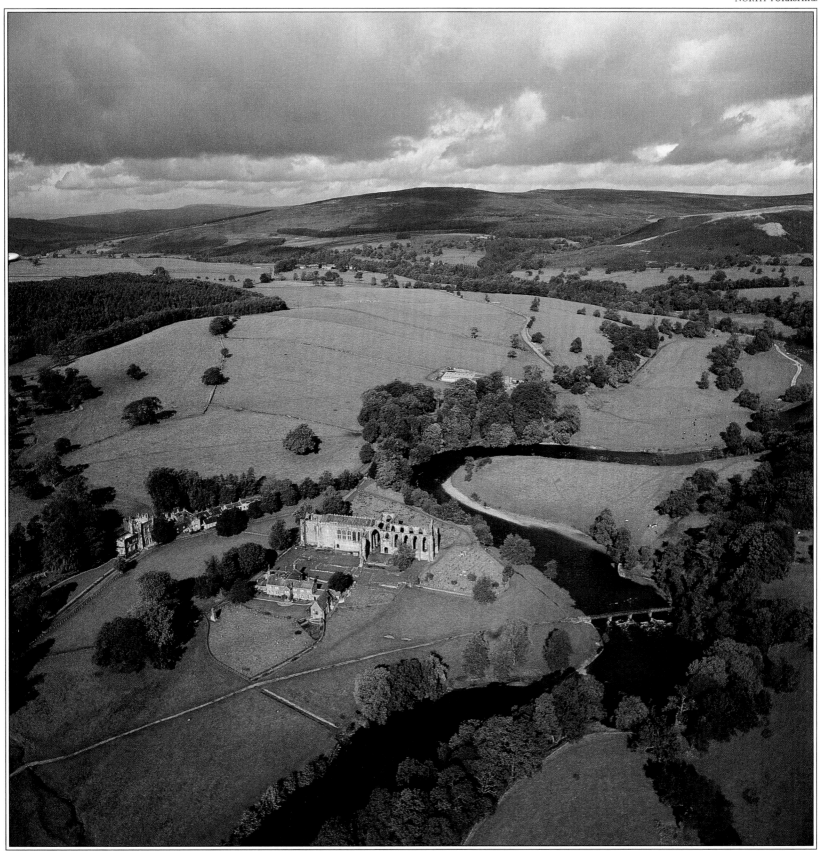

BOLTON ABBEY

*Bolton Abbey's buildings and idyllic setting beside the River Wharfe have been admired
by many visitors. Wordsworth came here in the summer of 1807, and his poems
'Song at the Feast of Brougham Castle' and 'The White Doe of Rylstone' both deal
with characters and legends connected with this spot; Turner and Girtin painted here.
It was also one of the earliest places in the Dales to be opened up to mass tourism.*

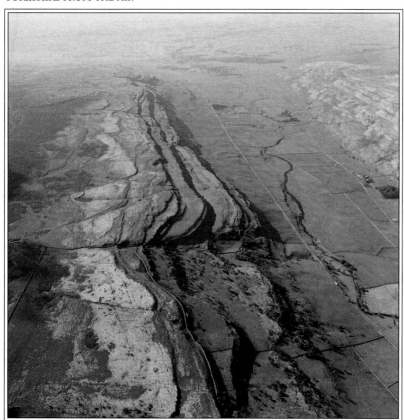

RAVEN SCAR, INGLEBOROUGH

The tiered limestone cliffs of Raven Scar, on the left of the picture, buttress the north-western slopes of Ingleborough, the central hill of the Pennine 'Three Peaks'. Just across the valley can be seen, in Twistleton Scar, the lower slopes leading to the threatening bulk of Whernside which, at 2,419 feet, is Yorkshire's highest point. On the top of Raven Scar is the 'pavement' so characteristic of Great Scar Limestone. There is only a sparse layer of soil covering the limestone and the level rock strata allow acidic rain water to penetrate between vertical and horizontal crevices in the rock. The water dissolves the limestone and gradually enlarges the cracks, dividing the surface of the pavement into corrugated 'clints'.

WIFEHOLE, INGLEBOROUGH

The lower slopes of Ingleborough are shot through with pot holes: vertical holes bored into the limestone by streams coming off the hillside. Some of them are as much as 400 feet deep with caves carved out at the bottom of the limestone where the water meets the impervious slate beneath. Gaping Ghyll and Alum Pot are Ingleborough's two most famous such holes, but there are many others, such as the quaintly-named Wifehole at the northern end of Raven Scar. History does not relate whose wife fell (or was pushed?) down this innocent-looking but potentially lethal shaft in the rock.

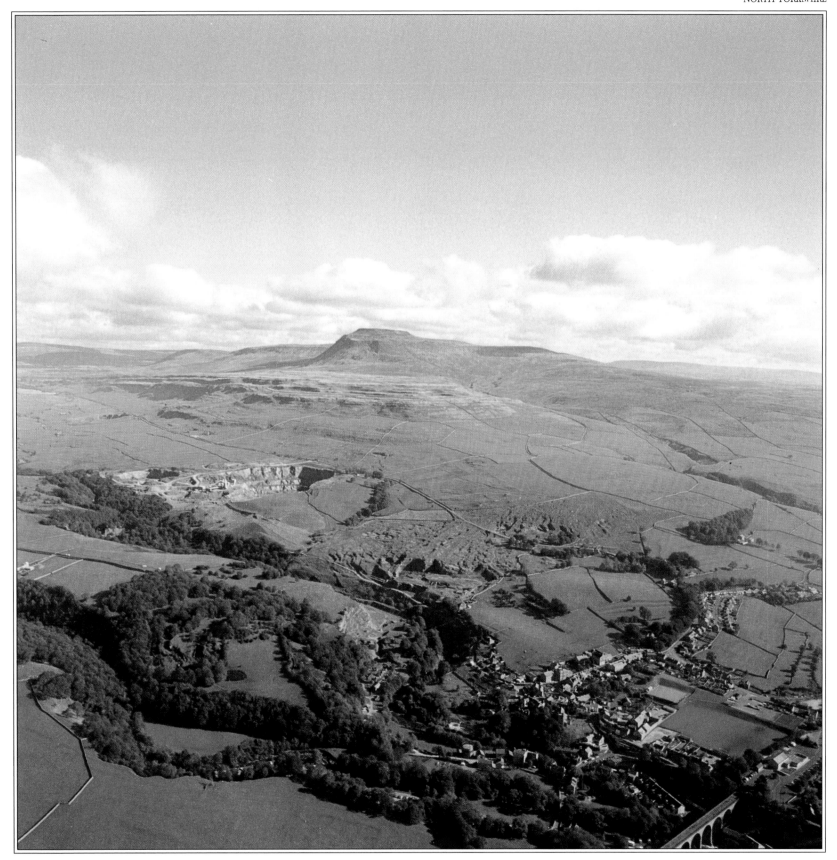

INGLETON AND INGLEBOROUGH

On the western edge of the Yorkshire Dales, the little village of Ingleton nestles under
the towering bulk of Ingleborough, which at 2,373 feet is the second-highest hill in
Yorkshire. The flat cap of Millstone Grit on its summit is nearly a mile in
circumference and at one time horse races were held there. In the first century AD
Venutius, the Brigantian leader, used a fort there for his headquarters.

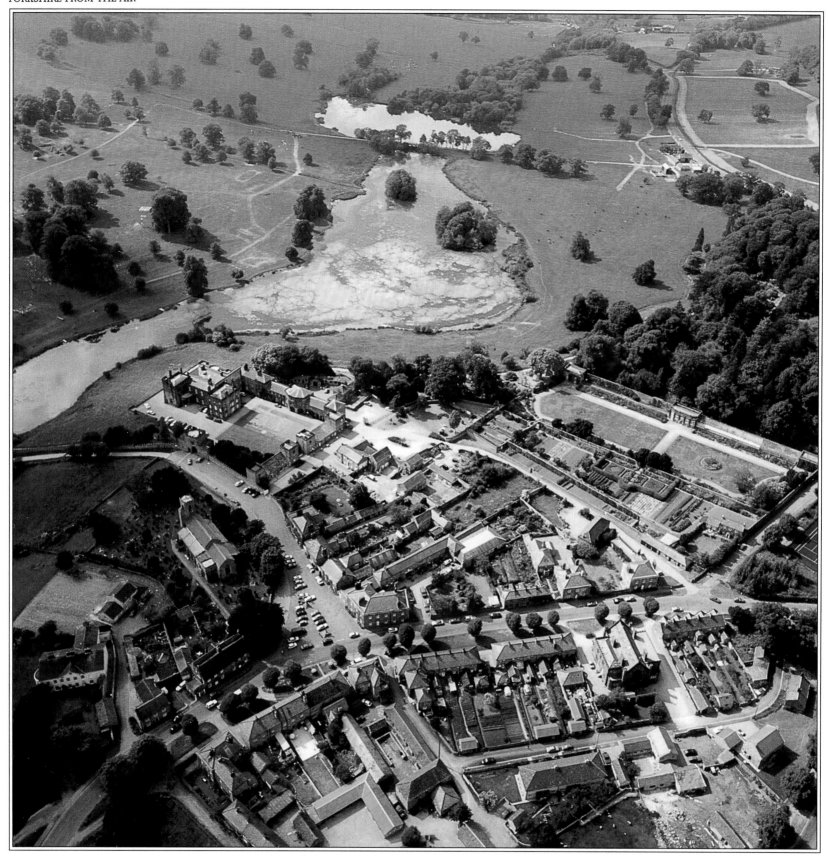

RIPLEY

The appearance of the village of Ripley, just north of Harrogate, was dramatically changed in 1827-8 by its eccentric owner, Sir William Amcotts Ingilby. Deciding to rebuild the village in Alsatian style, he replaced the existing thatched cottages with mock-Gothic or Tudor stone houses, and named the village hall the 'Hôtel de Ville' and his castle the 'Schloss'. He also created the lake by damming the River Nidd.

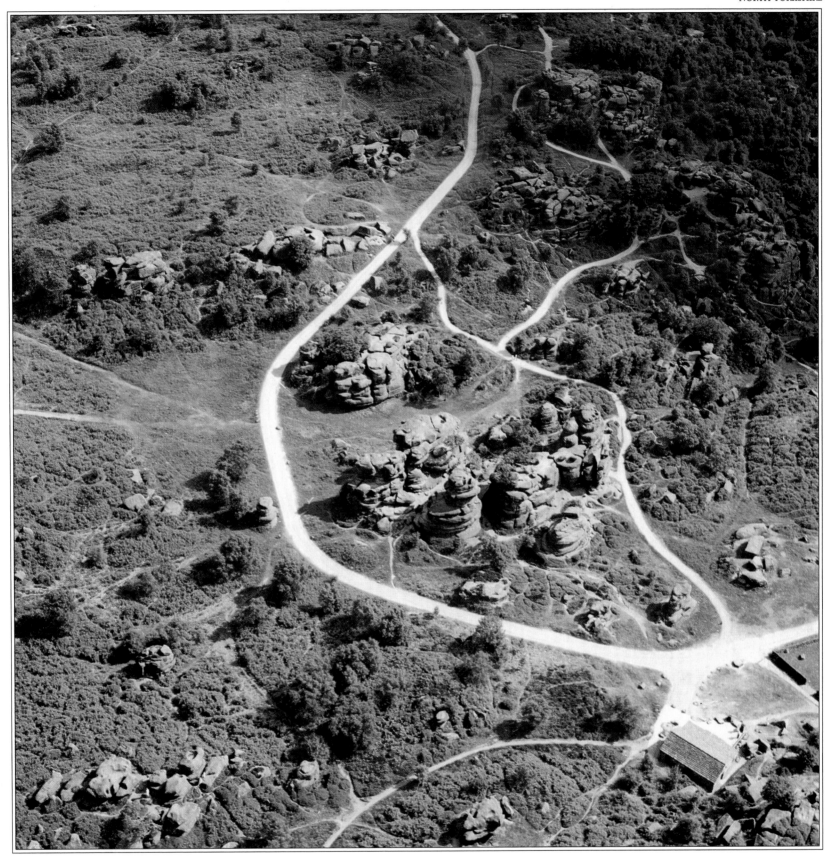

BRIMHAM ROCKS

On the moors between Pateley Bridge and Ripon, and spread over an area of some 50
acres, stand these curiously misshapen reminders of an earlier geological era. Formed
by the erosive action of desert sandstorms during Permian times, these pillars of
Millstone Grit stand twenty feet or more tall. Some blocks are balanced on the top of
others and wind, ice and water have carved many of them into fantastic shapes.

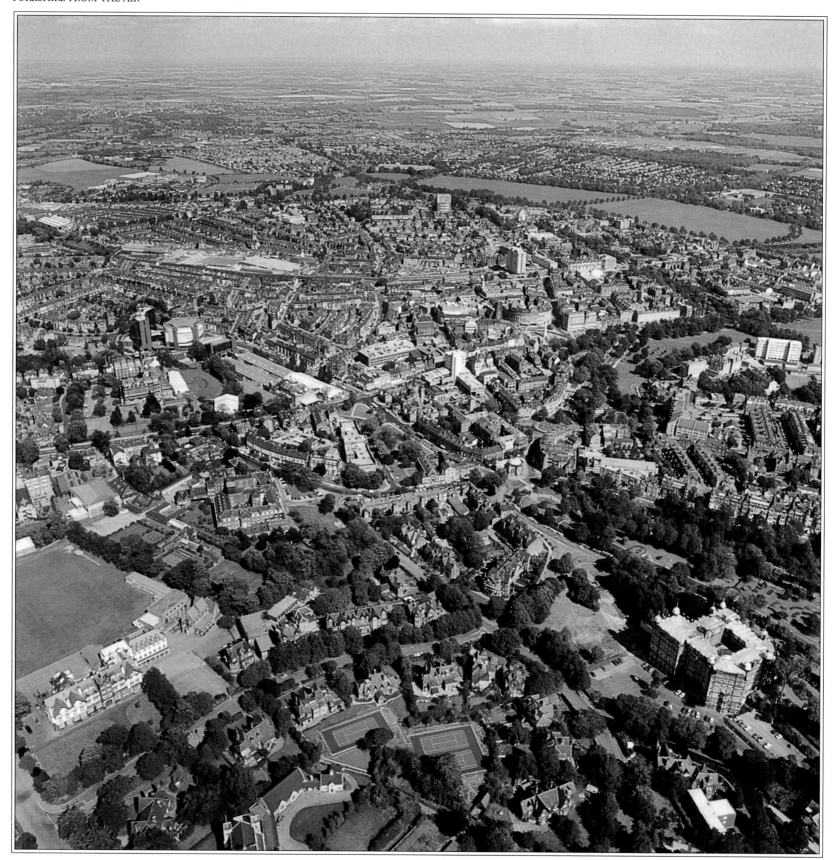

HARROGATE

More than 80 springs rise near the centre of Harrogate and from the seventeenth
century to the nineteenth people flocked here in an attempt to cure disorders ranging
from epilepsy to jaundice. No less than 35 of the springs can be found in the Valley
Gardens area in the lower right hand corner of the picture, and the little green-roofed
Pump Room at the top of the gardens has been kept as a museum of spa life.

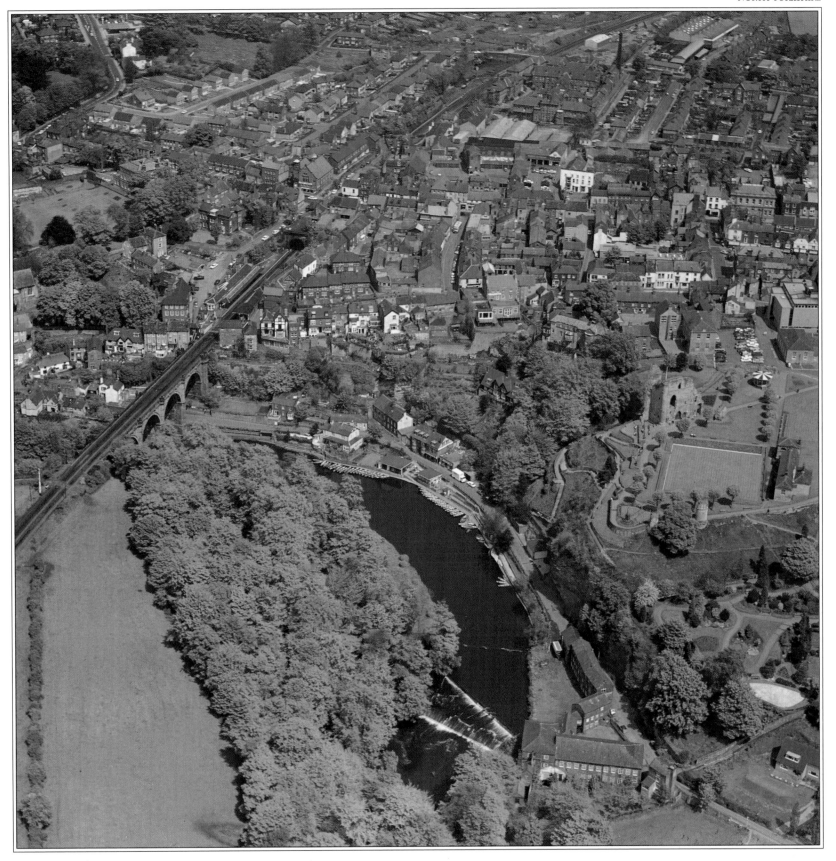

KNARESBOROUGH

Two miles north-east of Harrogate, on a picturesque chasm carved into the limestone
by the River Nidd, stands the much older town of Knaresborough. It was to
Knaresborough Castle, of which little now remains, that the knights fled after
murdering Thomas à Becket at Canterbury. The town's most famous daughter was the
prophetess Mother Shipton, who was born in 1488 and lived in a cave beside the river.

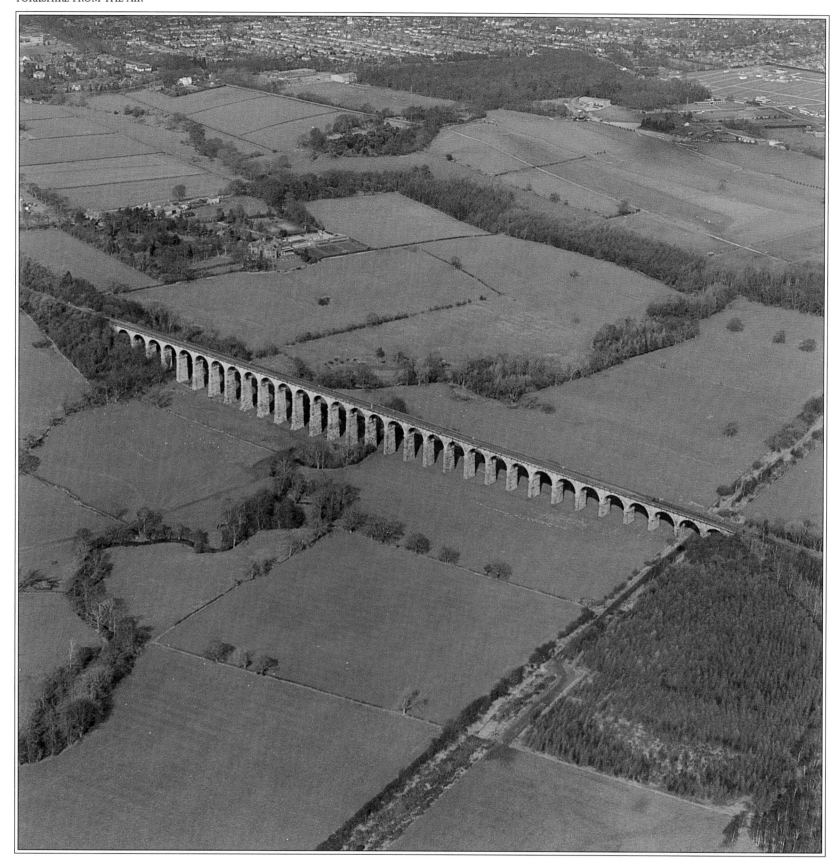

PANNAL, NEAR HARROGATE

The railway from Leeds crosses the charmingly-named Crimple Beck on the outskirts
of Harrogate by means of an impressive viaduct. The coming of the railways in the
nineteenth century made a huge difference to Yorkshire: a previously remote region of
England could now export its growing quantity of goods, the population exodus was
arrested, and tourists flocked in to its beauty spots.

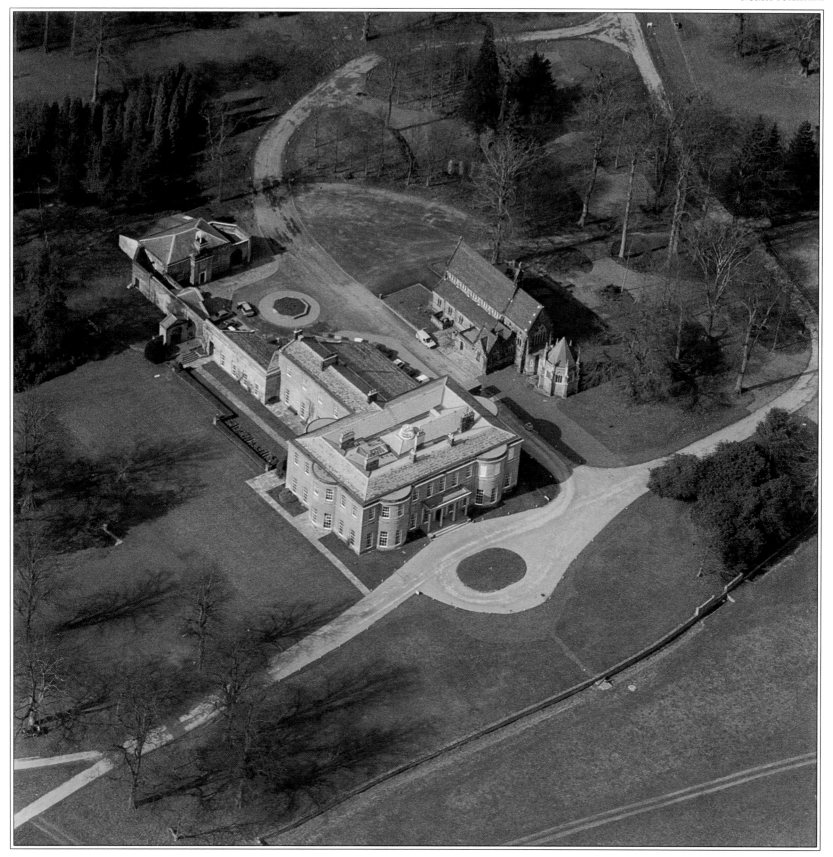

RUDDING PARK, FOLLIFOOT

In many ways the story of Rudding Park, not far from Harrogate, typifies that of
many other large Yorkshire houses in recent years. With 40 rooms, this elegant
Regency mansion with a park by Repton had become too expensive to maintain as a
family home, and was sold 16 years ago by the Radcliffe family who had lived there
for 150 years. The new owners have developed the estate.

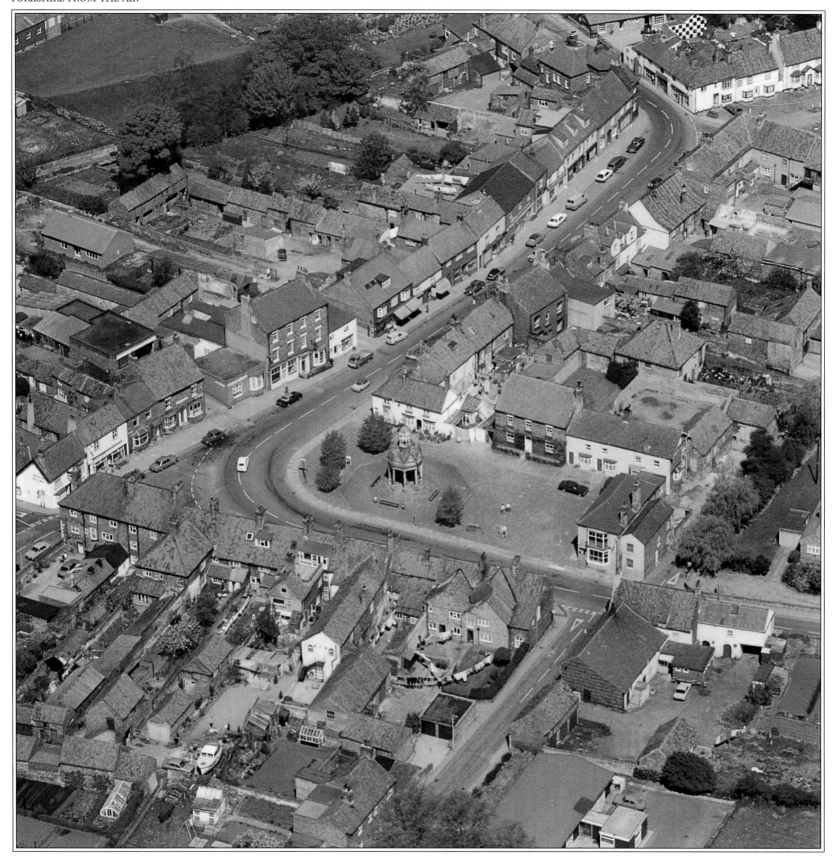

BOROUGHBRIDGE

Six miles south-east of Ripon, Boroughbridge is an old coaching town on the River
Ure. The bridge from which it takes its name was first built in the days of William the
Conqueror to carry the main road from London to Edinburgh: Boroughbridge is
roughly half-way between the two. The serenity of the town centre has happily been
preserved in modern times by the construction of a by-pass for the A1 in 1963.

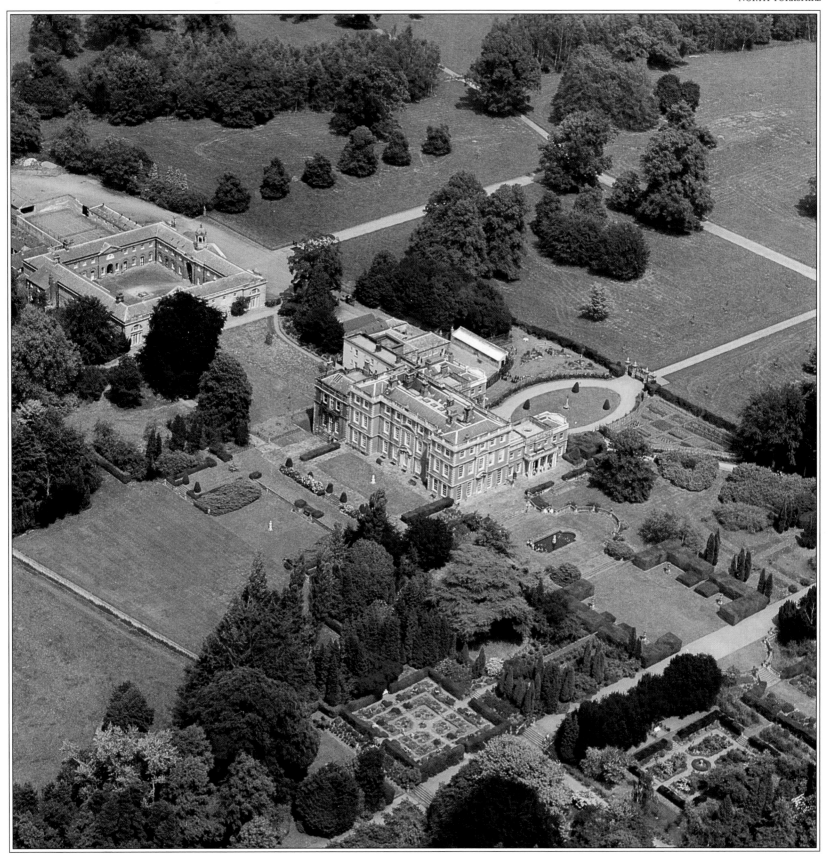

NEWBY HALL

Three miles from Boroughbridge, and set in 25 acres of parkland, Newby has both one
of the most beautiful gardens in England and one of the finest Adam interiors. The
house, a large red-brick mansion, was originally built with profits from his coal mines
by Sir Edward Blackett in the 1690s. It passed to the Weddell family in 1748 and
betwen 1770 and 1780 they employed Robert Adam to make extensive improvements.

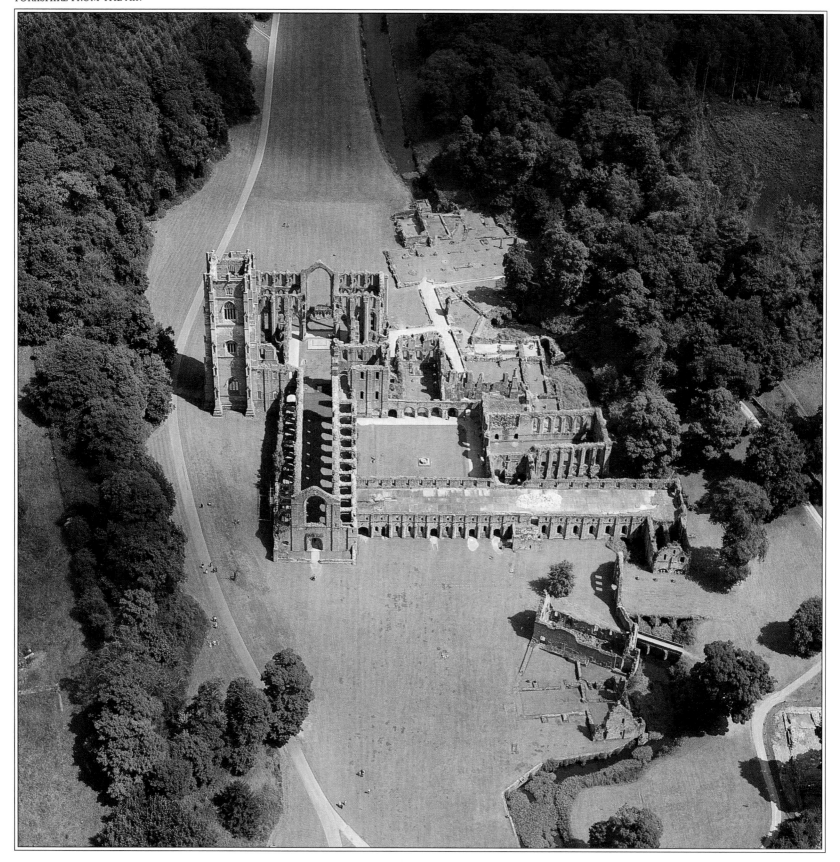

FOUNTAINS ABBEY

The serene beauty of Fountains is a profound monument to Cistercian genius in both
building and farming. Founded in 1132 beside the River Skell, the abbey eventually
acquired estates of more than a million acres in Nidderdale, Wharfedale and
Ribblesdale. The sweet grass provided ideal grazing for sheep, and the wool from their
fleeces was to make Fountains the richest of all Cistercian monasteries.

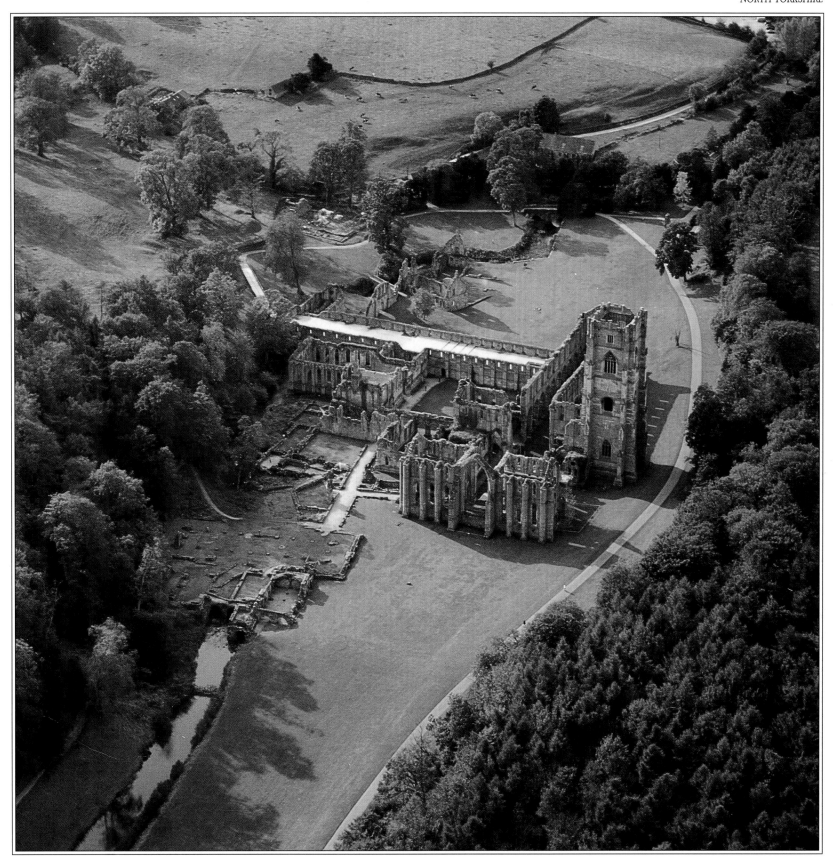

FOUNTAINS ABBEY

The church and many of the monastery buildings are still standing almost to roof level.
The majestic Perpendicular style Great Tower, on the right, is attached to the church:
the long building running from the end of the nave across the back of the picture to the
left housed the lay brothers on whose manual labour much of this huge monastic
enterprise depended. In the foreground is the famous Chapel of the Nine Altars.

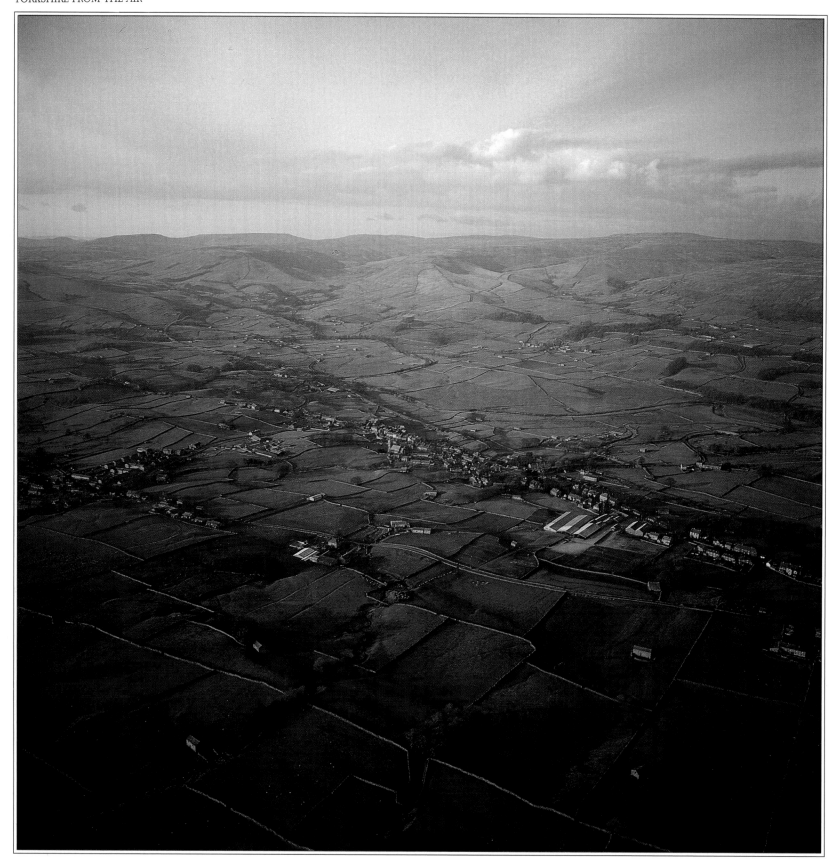

HAWES, WENSLEYDALE

Unlike Swaledale to the north, Wensleydale has a gentle, pastoral landscape even
fairly high up the valley. Hawes is the capital of upper Wensleydale, and one of the
highest market towns in England: its name comes from the Anglo-Saxon 'haus' which
means 'mountain pass'. It increased in importance when the railway came here in
1878, opening up the higher reaches of the Ure to tourism.

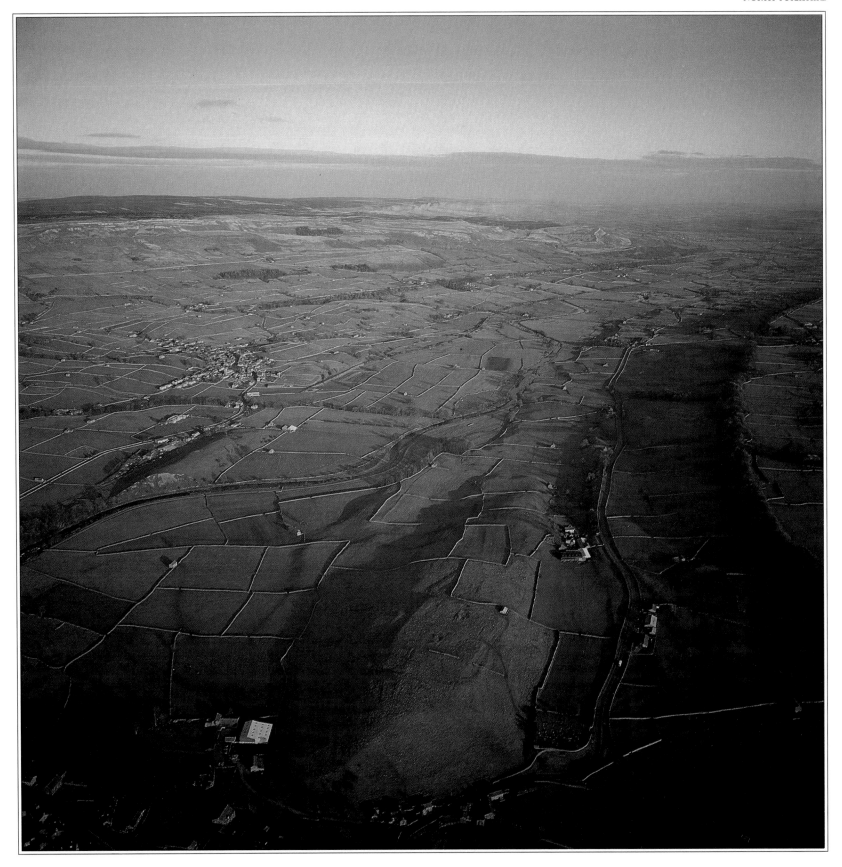

THE ROMAN FORT AT BAINBRIDGE

*A grassy knoll at the confluence of the Rivers Ure and Bain provided an ideal site for
the Roman fort of Virosidum. Bainbridge is in the centre of the Dales area, the
heartland of Brigantian resistance to the Romans during the first and second centuries
AD, and the fort here was garrisoned almost continually from c. AD 80 to the end of
the Roman occupation.*

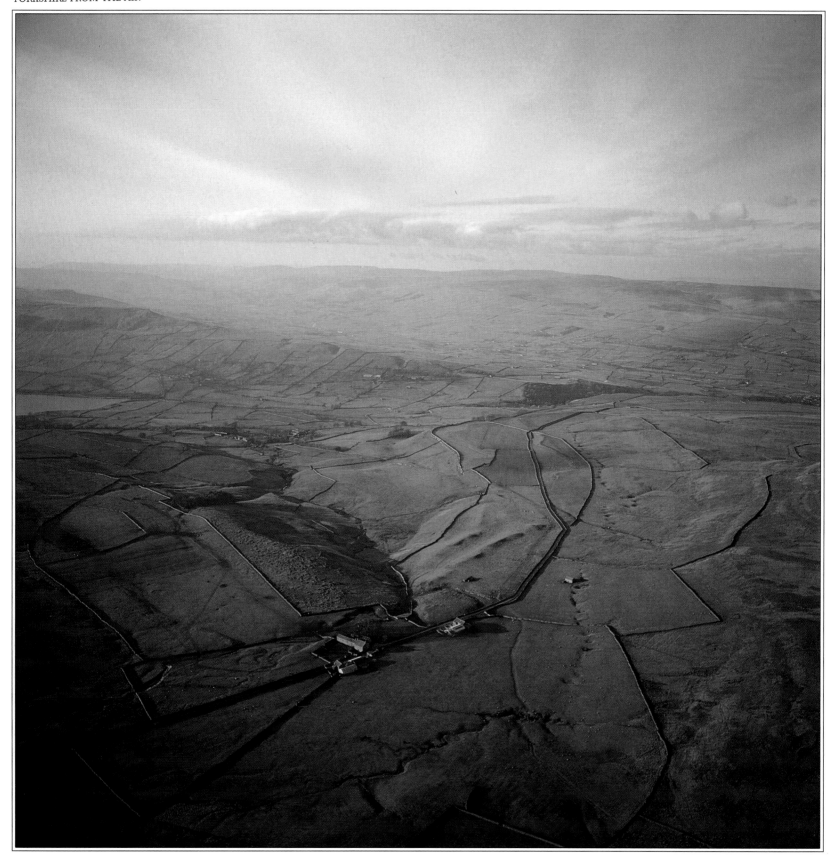

CARPLEY GREEN

The tiny, isolated hamlet of Carpley Green is set in spectacular surroundings between
Addlebrough hill and the little glacial lake of Semer Water. In 1937 a lowering of the
level of the lake revealed that this was an ancient place of settlement – there were Iron
Age artefacts together with the remains of a Bronze Age settlement and even of an
earlier Neolithic one.

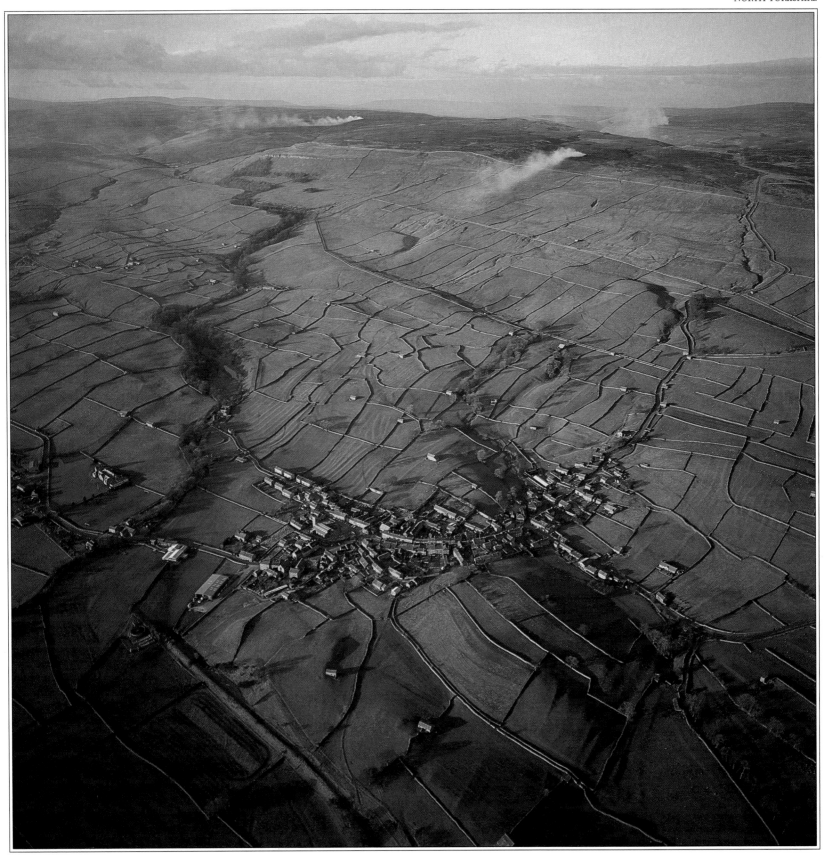

ASKRIGG, WENSLEYDALE

Two roads come over the moor from Swaledale to meet at Askrigg, a huddle of
seventeenth and eighteenth-century houses set amidst a patchwork of small walled
fields. The walls are almost all at least a hundred years old and most date from the
series of Enclosure Acts passed between about 1770 and 1849, although some are of
sixteenth-century date or even earlier.

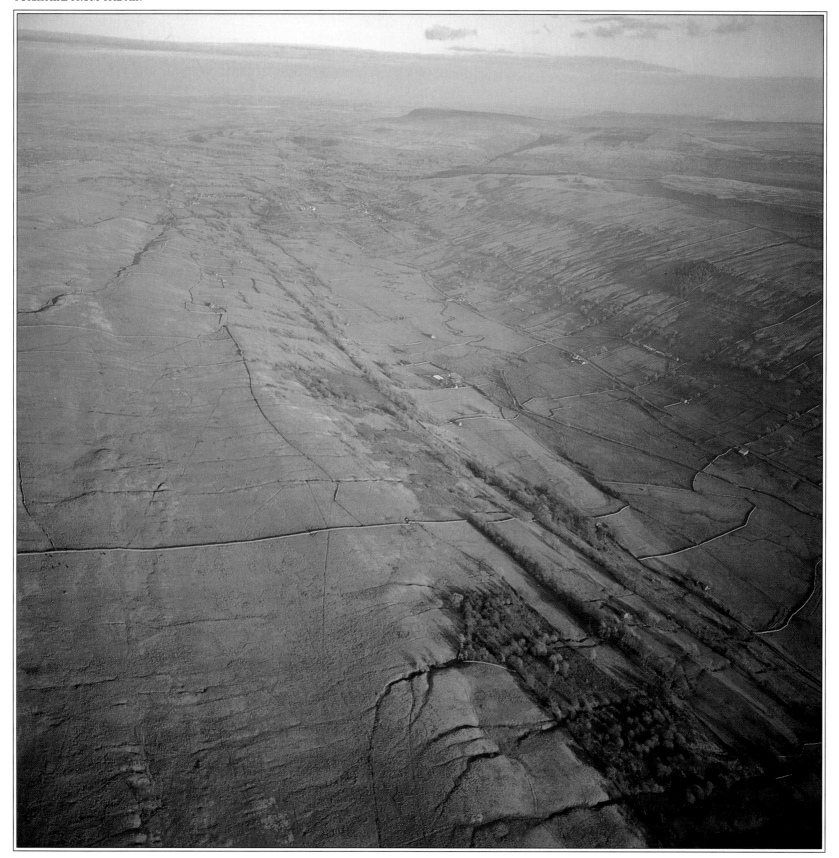

BISHOPDALE

*Wensleydale has several side valleys with tributaries running down them and
Bishopdale is one of the quietest and least-known of these. Like Wensleydale it is
composed of rocks of the Yoredale Series – alternate layers of shale,
sandstone and limestone that have produced a
stepped landscape.*

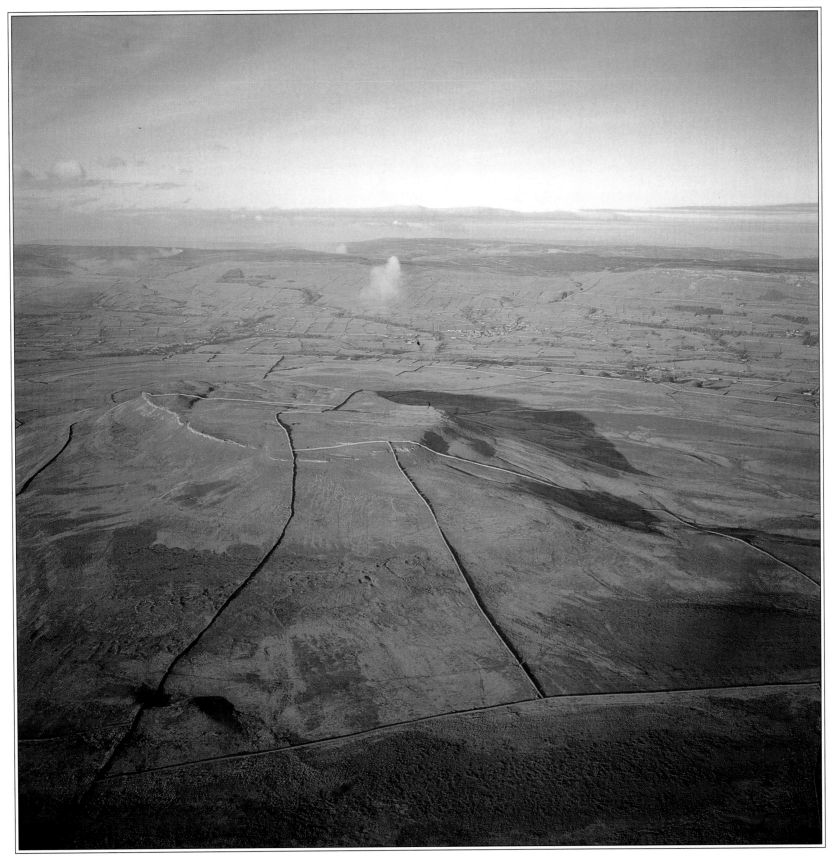

ADDLEBROUGH

Like Ingleborough to the south-west, flat-topped Addlebrough was once the site of a
Brigantian fort during Venutius' campaign against the Romans in the first century AD.
The valley beyond is Wensleydale, with the villages of Bainbridge (to the left) and
Askrigg. On the distant moors can be seen a familiar Yorkshire sight – heather-
burning.

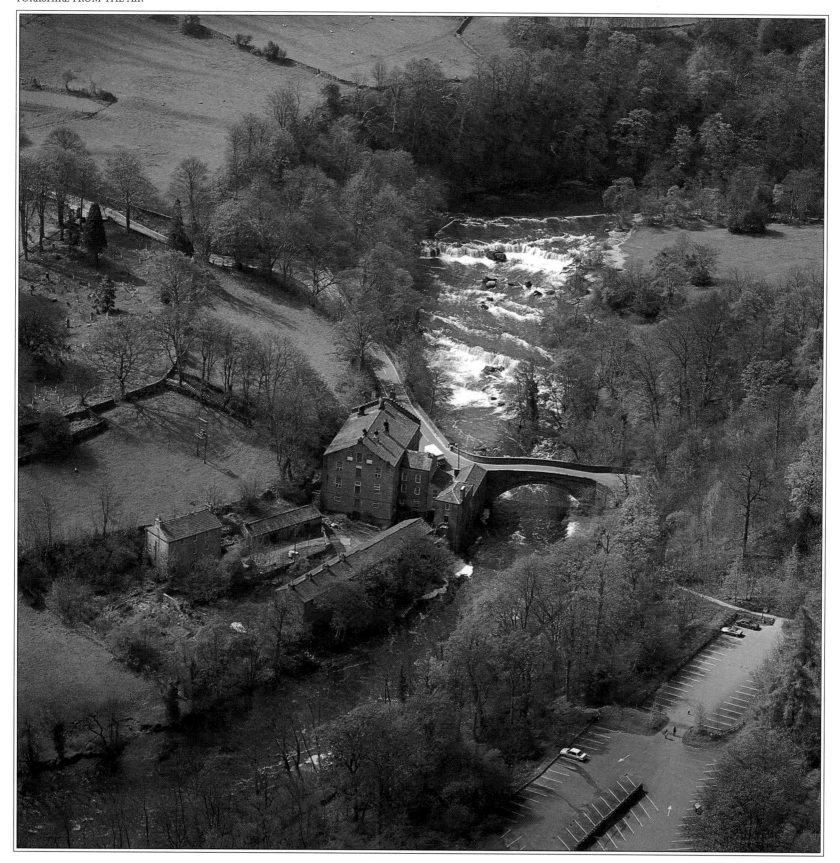

AYSGARTH FALLS

In Wensleydale the Great Scar Limestone forms only the valley floor, with the tiered
rocks of the Yoredale Series rising above it. Nevertheless, even here it can create
spectacular effects as at Aysgarth, where the River Ure tumbles over three broad steps
to create the famous Falls. The picture shows the upper falls and the old pack-horse
bridge below them, which provides a favourite viewing spot.

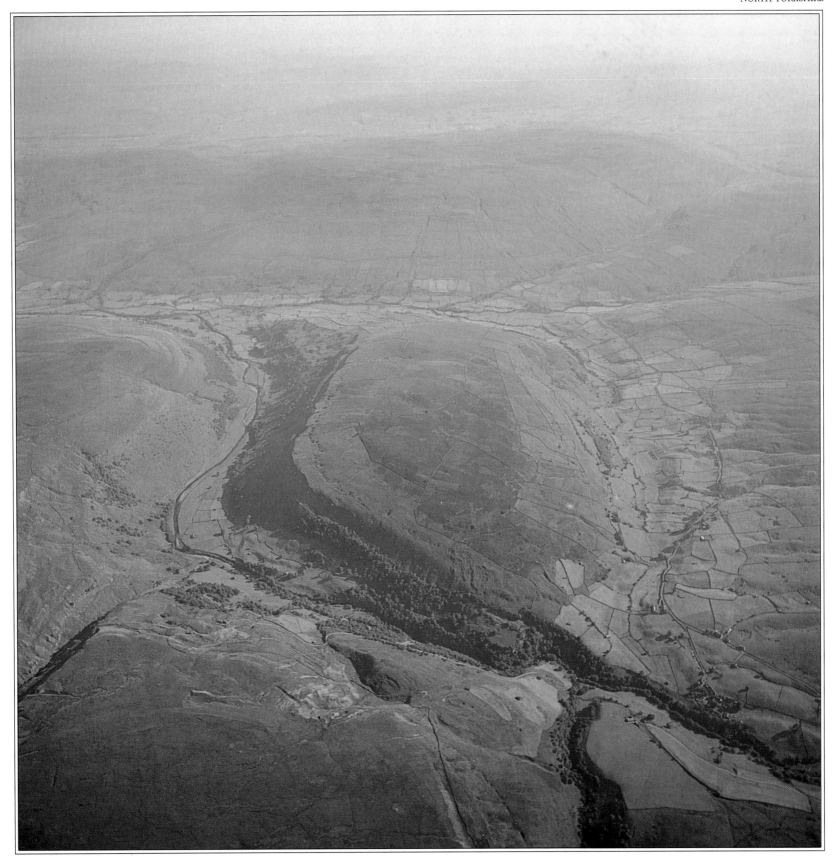

KISDON HILL, SWALEDALE

From the air it is clear why Kisdon Hill used to be known as Kisdon Island: its
snake's-head outline is bounded by water on all sides. To the left, amongst the woods,
flows the Swale; to the right the Skeb Skeugh Beck and in the distance, on the
southern side, Muker Beck. An old track across the hill, known as Corpse Way, used
to be used by funeral processions bringing bodies for burial at the church at Grinton.

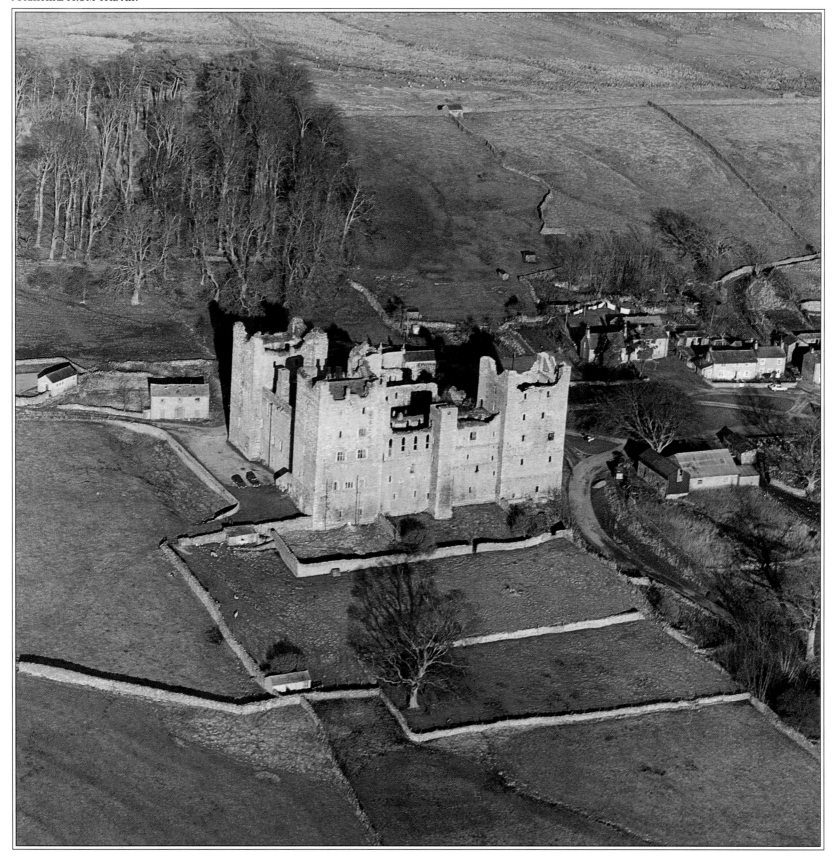

BOLTON CASTLE

Bolton Castle was built between 1379 and 1399 by the first Lord Scrope, a Chancellor
of England. Mary Queen of Scots was held prisoner here and the castle was also
besieged by Cromwell's troops during the Civil War. With its four mighty corner
towers enclosing four ranges of living quarters and a courtyard, it represents a balance
between the need for defence and for domestic comfort and order.

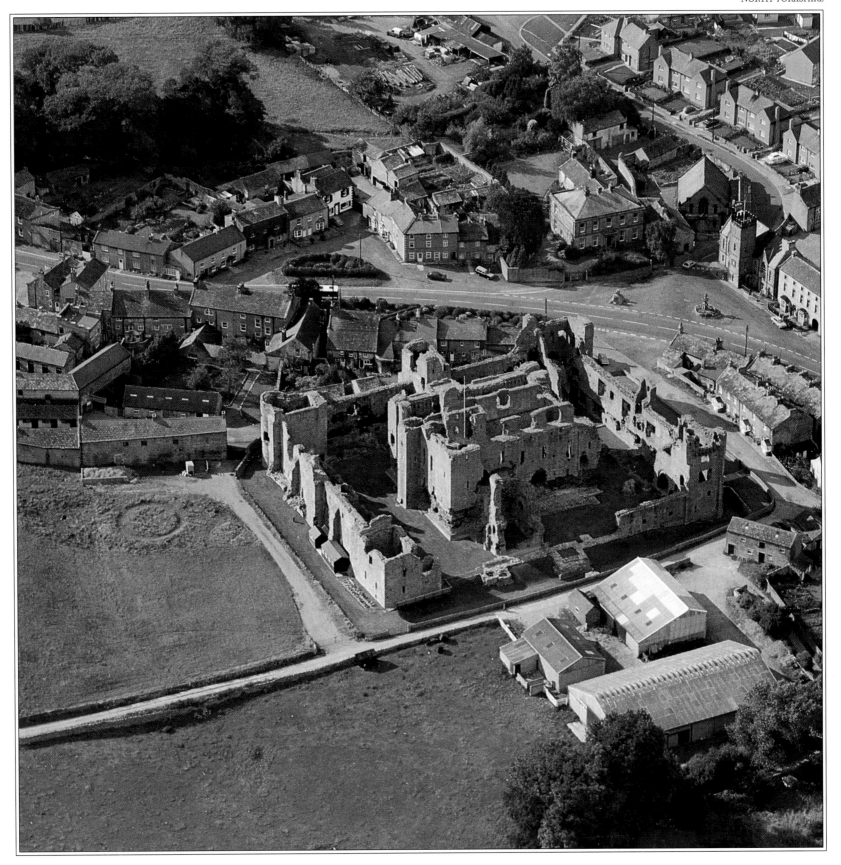

MIDDLEHAM CASTLE

An imposing and romantic ruin guarding Coverdale and the road from Richmond to
Skipton, Middleham had its heyday in the fifteenth century as the fortress of Warwick
'the Kingmaker' and the Court of the North of his son-in-law Richard III. In the mid-
seventeenth century part of the walls were blown away and the result was a free-for-all
for the citizens of Middleham, who plundered the stone for their houses.

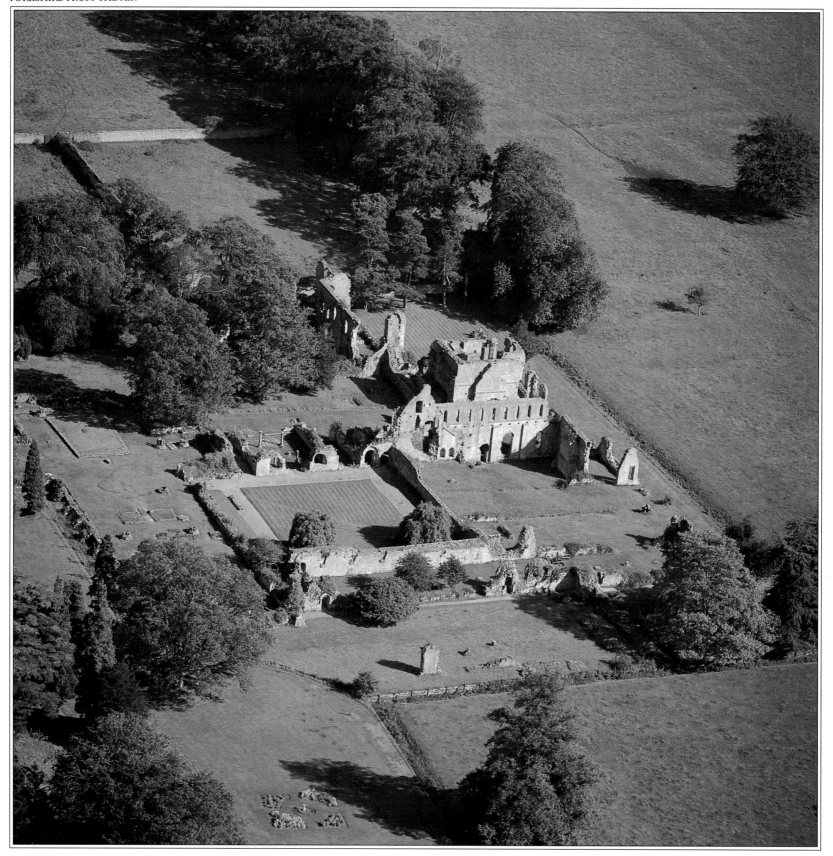

JERVAULX ABBEY

Bathed in sunlight and resting peacefully in the middle of its wooded park, Jervaulx
today gives little hint of the violent events that took place here at the time of the
Dissolution. When the King's men arrived, after plundering the lead from the roofs,
and removing anything valuable, they used gunpowder to demolish the fabric. Today
the largest building standing of this great Cistercian abbey is the long dormitory.

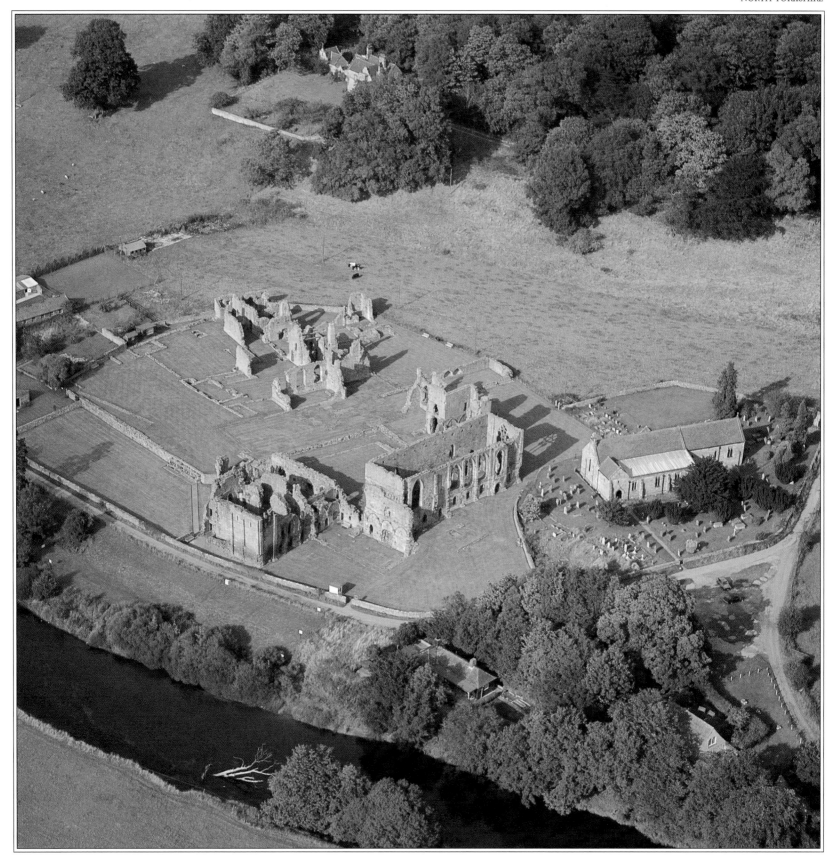

EASBY ABBEY

Founded in 1151 on the north bank of the Swale less than a mile from Richmond,
Easby was a Premonstratensian house dedicated to St Agatha. Like the Cistercians at
Jervaulx, Fountains and elsewhere, the Premonstratensians owed their riches
principally to sheep farming. Pevsner described the Abbey as 'one of the most
picturesque monastic ruins in the county richest in monastic ruins'.

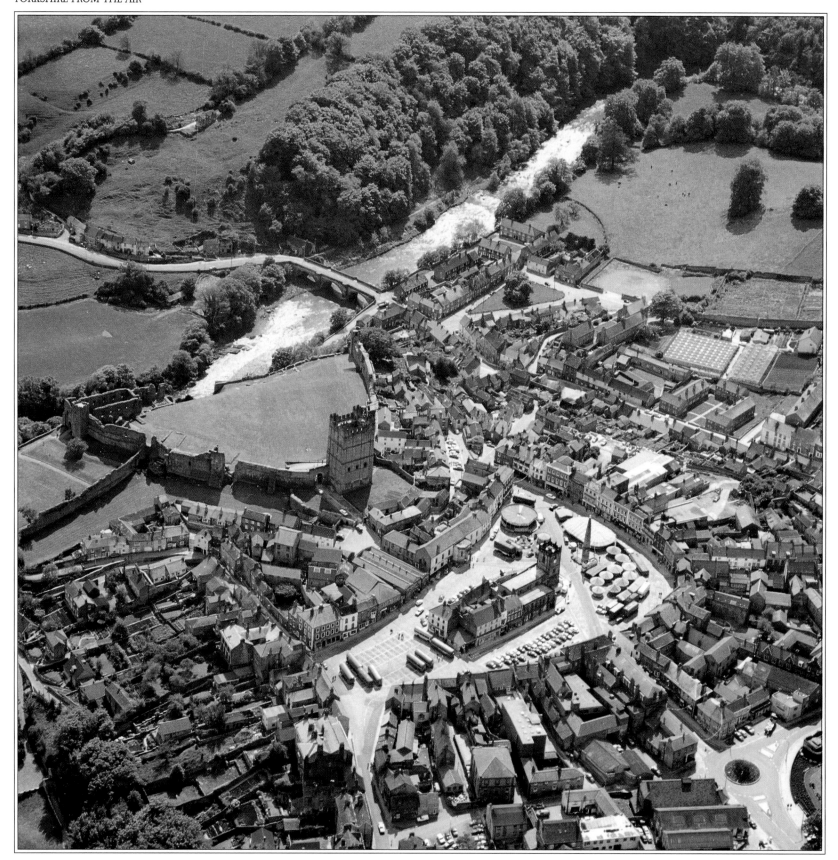

RICHMOND

The ancient market town of Richmond is Swaledale's capital and the northern
gateway to the Dales. Surely one of the most attractive small towns in Britain, it has a
splendid situation and steep, narrow streets. In the middle of the strangely-shaped
cobbled market place stands a unique Norman church with shops built into its walls;
it is now the regimental museum of the Green Howards.

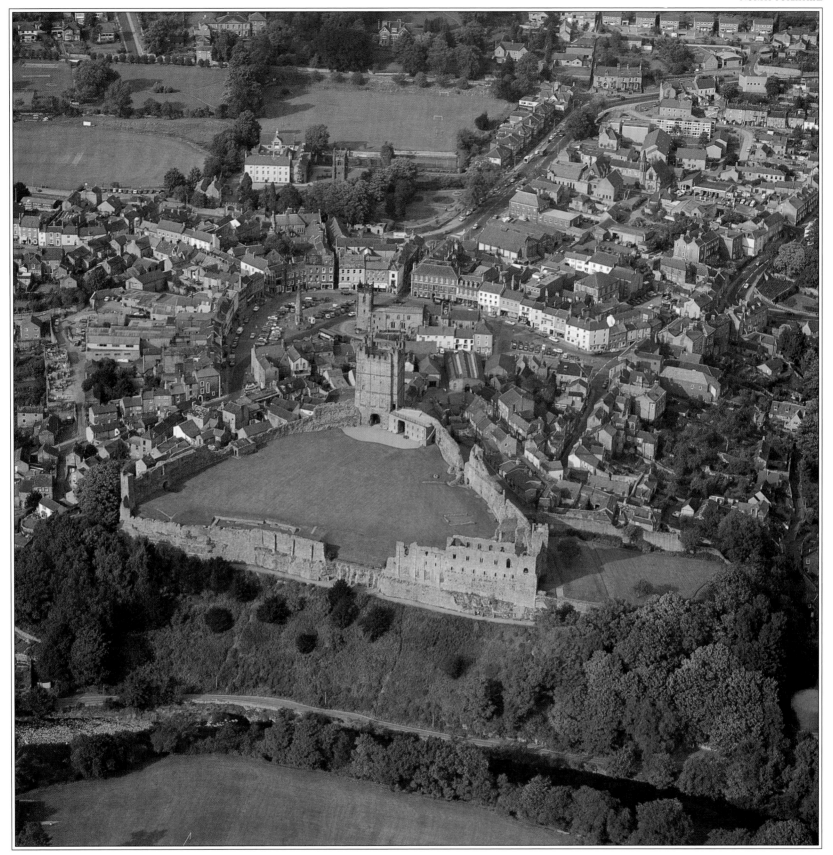

RICHMOND CASTLE

Seen from the other side of the river, the dominating position of Richmond's castle is
all the more apparent: its giant walls seem almost a continuation of the precipitous
bank of the Swale on which it is constructed. The castle was built in 1071 by Earl
Alan Rufus; its magnificent keep, one of the tallest in England, has walls
eleven feet thick.

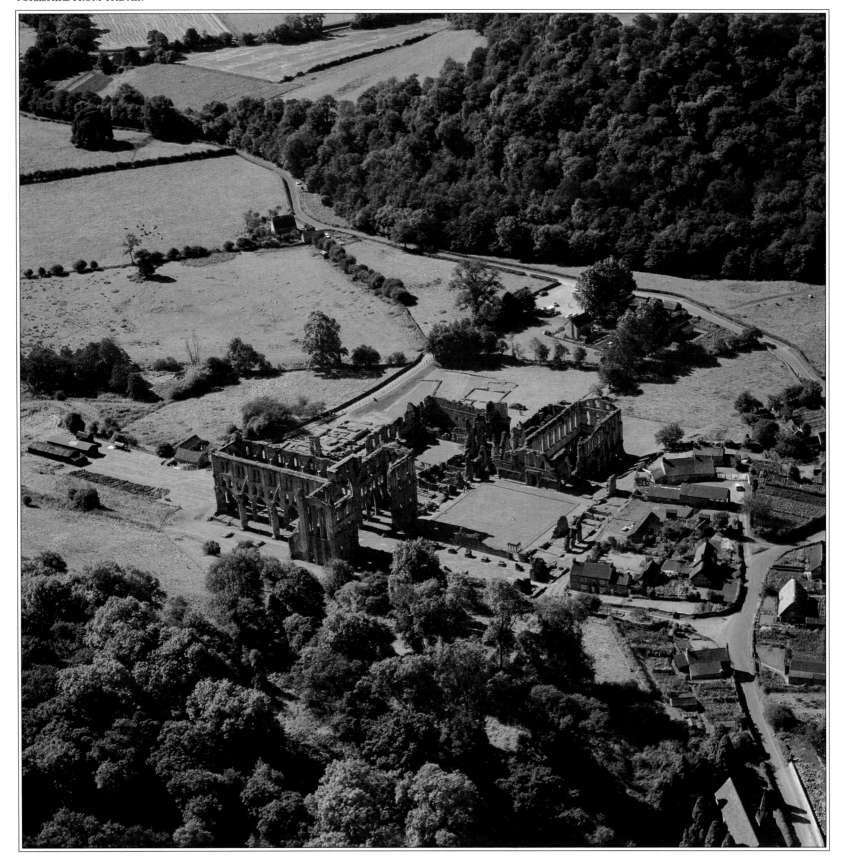

RIEVAULX ABBEY

St Aelred, Abbot of Rievaulx c. 1150-60, wrote that the abbey provided 'a marvellous
freedom from the tumult of the world'. Founded in 1132, within fifteen years it had
140 monks and 500 lay brothers, and estates and influence that stretched for miles
around, for as well as sheep-farming the brothers were involved in
mining and stud-farming.

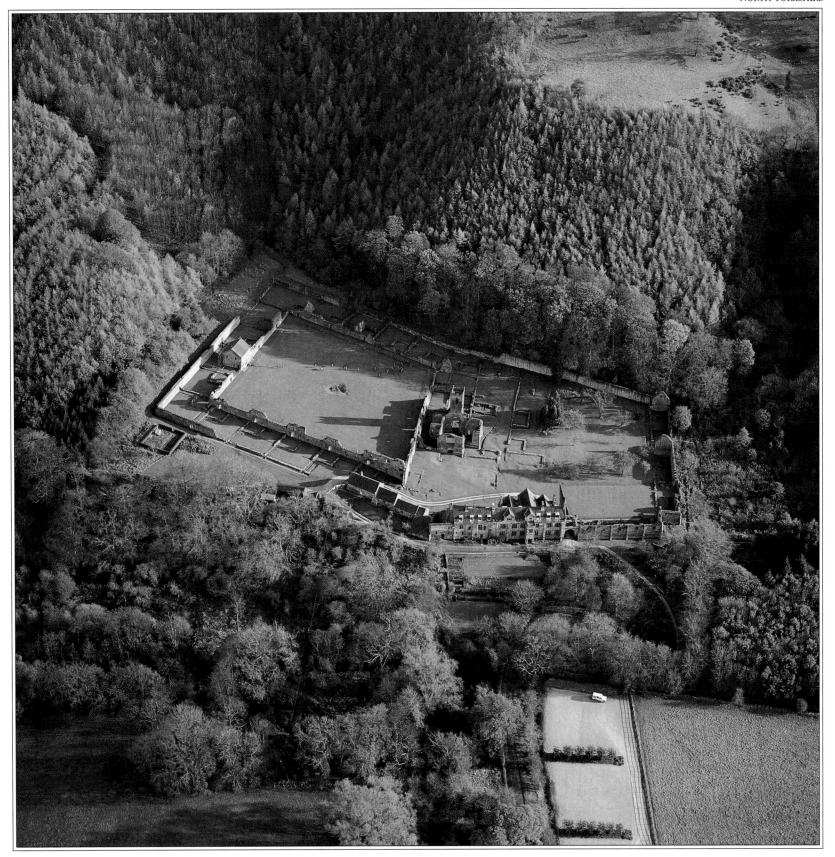

MOUNT GRACE PRIORY

*Just off the western edge of the North York Moors are the intriguing remains of the
only Carthusian monastery in Yorkshire. Very different in character from the
splendours of Reivaulx or Fountains, Mount Grace dates from 1398, when it was
founded by a nephew of Richard II, Thomas Holland, Duke of Surrey. The
Carthusians led a hermit-style existence, spending all their time alone in their cells.*

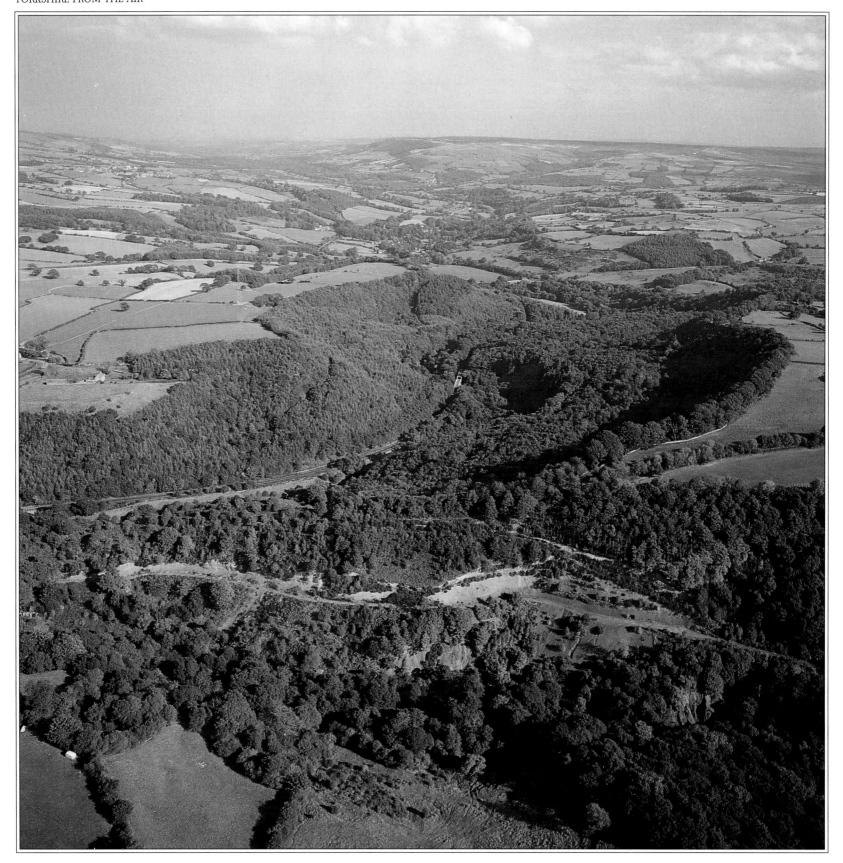

ARNECLIFF WOOD, GLAISDALE

At the confluence of the Esk with one of its many tributaries, Glaisdale Beck, which
flows in from the south down a broad and beautiful dale, Arncecliff Wood is
particularly pretty and is very popular with walkers. Over 50 species of birds have
been seen in such woods on the North York Moors, including blackcaps, tree creepers
and spotted and pied flycatchers.

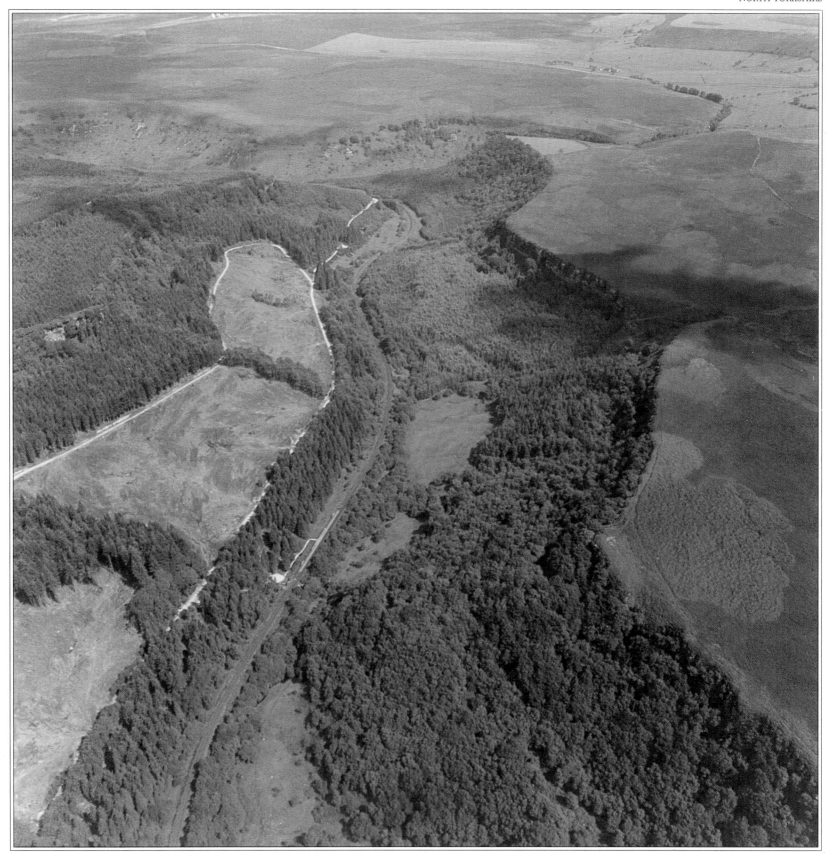

NEWTON DALE

The twisting, precipitous valley of Newton Dale is thought to have been cut by a
torrent of glacial meltwater flowing down to the Vale of Pickering during the Ice Age.
There is no road here but the North Yorkshire Moors Railway, built by George
Stephenson in the 1830s and still in use, will carry you up it. The forest covering the
dale is part of huge Cropton Forest.

49

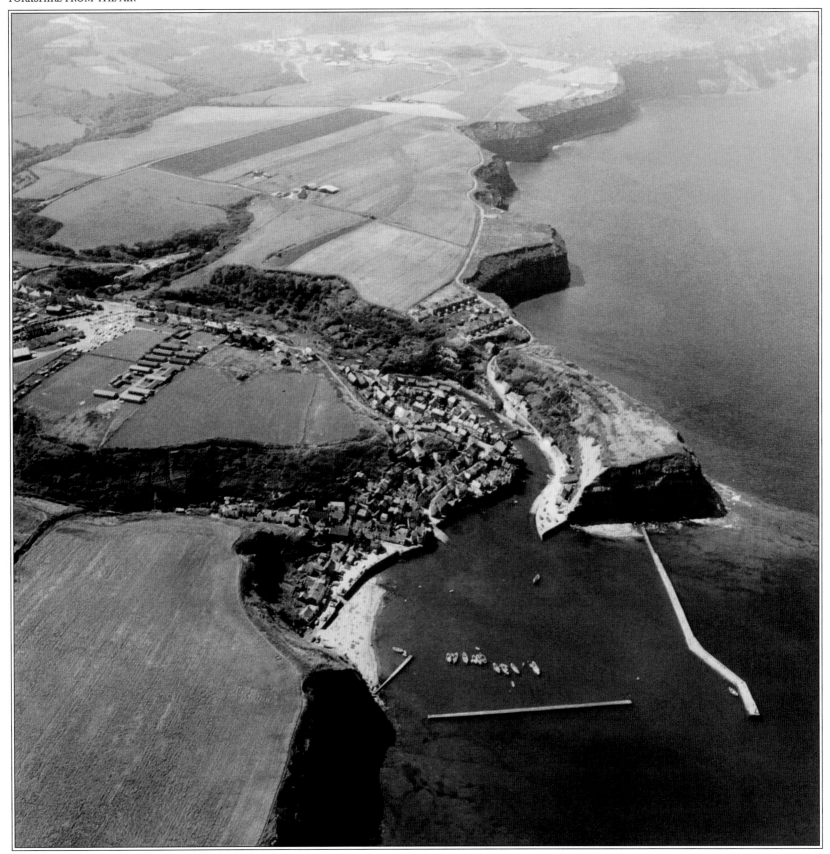

STAITHES

Staithes, along with a number of locations on or near the north-east coast, is part of
the Captain Cook story, for it was here that the young James Cook in the prosaic
trade of an apprentice grocer and haberdasher, had his first real contact with the sea:
he had been born several miles inland and had started life as a farm labourer. In those
days Staithes was a busy fishing port and shipbuilding centre.

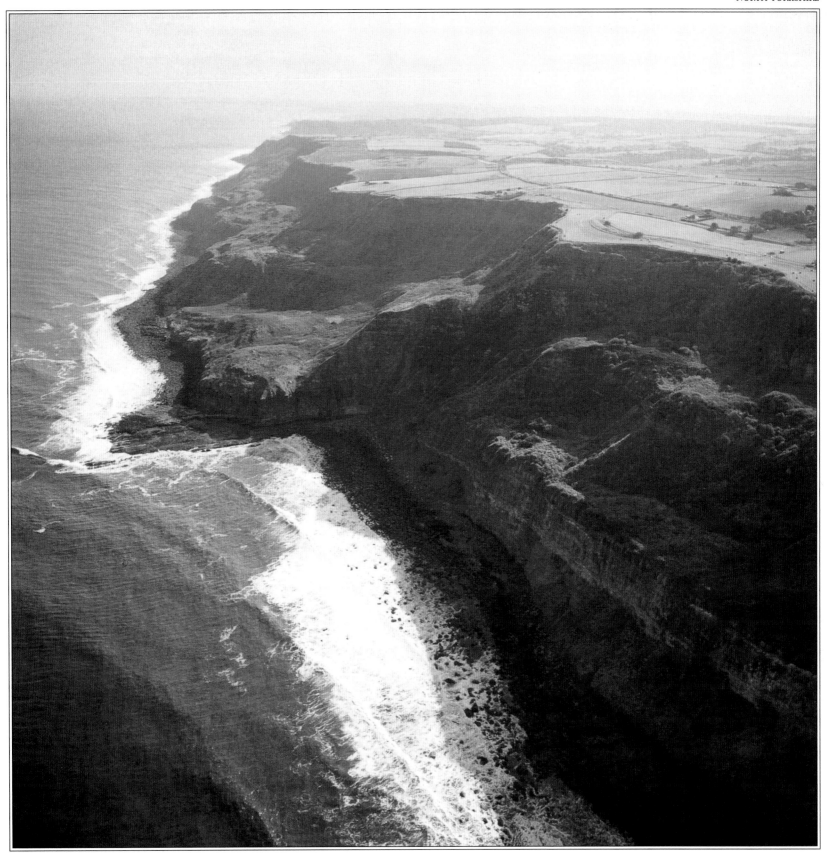

BEAST CLIFF

Water surges at the bottom of the menacingly-named Beast Cliff, the point between
Robin Hood's Bay and Scarborough where Staintondale Moor meets the sea. Much of
Yorkshire's most spectacular coastline – a stretch from Staithes nearly to Scarborough
– falls within the North York Moors National Park, and it has also been designated a
Heritage Coast to preserve its dramatic and rugged beauty.

 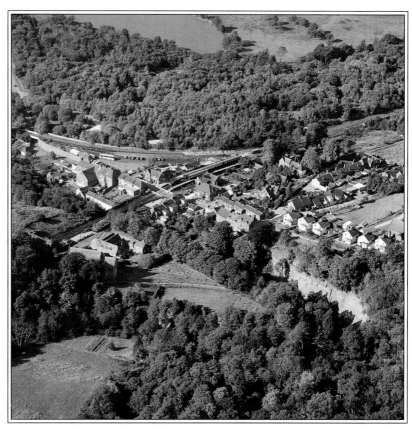

EGTON BRIDGE, ESKDALE

Eskdale is renowned for its pretty, unspoilt villages and dramatic scenery, and the village of Egton Bridge is one of its most picturesque. It was the birthplace of Father Nicholas Postgate, the 'Martyr of the Moors' who was executed in 1679 at the age of 82 for the sole crime of baptising a child into the Catholic faith, and it is still a thriving Catholic parish. The scenic Esk Valley Line can be seen running away down the dale; there are small stations at many of the villages it passes and it is much used by tourists in summer.

GROSMONT, ESKDALE

A little further down Eskdale, and also on the Esk Valley Line, seen crossing the back of the village, is the former mining village of Grosmont, built when a scar of ironstone was discovered nearby in 1836. Grosmont's main claim to fame nowadays is as the northern terminus of the private North York Moors Railway, over whose 18-mile route trains are pulled by historic steam and diesel engines. The line was originally built by George Stephenson in 1836 as a horse-drawn service; in 1845 a steam locomotive was introduced but nevertheless the coaches had to be hauled up some of the steepest gradients by rope.

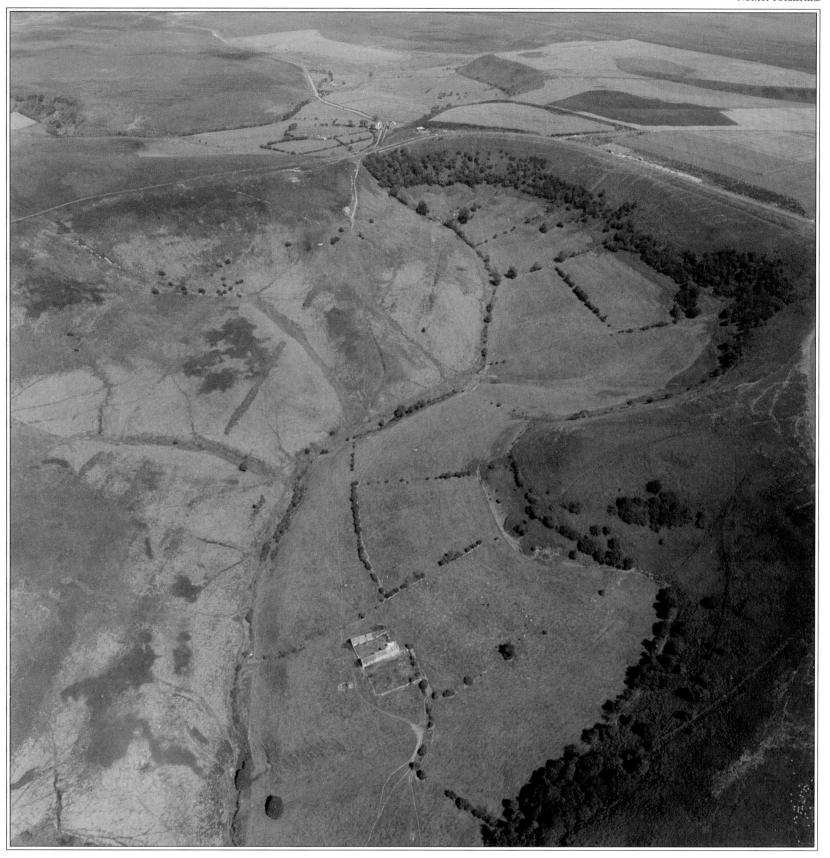

THE HOLE OF HORCUM

Between the two huge wooded areas of Cropton Forest and Dalby Forest in the
southern part of the North York Moors lies an immense natural amphitheatre. The
Hole of Horcum is large enough to enclose two farms and legend has it that it was dug
out by a giant, Wade, to throw at this wife, Bell. The more mundane real cause is a
spring line at the upper edge of the Oxford Clay of the area, overlaid by porous rock.

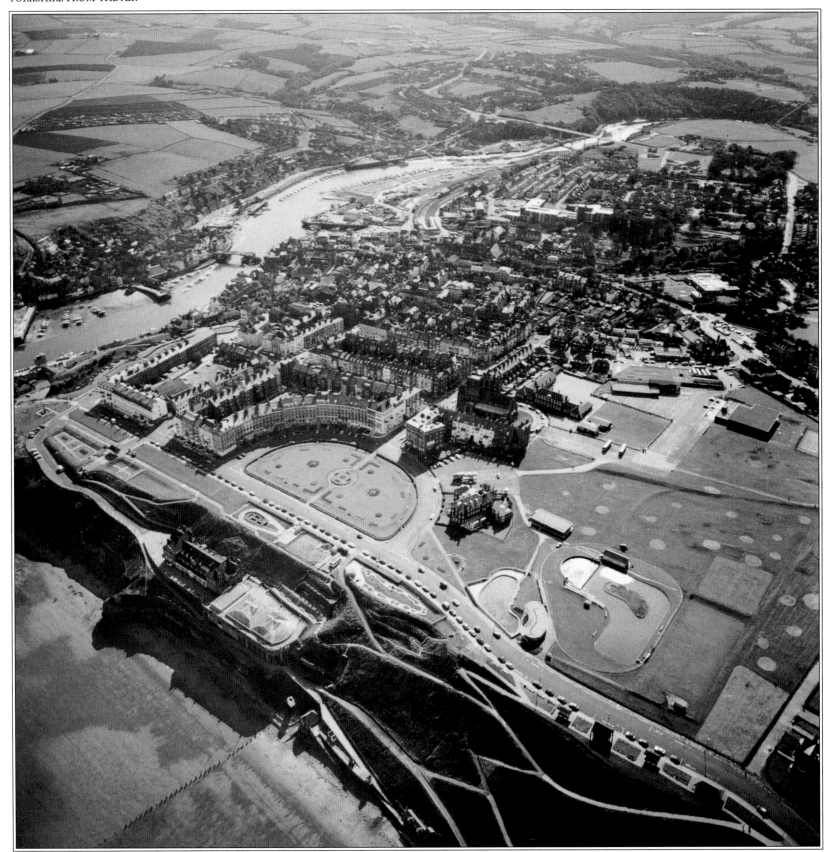

WHITBY

Surrounded by a barrier of moorland, Whitby has long looked to the sea for its
livelihood, although nowadays this is as a seaside resort rather than as an important
port. Until about 1830, the town was a thriving whaling port, with 55 ships plying
the trade in its heyday. It was from Whitby, too, that Captain Cook first went to sea
as an apprentice on a collier, and from here that he set forth on his great voyages.

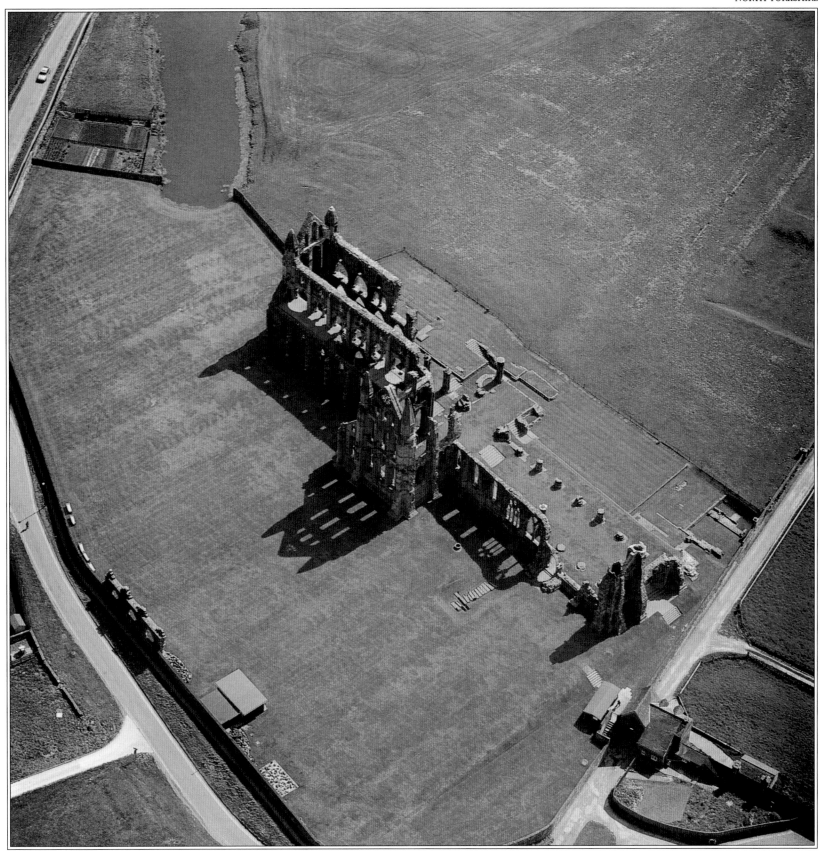

WHITBY ABBEY

On a high, windswept hill fully exposed to the North Sea, Whitby Abbey has none of
the cosiness of the Cistercian valley sites; austerity, one feels, is the prevailing spirit
here. Yet this is probably the third or fourth abbey to have stood on this spot, the first
being that of Saint Hilda, daughter of King Oswy of Northumbria, who founded a
mixed monastery of men and women on land given by her father in 657.

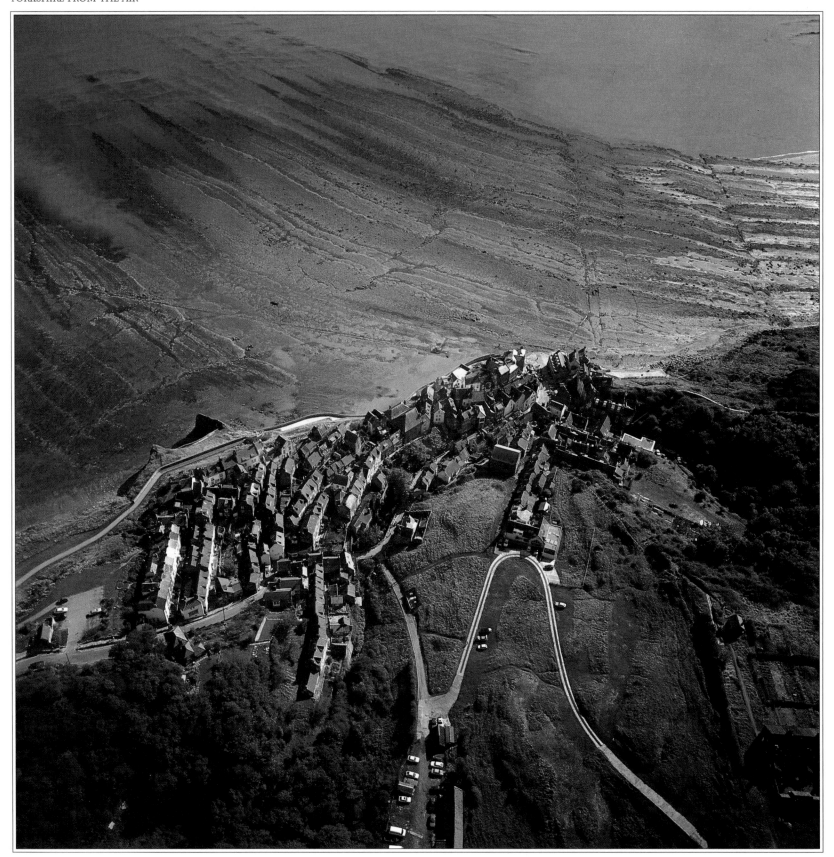

ROBIN HOOD'S BAY

Most of Yorkshire's coast ends abruptly and dramatically in rugged cliffs, only
occasionally interspersed with sandy bays. Robin Hood's Bay, south of Whitby, is one
of the largest and most beautiful of these, carved from some of the oldest rocks in the
area, which make intriguing patterns at low tide. The little village of the same name
jostles precariously on the edges of a ravine at the northern end of the bay.

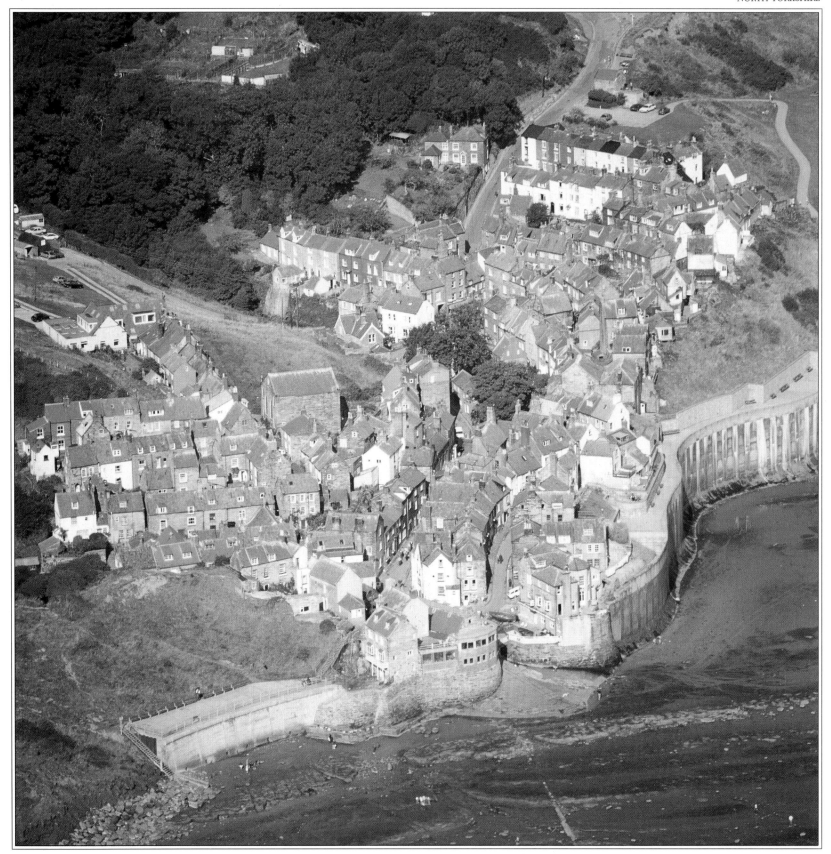

ROBIN HOOD'S BAY

There are modern houses on the top of the hill, but what makes this one of the most
picturesque villages in all Yorkshire are the little red-roofed cottages crowding the steep
cobbled streets leading down to the sea. The association with Robin Hood (Robert, Earl
of Huntingdon) has been claimed since at least 1538: Robin Hood said that he would
take up residence in whatever spot on the east coast a shot from his bow landed.

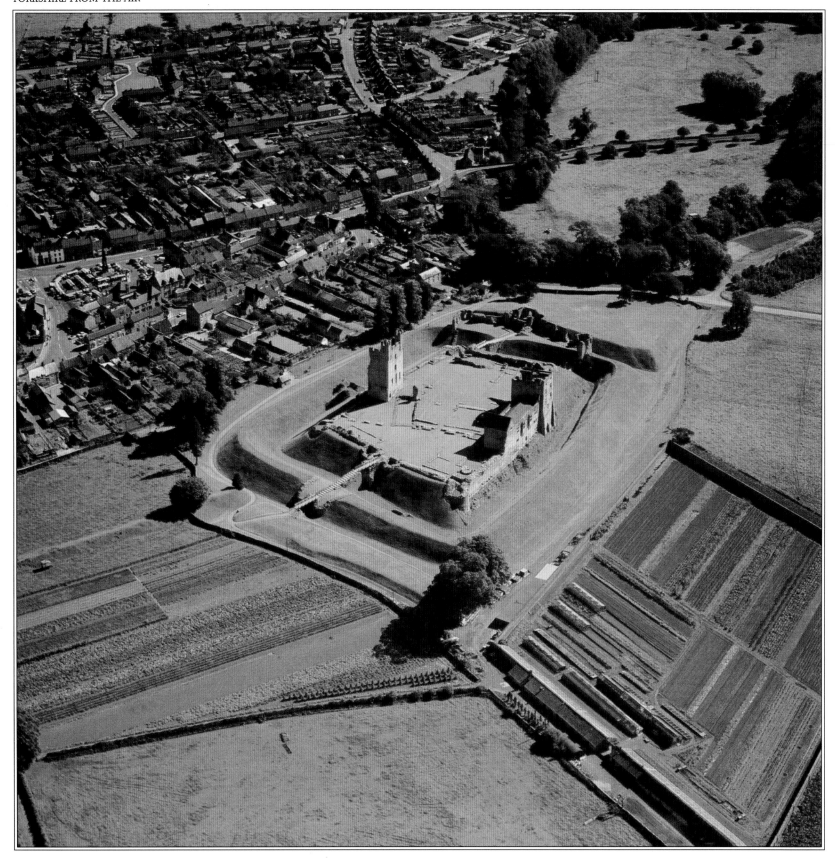

HELMSLEY AND HELMSLEY CASTLE

Helmsley is an attractive little market town tucked at the foot of the Hambleton and
Tabular Hills on the southern side of the North York Moors. It has a pleasant market
not-quite-square and an ancient church. The imposing earthworks of the thirteenth-
century castle seem to dwarf both, however. The keep stands on the side nearest to the
town, and opposite it is a range which was renovated in Tudor times.

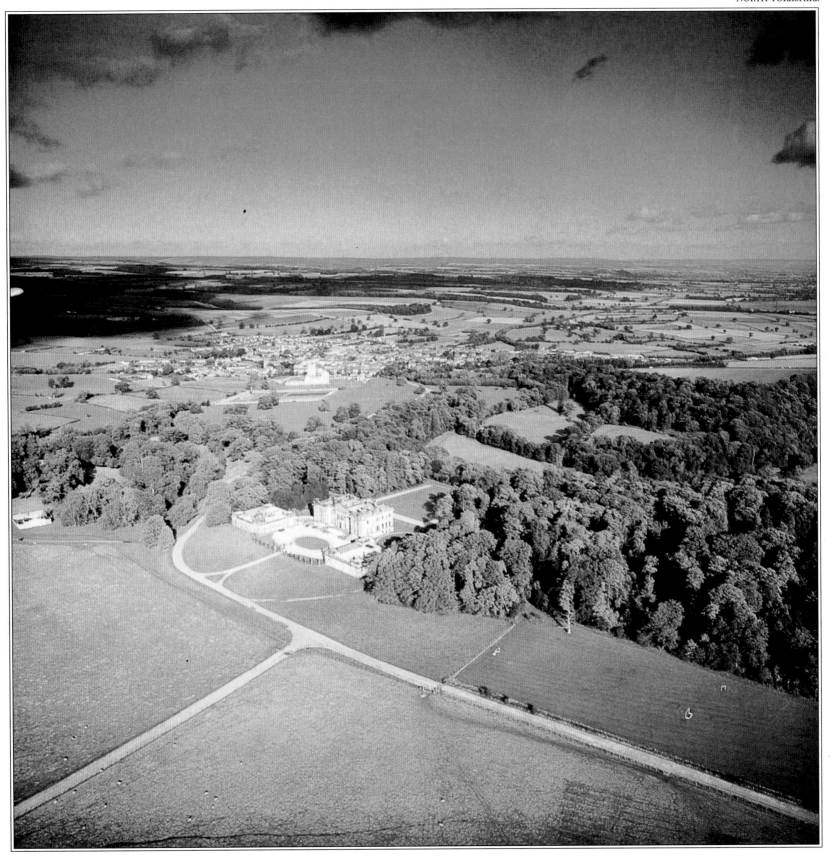

DUNCOMBE PARK, RYEDALE

The pretty countryside round Helmsley is the product of one of Yorkshire's gentlest
dales, Ryedale; beyond is Riccardale. Having passed Rievaulx a few miles upstream,
the Rye curls round the beautiful landscaped grounds of Duncombe Park in the
foreground, and north to Helmsley, whose red pantiled roofs are
characteristic in the dales of the North York Moors.

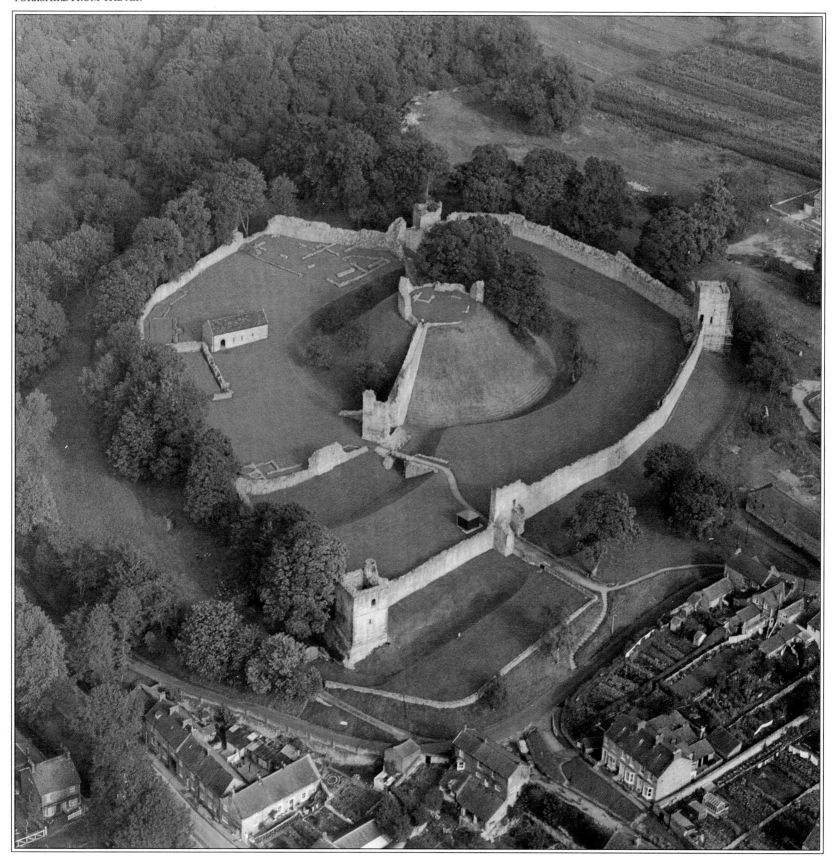

PICKERING CASTLE

The heart-shaped walls of Pickering's twelfth-century castle make an attractive pattern
from the air. Inside, the keep is surrounded by a fine moat. Because of its setting in
good hunting country, Pickering Castle was much visited by medieval monarchs, and
parts of the old Royal Forest of Pickering, to the north of the town, still
belong to the Queen. King John and Edwards I, II and III all stayed here.

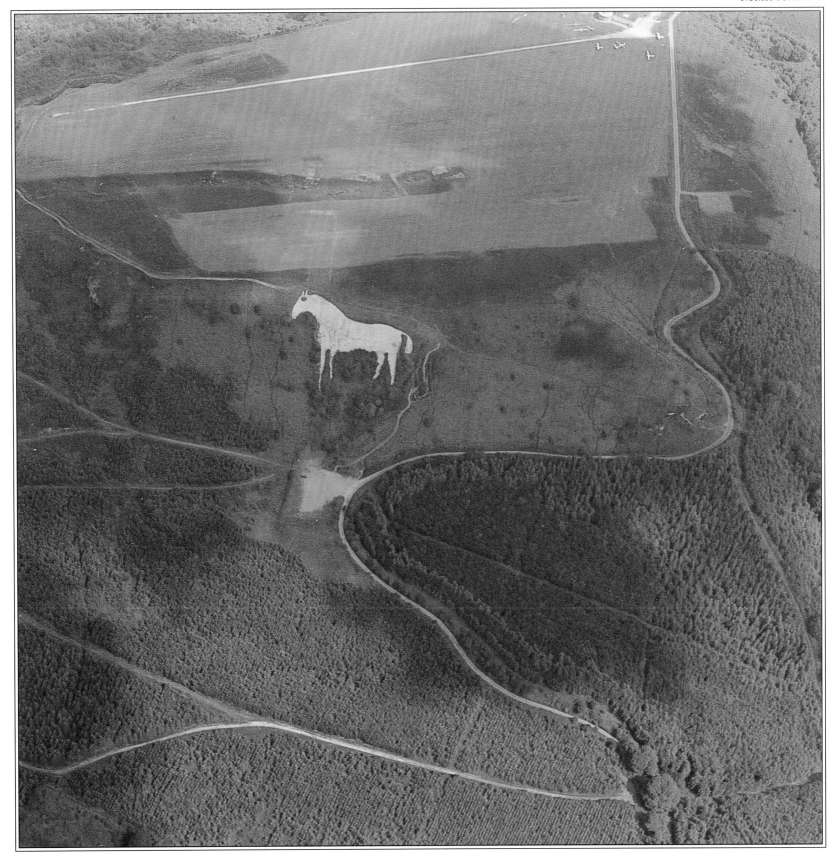

KILBURN WHITE HORSE

On Roulston Scar, near Sutton Bank, is carved a curious memorial to Victorian energy
and determination: an artificially coloured white horse. The only turf-cut figure in the
north of England, it was the brainchild of one Thomas Taylor, who inspired the local
schoolmaster and about 30 helpers to cut it from the hillside in 1857. Since the rock
below was not chalk they resorted to whitewash to make it show up.

61

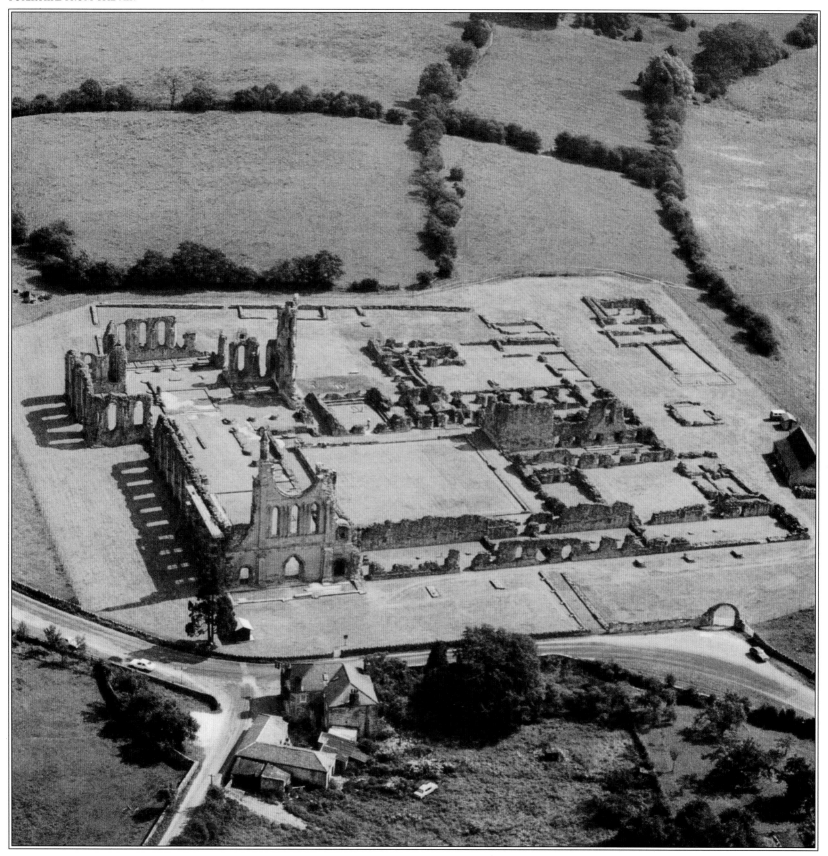

BYLAND ABBEY

Byland Abbey, below the Hambleton Hills near Coxwold, was built on this site
only after several moves: the original location at Old Byland turned out to be within
earshot of the bells of nearby Rievaulx. Byland boasts an enormous church – at
100 metres long and over 40 metres wide it is the biggest Cistercian church in England
– and the tall west front is a landmark for miles around.

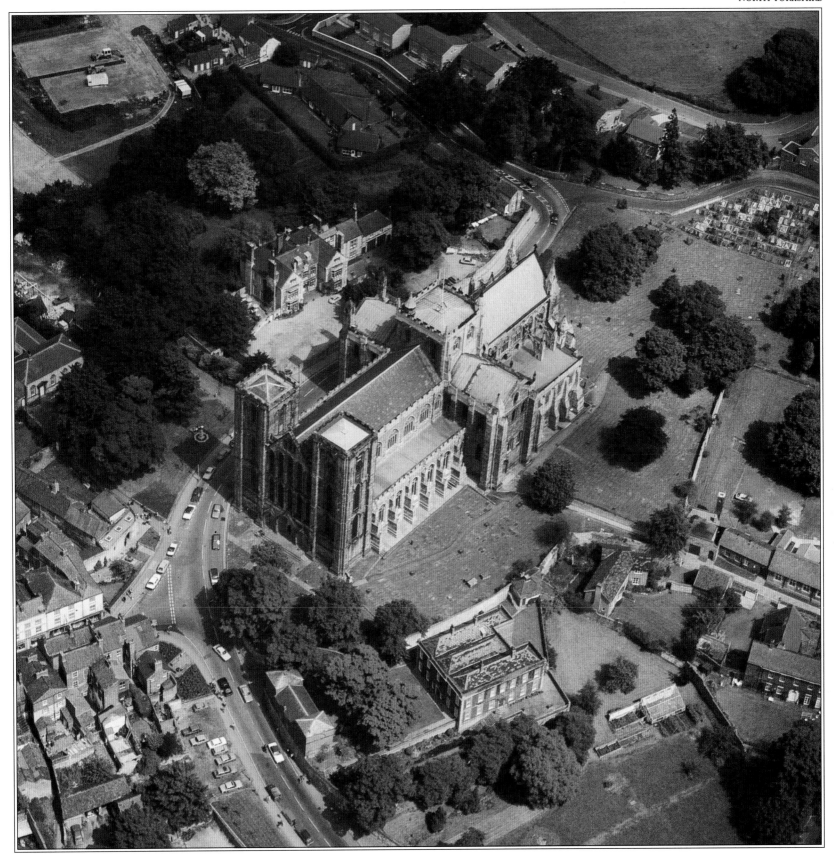

RIPON CATHEDRAL

*Although it dates mostly from the twelfth century, the great church at Ripon has only
had cathedral status since 1836: the only period before this that Ripon was a cathedral
city was for a brief time in the seventh century under the famous Bishop Wilfrid. Built
by the Normans of local Millstone Grit on the remains of Wilfrid's monastery, the
Cathedral was extensively restored in the 1860s by Sir Gilbert Scott.*

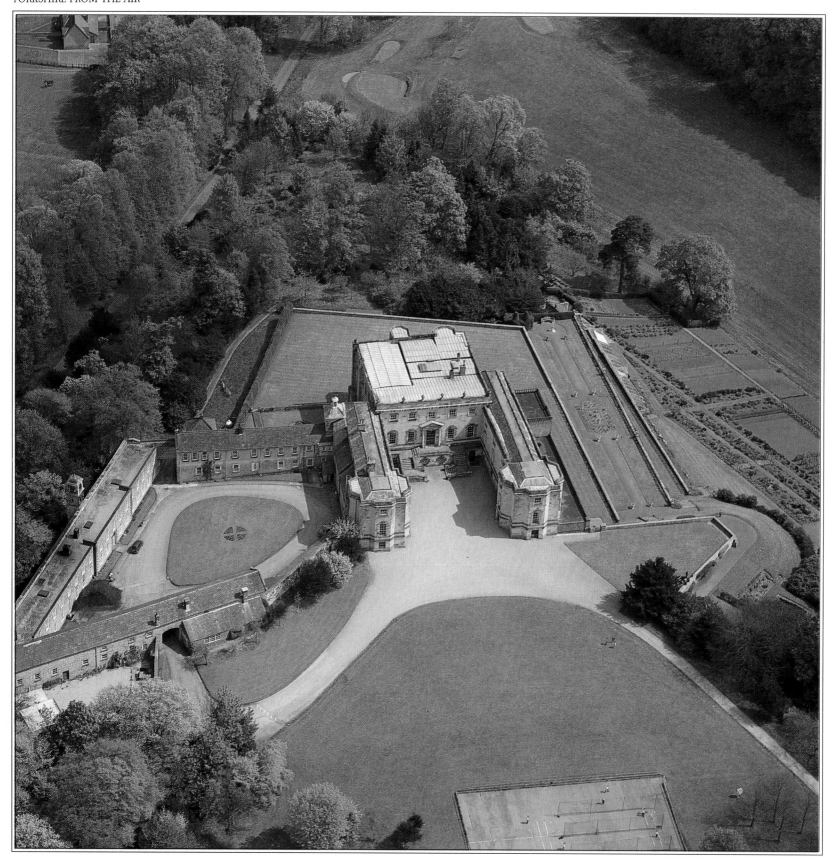

GILLING CASTLE

Gilling Castle has an eighteenth-century air about it, but much of it is considerably
older. The basement includes part of a fourteenth-century tower, and a Tudor house
was built by Sir William Fairfax over this between 1575 and 1585. Finally in the
eighteenth century the wings were added and the old house remodelled. Gilling is now
the preparatory school for the public school at Ampleforth.

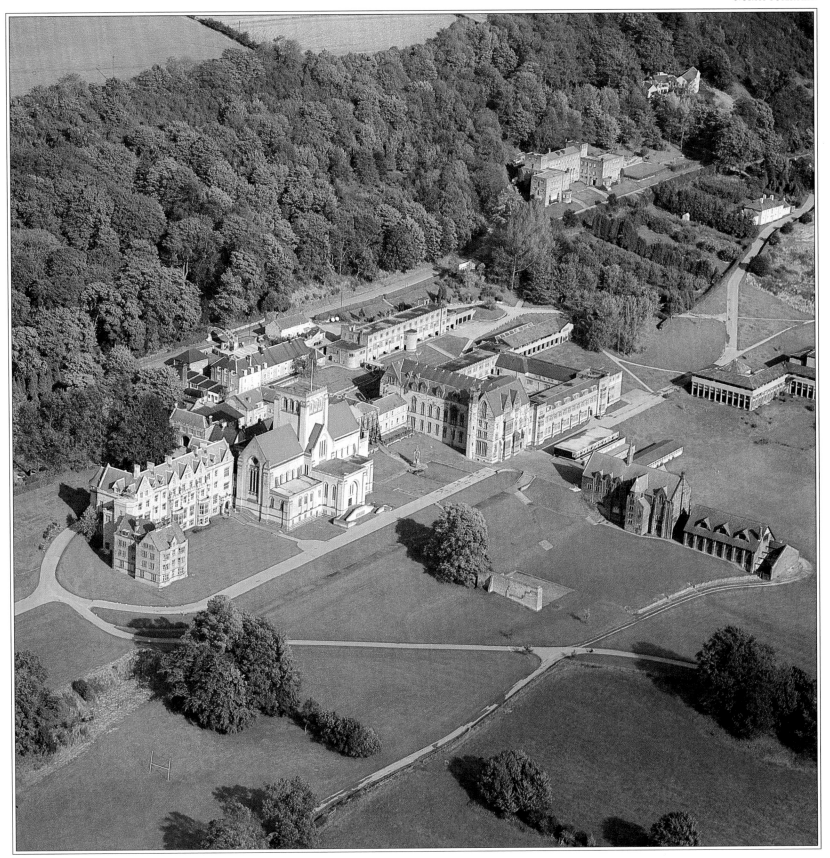

AMPLEFORTH COLLEGE

*It seems suitable that Yorkshire, the scene of so much monastic piety in the past,
should also be home to England's premier Roman Catholic public school and to a
flourishing modern abbey. A community of English Benedictine monks who had fled
from France first came to Ampleforth in 1802; the monastery dates from 1894-8 and
the New Church, by Sir Gilbert Scott, was completed in 1961.*

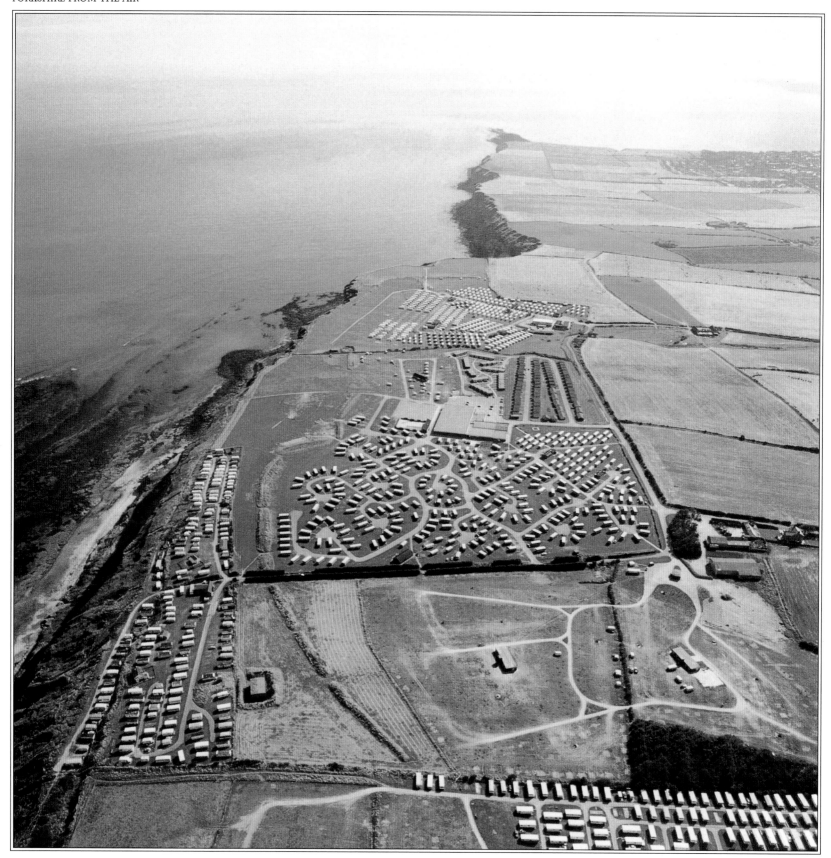

GRISTHORPE

The cliff tops of the Yorkshire coast are a magnet to caravanners and campers, and the
sites they use make unexpected patterns when seen from the air. Gristhorpe Cliff is
just south of Cayton Bay, between Scarborough and Filey, and there are four caravan
and mobile home sites here alone. Out to sea are the Castle Rocks and Casty Rocks;
there is also a sandy beach, and this is a good place for fossil-hunting, too.

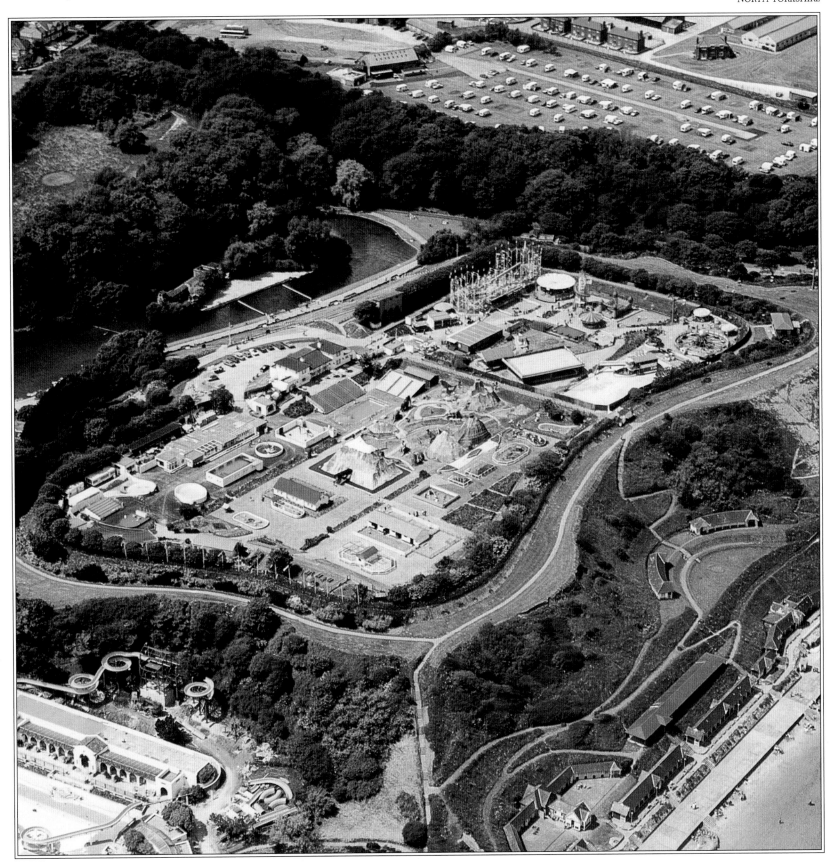

MARVEL'S LEISURE AND NORTH BAY AMUSEMENT PARK, SCARBOROUGH

Scarborough thinks of itself as a town with entertainment to suit all tastes: as well as
six theatres, including *Alan Ayckbourn's Theatre in the Round*, where his new plays
are first put on, and five concert venues, there are children's paradises like this one.
Marvel's Leisure Park offers such delights as roller coasters, a Land of
the Dinosaurs, and a replica New Orleans Street.

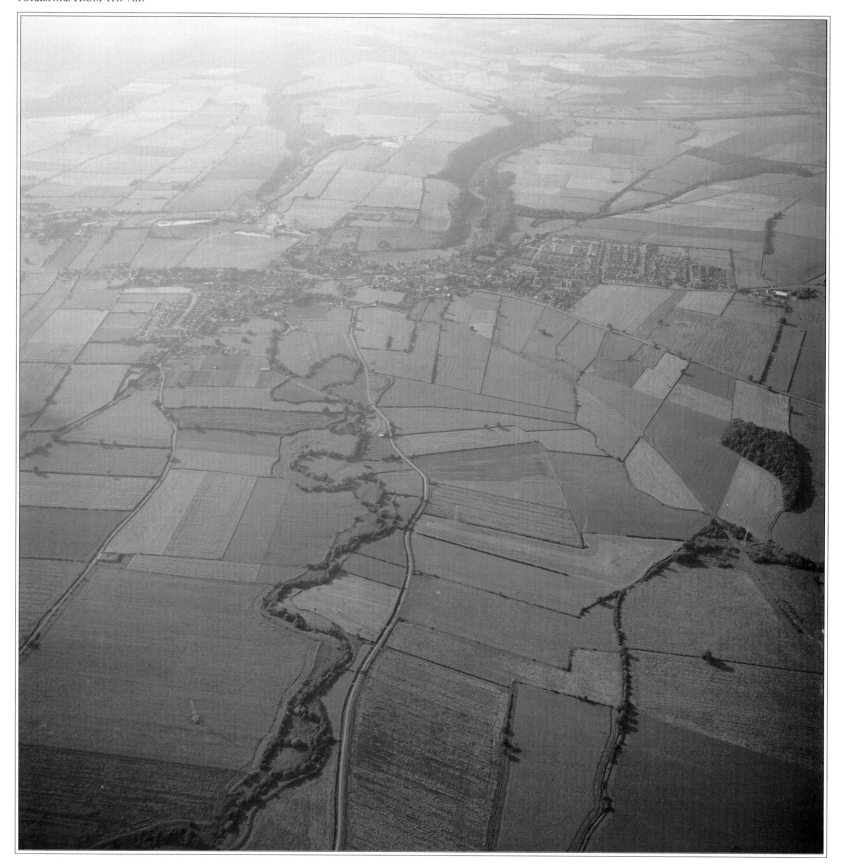

RIVER DERWENT

Just inland from Scarborough is one of the most attractive stretches of the River
Derwent. Skirting the eastern edges of Wykeham Forest, which can be seen in the
distance to the left, it cuts through the famous wooded beauty spot of Forge Valley.
After dividing the villages of East and West Ayton, it pursues a charmingly wayward
course south as it reaches more level farmland.

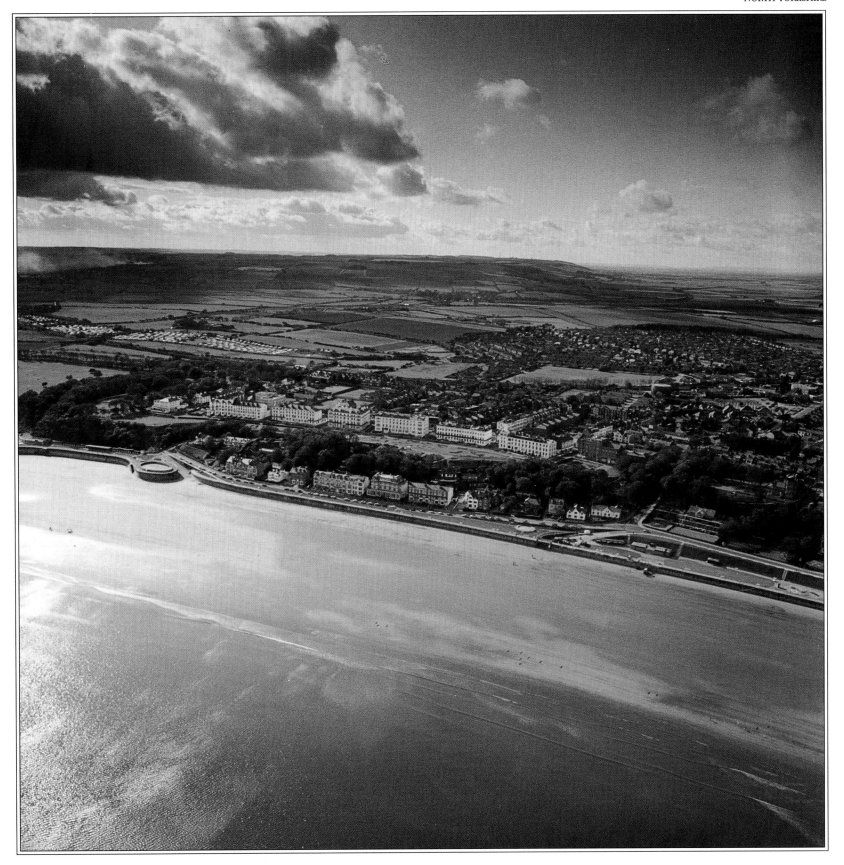

FILEY

*Although rather overshadowed by its larger neighbours Scarborough and Bridlington,
Filey is a successful little holiday resort. Its white Victorian Crescent, very similar to
those in other spa towns, once overlooked the town baths, but a neat
garden has replaced these. Charlotte Bronte often stayed in a house on Belle Vue
Street which runs down to the northern end of the crescent.*

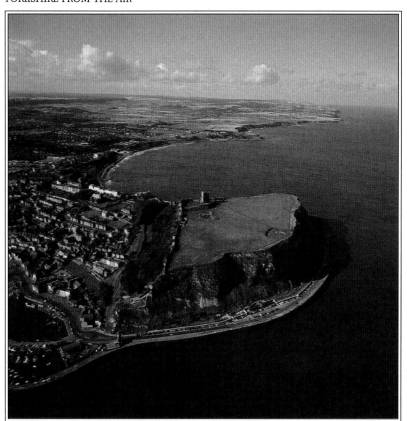 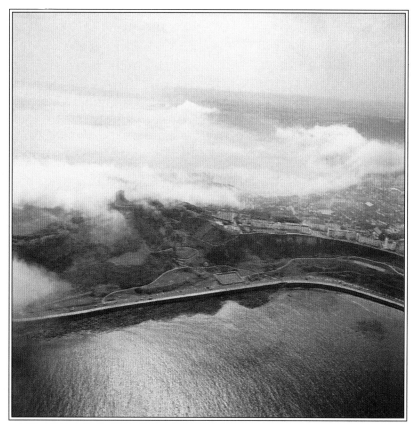

SCARBOROUGH

Scarborough's Castle Headland dominates the old town and the harbours when seen from the south. A 300-foot high bluff almost separated from the mainland by a deep cleft, it is perfectly situated for defensive purposes and has been a place of settlement for millennia. The remains of a late Bronze Age and early Iron Age village of the fifth century BC have been found here, together with those of a Roman signal station; the keep, set back from the sea, is Norman, dating from 1127. On the steep southern slope of the headland are the oldest houses in Scarborough, those of the original fishing village. They overlook two harbours, the nearer of the two, the East Harbour, being used mainly by yachts and holiday boats while the Old Harbour beyond it is the fishermen's preserve.

SCARBOROUGH

Scarborough thinks of itself as a holiday town but the weather sometimes gives a rude reminder of its northerly latitudes. Banks of a clinging, cold sea mist, known locally as sea-fret, can roll in with surprising suddenness, making this a dangerous coast for the unwary.

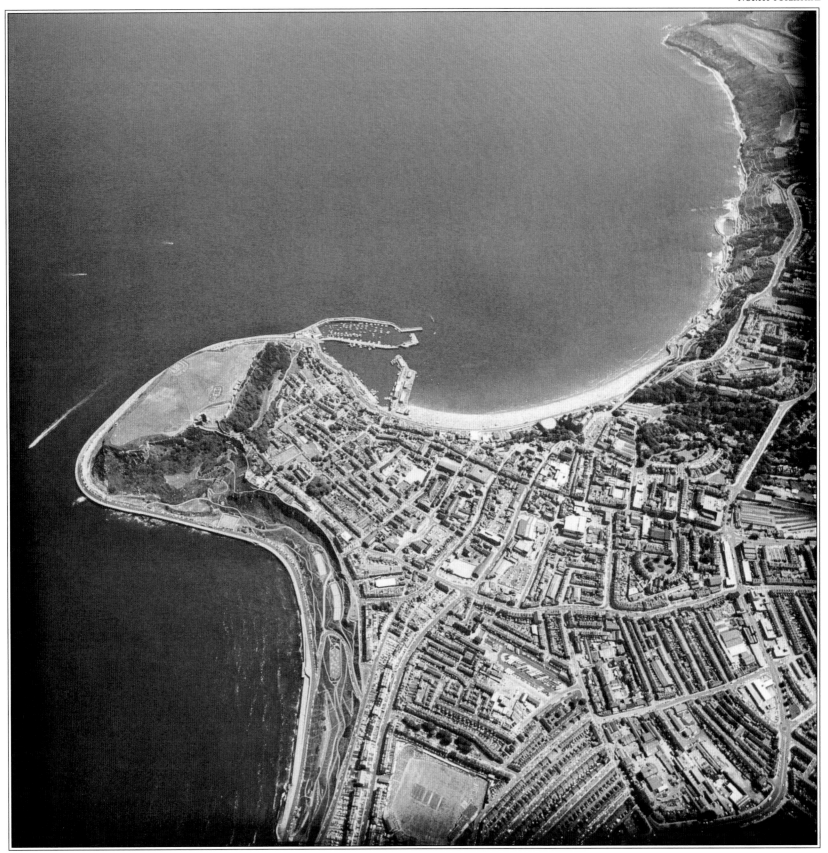

SCARBOROUGH

Sheltering behind its mighty headland, Scarborough, Janus-faced, looks out to sea both
north and south. Originally a fishing village, it came to prominence as a spa town late
in the seventeenth century. The opening of the York-Scarborough railway in
1845 opened up the town to the huge urban populations of Yorkshire's
industrial cities and it is still a bustling, busy place, particularly in summer.

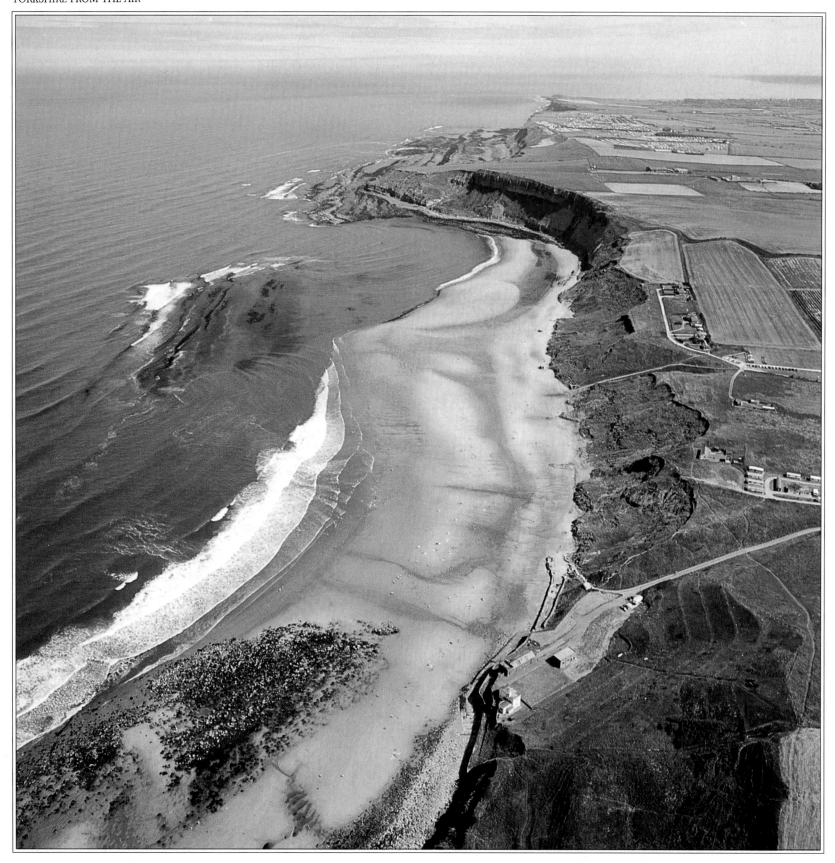

CAYTON BAY

From Scarborough southwards the number of sandy beaches increases, and
attractively-shaped Cayton Bay is the largest of these between Scarborough and Filey.
Much visited by picnickers and bathers, it is enclosed by gritstone headlands –
Osgodby Nab to the north, and Lebberston Cliff and the Calf Allen
Rocks to the south, as seen here.

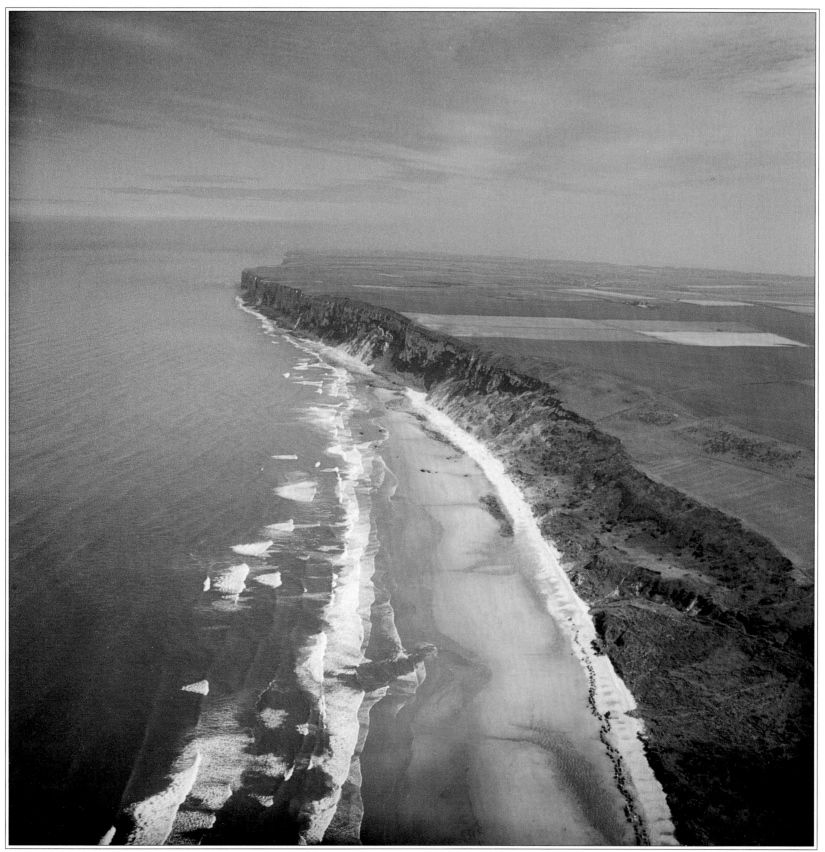

FILEY BAY

Filey Bay, running south in a wide arc from the Brigg for six and a half miles,
is the largest in Yorkshire. Here, where the Yorkshire Wolds come gently down to the
sea, can be seen the most northerly limit of chalk in Britain. This makes for a
beautiful, white-cliffed coastline but also leaves the area prey to the fierce erosion of
the stormy North Sea.

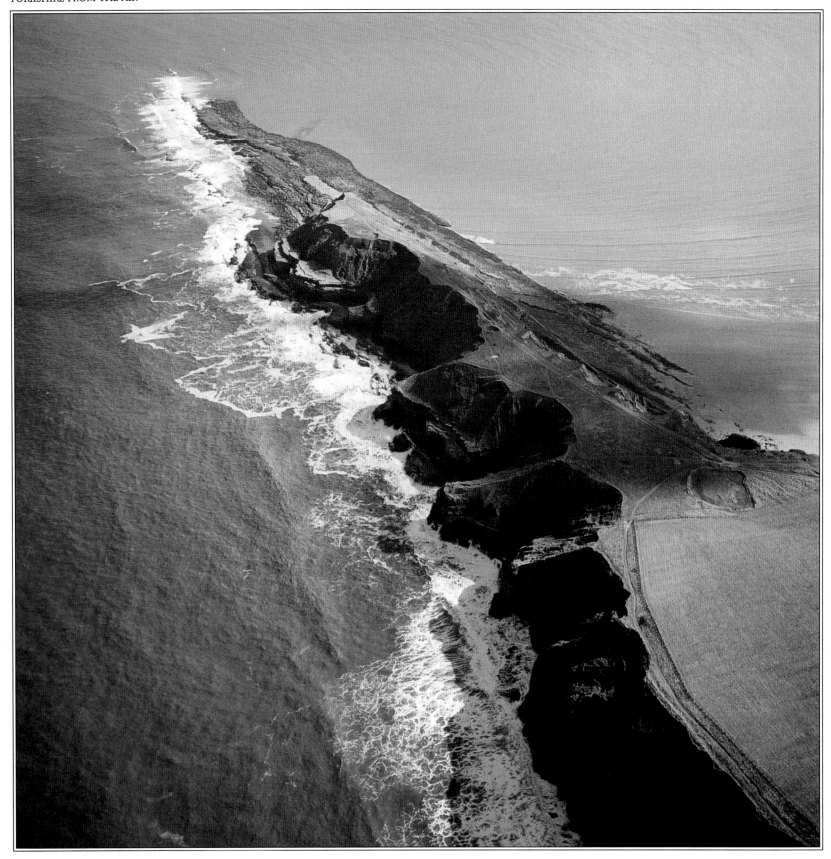

FILEY BRIGG

A striking finger of rock stretching out into the North Sea for nearly a mile, Filey Brigg
takes its name from the Norse for jetty or landing place. Formed of coralline oolite
with a cap of boulder clay over a lower stratum of calcareous grit, it has been
weathered and scooped by the sea into deep coves on the exposed northern side, the
largest of which is known as the Emperor's Bath.

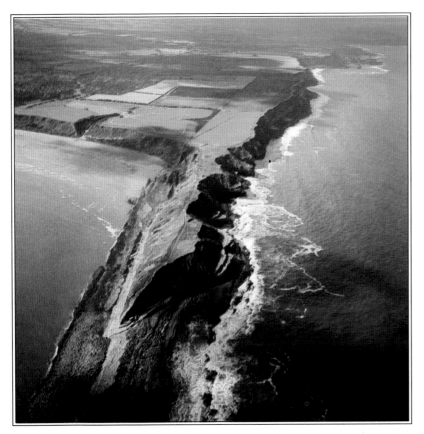

FILEY BRIGG

At low tide, the Brigg is a mass of teeming rock pools, a remarkable haven of small
marine life. It is also one of the best places for birdwatching on the coast, with
kittiwakes, guillemots, puffins and razorbills. But it is easy to misjudge the strength of
the sea and wind here: the Brigg has a gory history of shipwreck and many
unfortunates have been blown into the sea. There are also many
smuggling stories connected with the caves on the northern side, a suitably wild
and concealed spot for storing contraband.

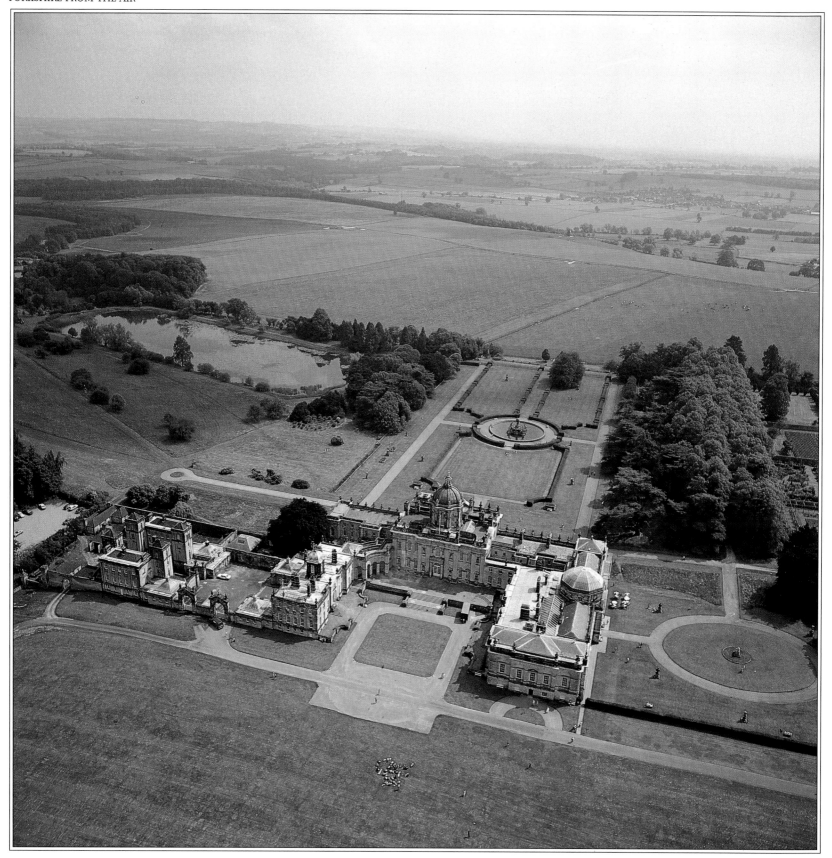

CASTLE HOWARD

Fifteen miles north-east of York stands one of Yorkshire's greatest houses, the Baroque
masterpiece of Castle Howard. Although the house contains many treasures, its chief
glory lies in the buildings: as well as the house there are temples and follies spread
through its large park, justifying Horace Walpole's description of it as "a palace, a
town, a fortified city".

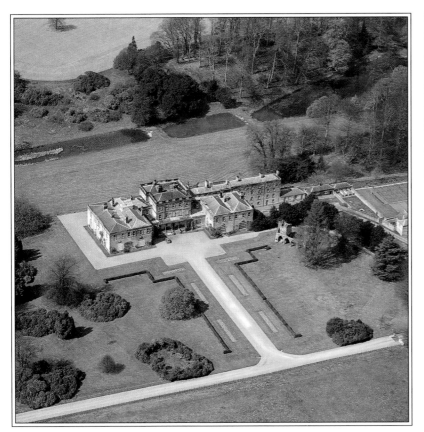 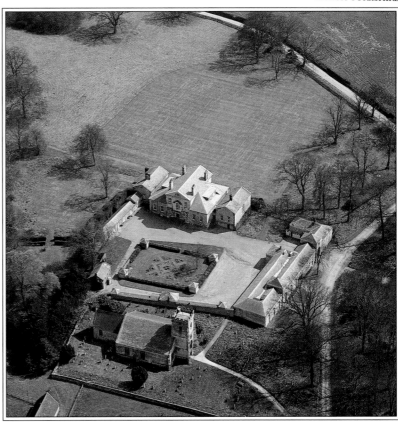

BIRDSALL HOUSE AND SETTRINGTON HOUSE

Yorkshire abounds in lesser country houses: strong, well-built mansions put up in the eighteenth and nineteenth centuries when the profits from mining and the textile industry gave industrialists a leg up the social ladder. Birdsall House, in a pleasant village nestling under the north-western edge of the Wolds, was begun in about 1750 and has a top floor added in 1872-5 by Salvin. It is still a private house. Another example is Settrington House (right), built in 1790, but gutted by fire in the 1960s and rebuilt to a new design by Francis Johnson. The church is eleventh-century.

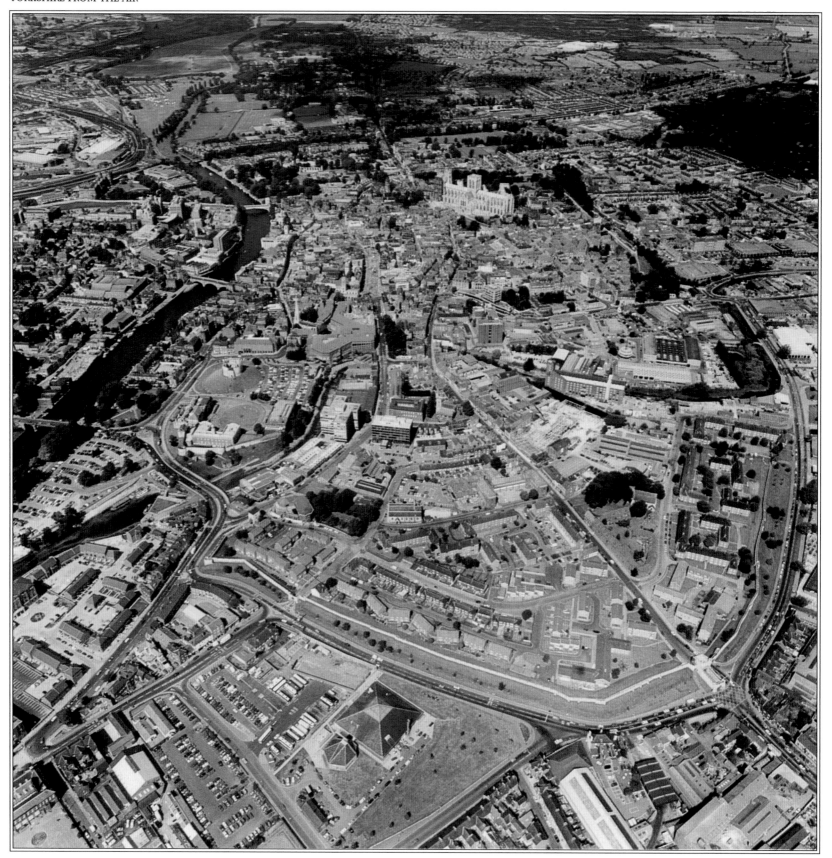

YORK

Historically, York is Yorkshire's greatest treasure. It is an ancient settlement,
established even before the Romans set up the camp of the Ninth Legion here in AD
71, and was conquered successively by the Saxons, the Vikings and the Normans. The
town of York grew up at first between the Rivers Ouse and Foss. In the Middle Ages
the city walls were enlarged; remains of these walls can be seen in the photograph.

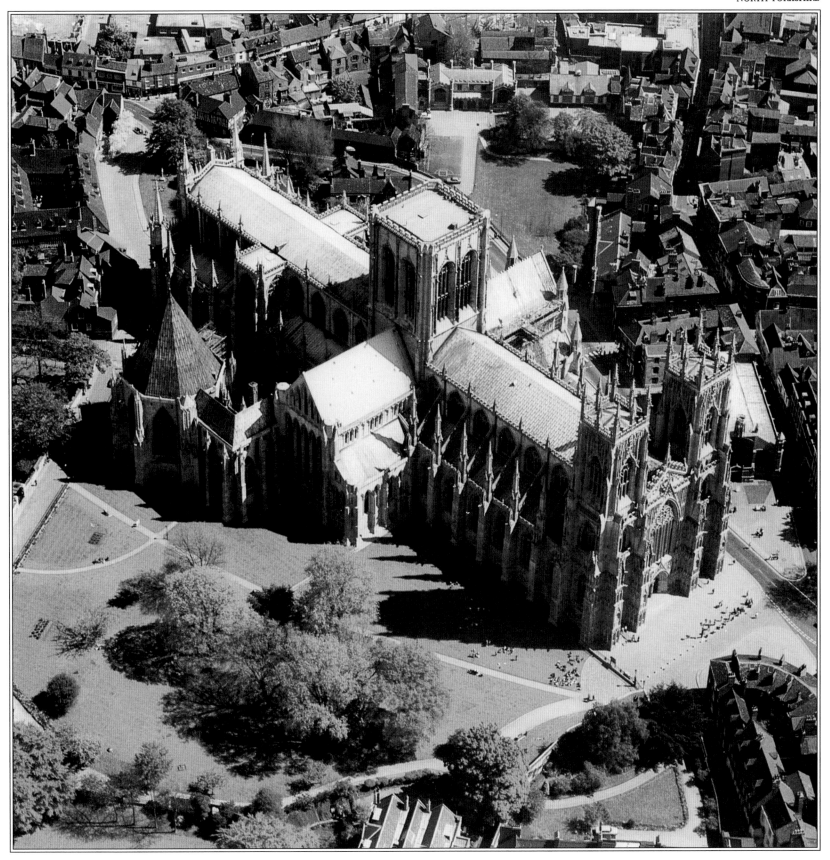

YORK MINSTER

York's famous Minster, the largest medieval cathedral in northern Europe, dominates
the city. The first church on this site was built when Paulinus, sent with Augustine to
convert the English, baptised Edwin, King of Northumbria, in AD 672. The present
building, now expertly restored after the disastrous fire in the south transept
in 1983, dates mainly from 1200-1480.

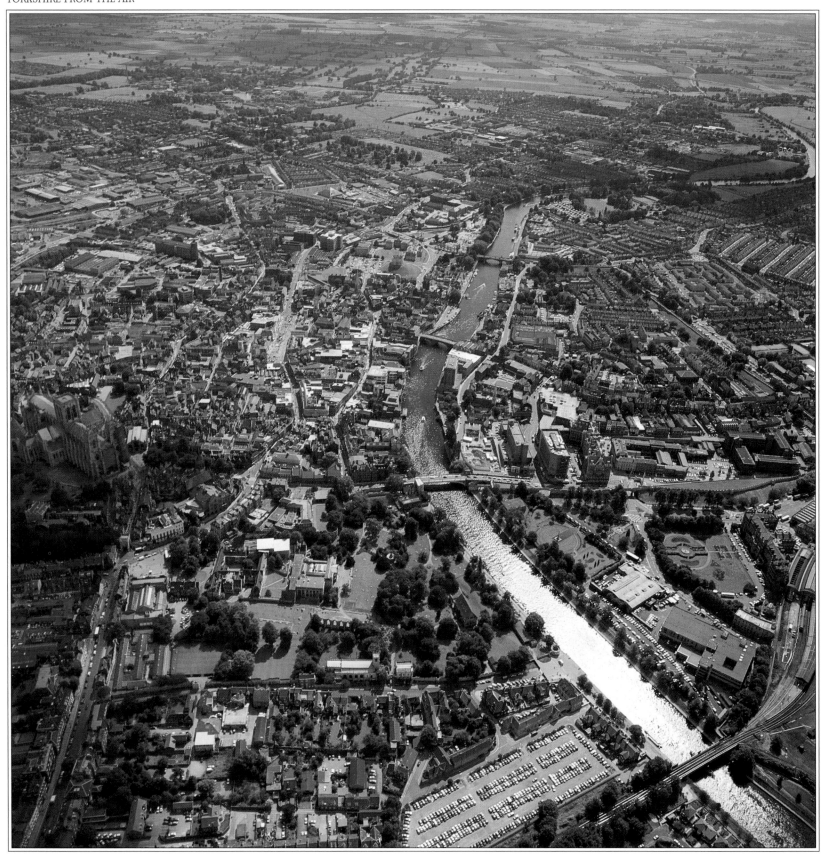

YORK

In the northern part of the city, in a 10-acre botanical park now known as the
Museum Gardens, can be seen the remains of another of York's great churches, the
Benedictine Abbey of St. Mary, founded in 1080. To the left of the gardens, on the
edge of a small square, is Bootham Bar, the northern gate of the city and
the only medieval gate to stand on the site of a Roman one.

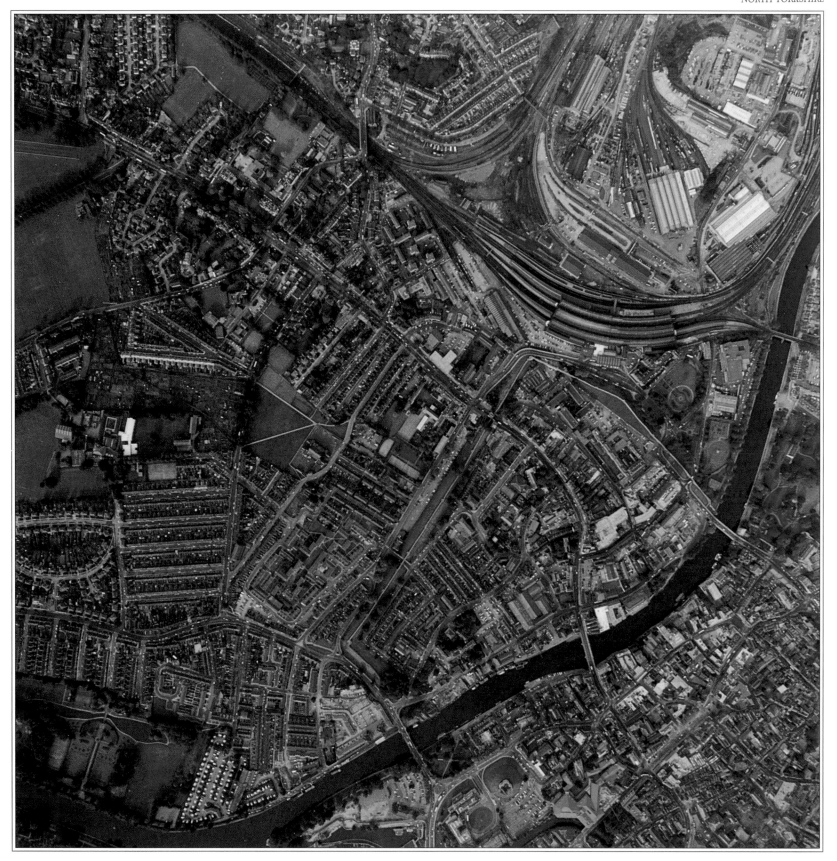

YORK

*The west bank of Ouse is less rich in historic buildings than the east bank but it was
here that the Romans set up their camp as a base for subduing the North of England.
There is also a continuous, well-preserved section of the medieval city wall, and, by the
station, the excellent National Railway Museum. York became an important railway
town largely through the efforts of the draper George Hudson.*

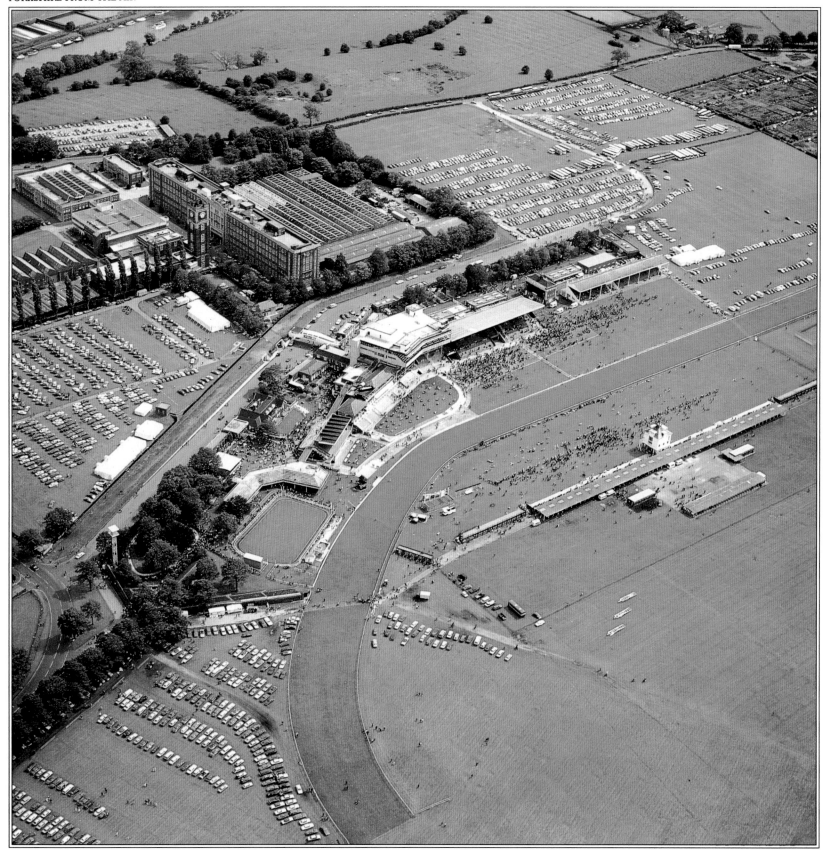

YORK RACES

Racing is taken seriously in Yorkshire, and of the many racecourses, York is regarded
as the 'Ascot of the North'. The racecourse was established in the Georgian period
when York became a very fashionable place, as can be seen by the many elegant town
buildings dating from that time. There are six meetings at York in the year, all flat
racing, of which the highlight is the Ebor meeting in August.

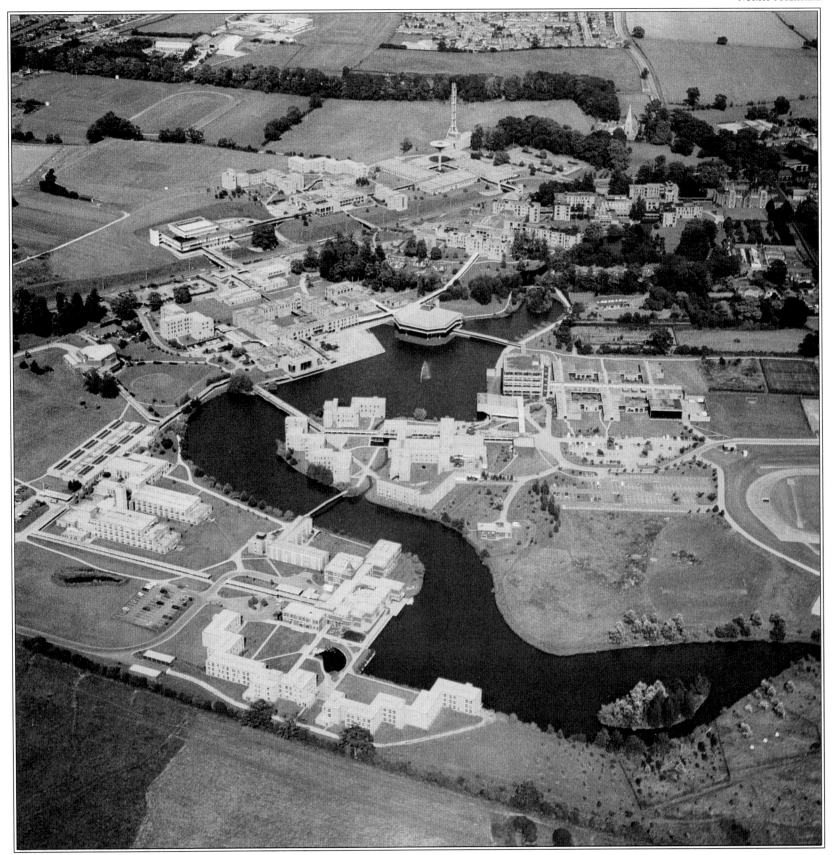

YORK UNIVERSITY

The space-age appearance of York's university, built in 1963, belies the fact that the city is an ancient seat of learning. A school was established at York in AD 735; here the scholar Alcuin taught students from all over Europe. The concrete blocks of the university buildings are grouped round an artificial lake; the semi-circular Central Hall jutting into it is used for degree ceremonies and concerts.

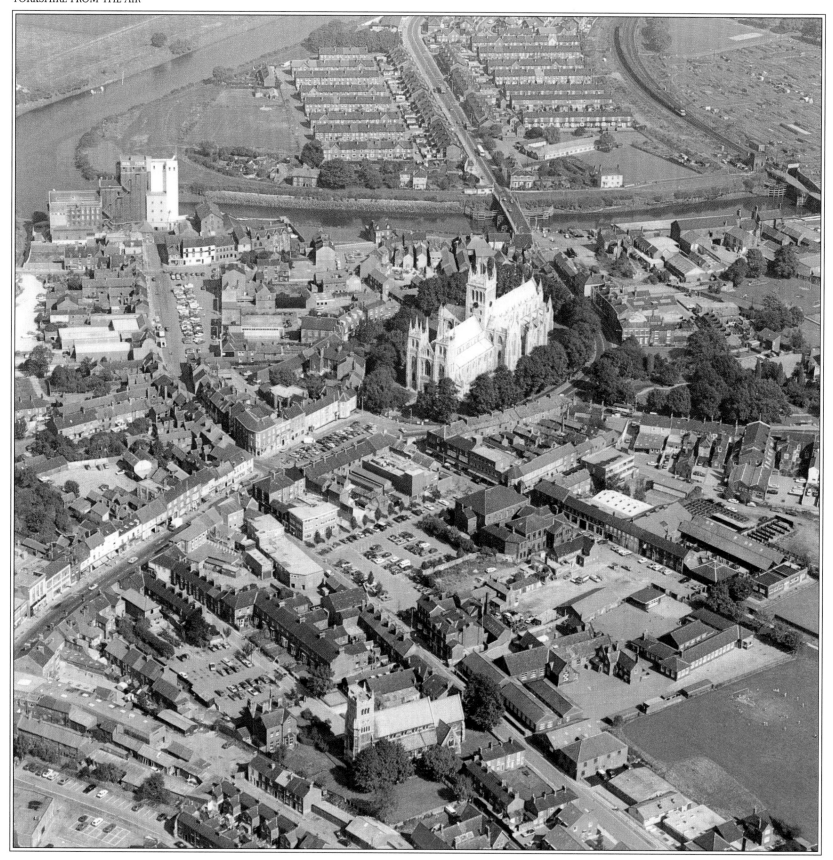

SELBY

Selby, a busy little port and market town on the Ouse, has grown up round its
magnificent limestone abbey church. The Abbey was founded in 1069 rather curiously
by monks from Auxerre who installed there the dried finger of St Germain, their
bishop; building began in 1100 and mercifully the church escaped harm at the
Dissolution of the Monasteries. Beyond the Abbey is a toll-bridge.

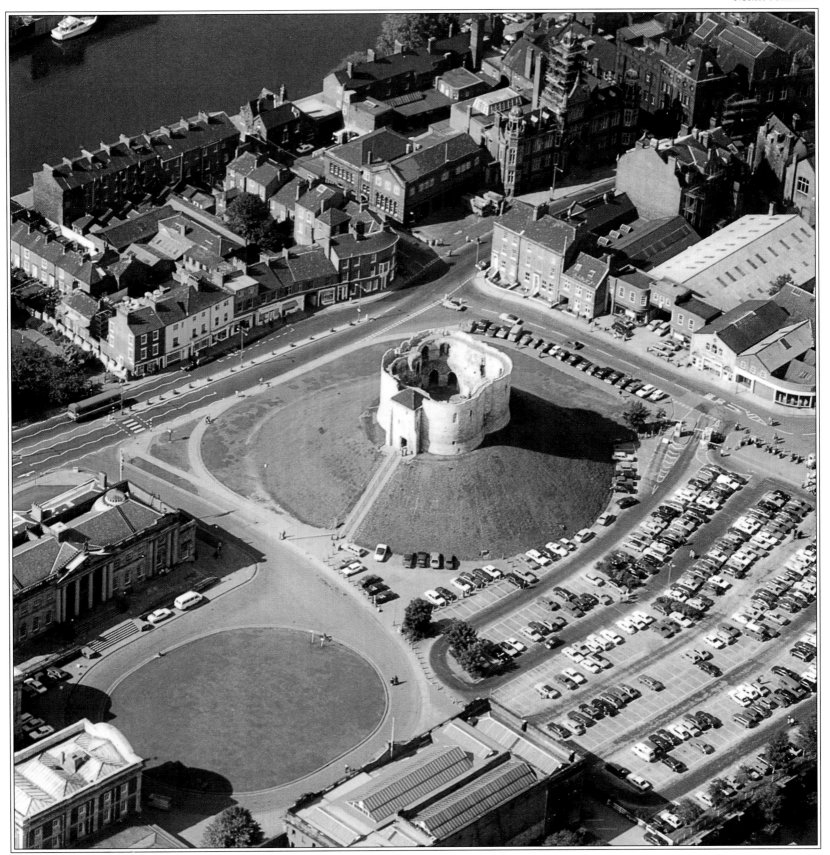

CLIFFORD'S TOWER, YORK

In the heart of the city stands a curious little quatrefoil building on a high mound.
This is Clifford's Tower, built between 1245 and 1259 on the site of a motte and
bailey castle raised by William the Conqueror. The place has a grisly history: the
tower's name derives from the Lancastrian leader Roger de Clifford, whose body was
hung in chains here after his execution in 1322.

FARMLAND NEAR ELVINGTON

Plough and pasture, sun and shade west of Elvington in the Vale of York make a
perfect composition for the aerial photographer. This low-lying rich agricultural land
stretches as far as the steep edges of the Wolds on the other side of the river Derwent.
The airfield at the top left of the picture was a base from where Halifax bombers flew
to targets in occupied Europe during World War II.

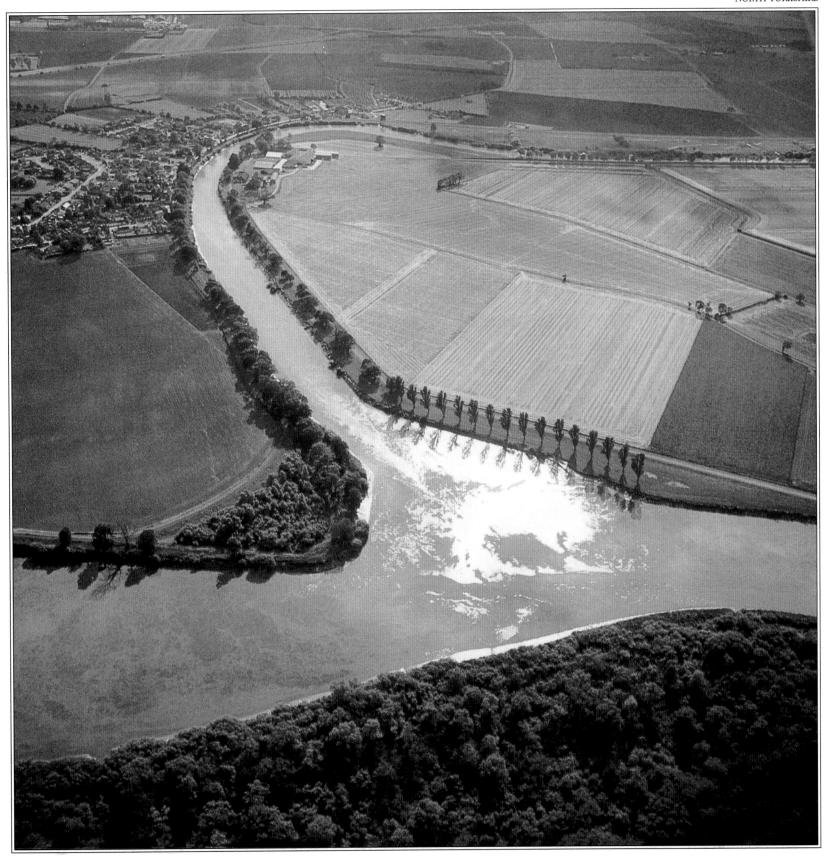

CONFLUENCE OF RIVERS OUSE AND AIRE

The rivers Ouse (on the left) and Aire (right) meet on the boundary of North Yorkshire
and Humberside. Both have made remarkable journeys to reach this point. The Aire
has crossed almost the breadth of Yorkshire from its source in the Dales near Malham.
The Ouse has not itself come so far, but carries the water from the Dales rivers Swale,
Ure, Nidd and Wharfe as well as that from the river Derwent.

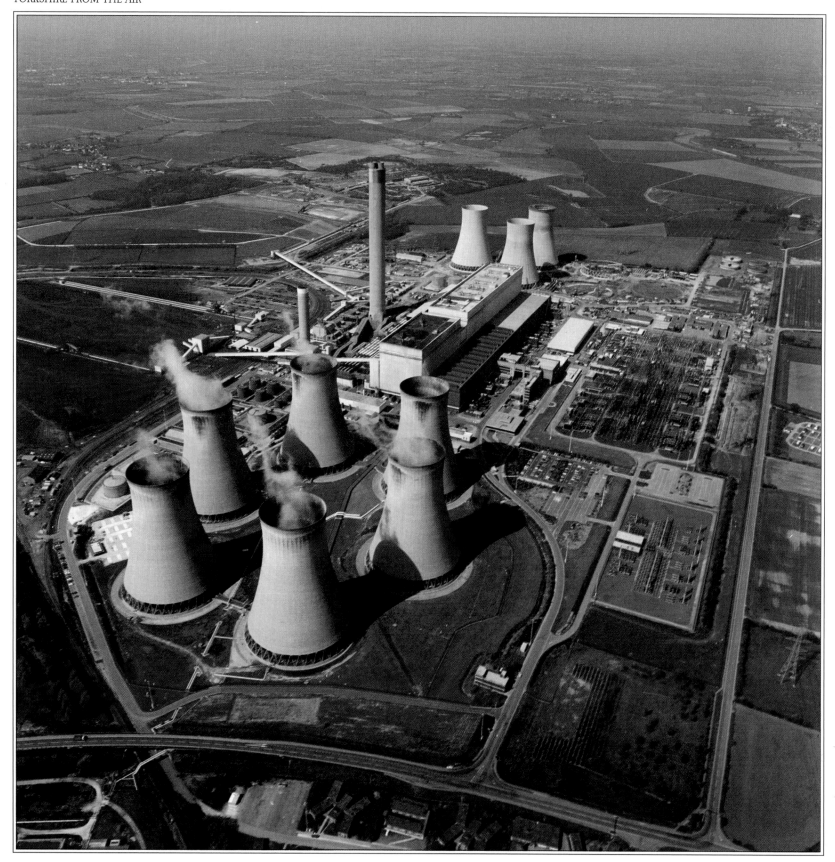

DRAX POWER STATION

Aerial photographs reveal unexpected symmetries and patterns, showing that beauty
can be found in some unlikely places. Just on the north-eastern tip of the Yorkshire,
Nottinghamshire and Derbyshire coalfield stands Drax, the largest coal-fired power
station in western Europe. The 11-12 million tons of coal it needs a year are delivered
by non-stop 'merry-go-round' trains direct from the collieries.

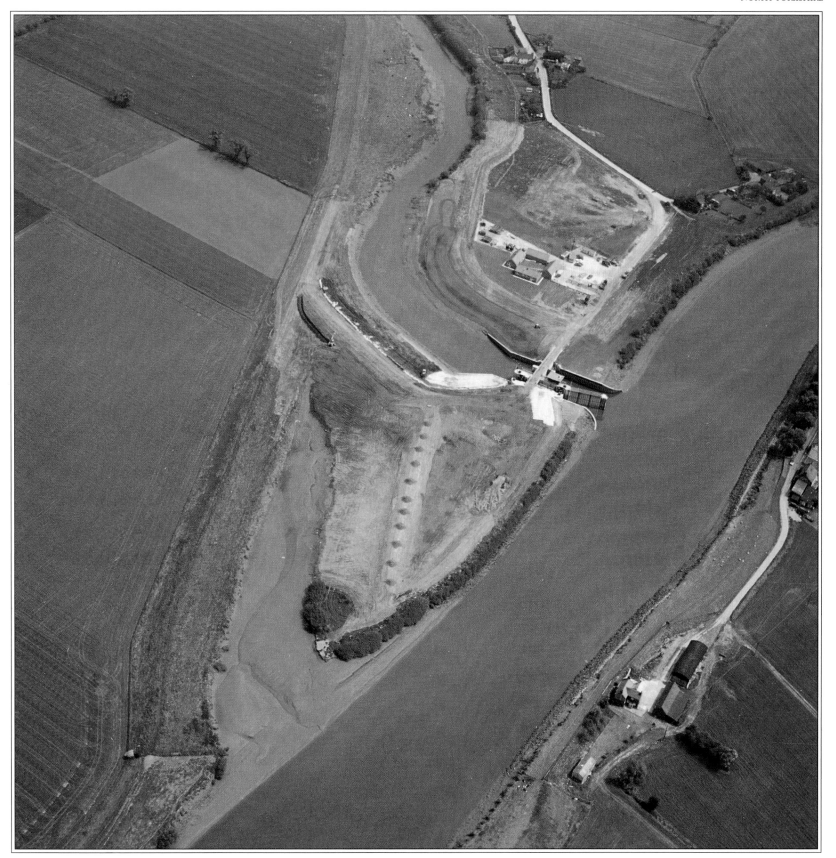

RIVERS OUSE AND DERWENT, NEAR DRAX

The huge power station at Drax needs an immense amount of water to operate
successfully, hence its positioning close to the confluence of the rivers Ouse and
Derwent. There is a tidal barrage on the Derwent here; the Ouse remains tidal almost
as far as York. The already large river now formed is swollen downstream by the Aire,
the Don and the Trent to become the mighty river Humber.

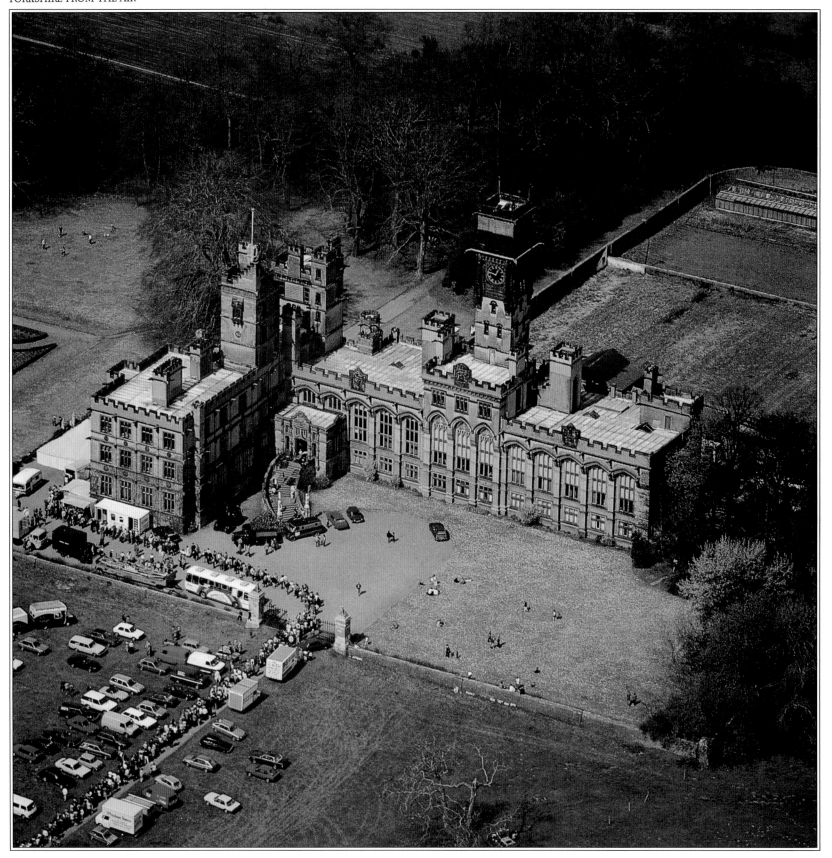

CARLTON TOWERS

Carlton Towers, with its extraordinary silhouette and bristling battlements, must
be Yorkshire's supreme example of Victorian Gothic. Underneath the grey
stucco stands a much smaller house, built in 1614; this was remodelled
by Pugin in 1871-7 to form the present extravagant structure. Most of the rather
sombre interior decoration was carried out by J. F. Bentley.

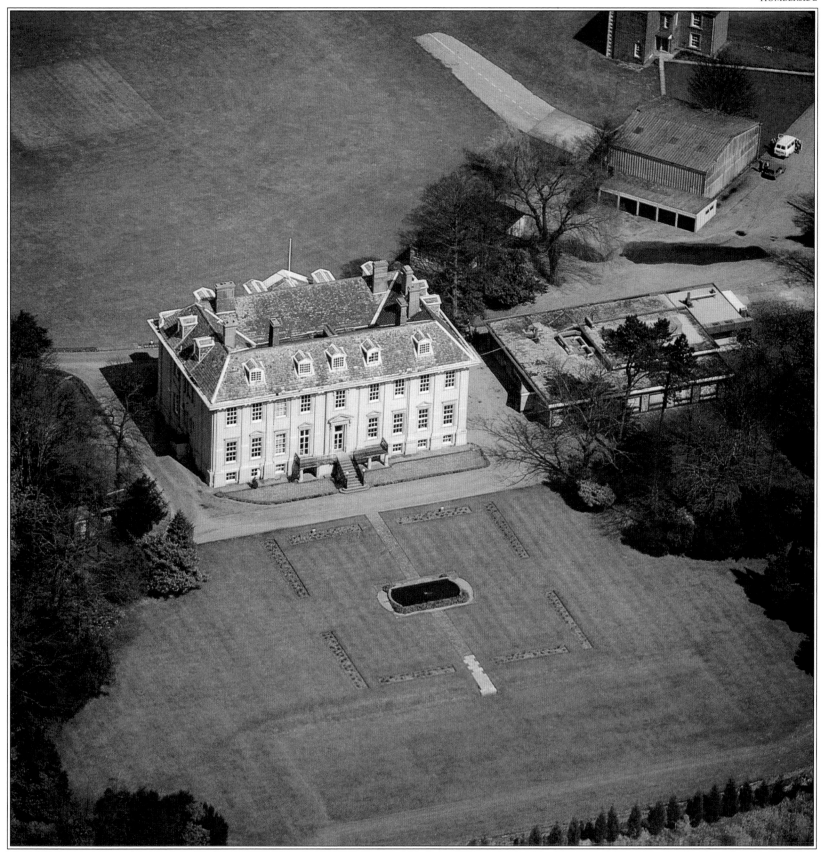

COWICK HALL

In the pocket of land west of Goole that used to belong to the West Riding but is now in the Boothferry district of Humberside stands dignified Cowick Hall, a fine example of the domestic architecture of James Paine, who rebuilt it in 1752. Running right round the house is a system of giant pilasters; on the far side is a pediment. Cowick is now the headquarters of a chemical company, whose laboratory is on the right.

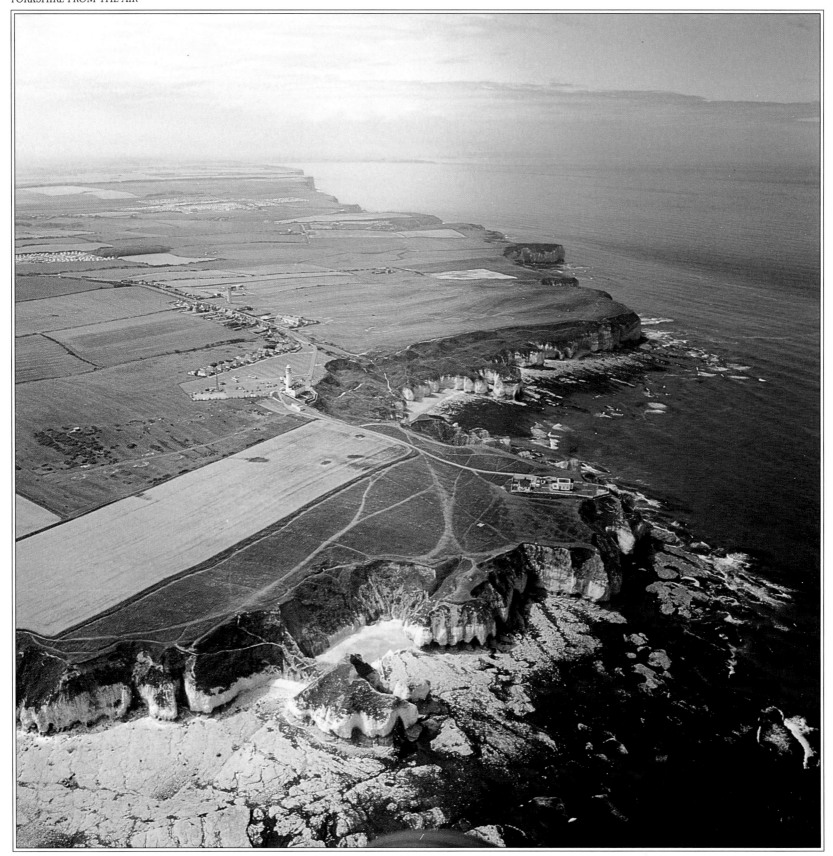

FLAMBOROUGH HEAD

On a summer's day the gently rippling sea, sculptured rocks and green fields of
Flamborough Head are one of Yorkshire's most beautiful sights. In bad weather,
however, the jagged headland takes on a less benign aspect. The fog rolls in and the
waves dash themselves against the precipitous cliffs. In spite of the lighthouse, whose
light is visible for 21 miles, the lifeboat is often called out.

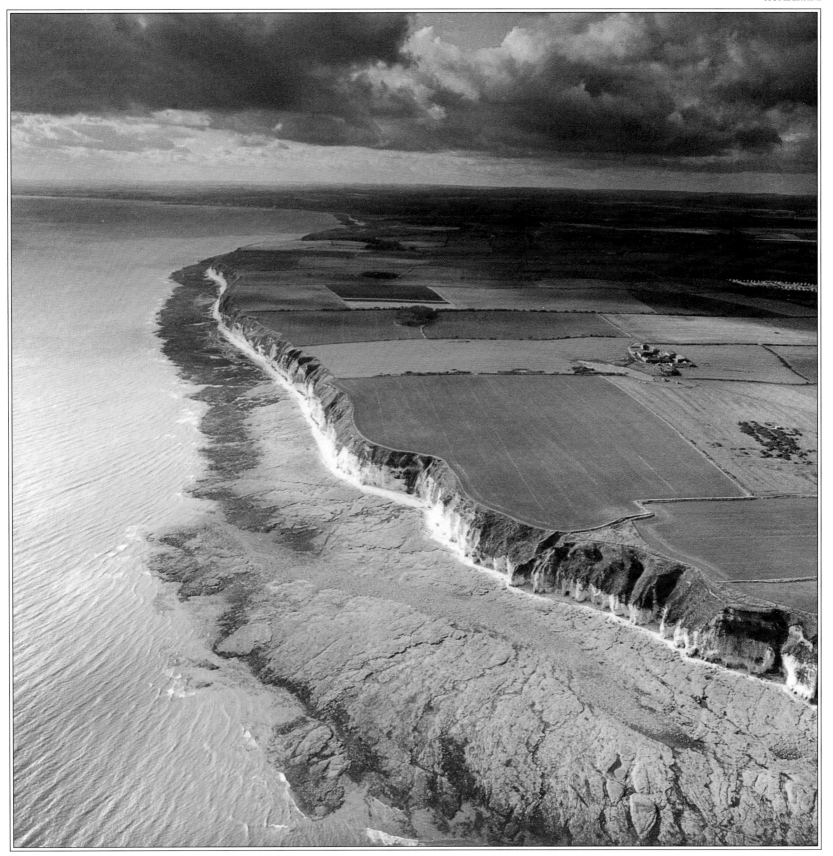

FLAMBOROUGH HEAD

*The dazzling white chalk of Flamborough's cliffs marks the eastern edge of the fertile
escarpment of the Yorkshire Wolds. Like the chalk of the white cliffs of Dover, the rock
is made up of the skeletons of billions of microscopic animals and plants and is
remarkably pure. At the foot of the cliffs at low tide are countless caves; many have
been given names – the Dovecot, the Kirk Hole and, inevitably, the Smugglers' Cave.*

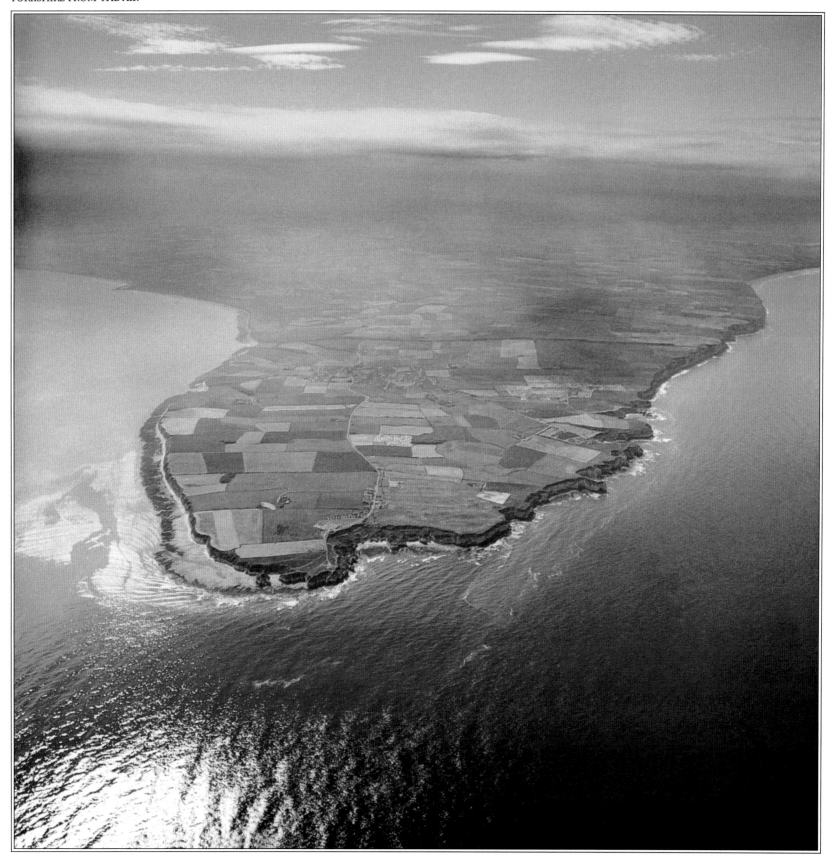

FLAMBOROUGH HEAD

Jutting so precipitously out into the North Sea, almost cut off from the 'mainland' by
Danes' Dyke, Flamborough's headland seems both remote and idyllic. The north side
has the highest and most dramatic cliffs – at Bempton, just north of Danes' Dyke,
they are more than 400 feet high – and it is here too that the only nesting colony of
gannets on mainland Britain can be seen.

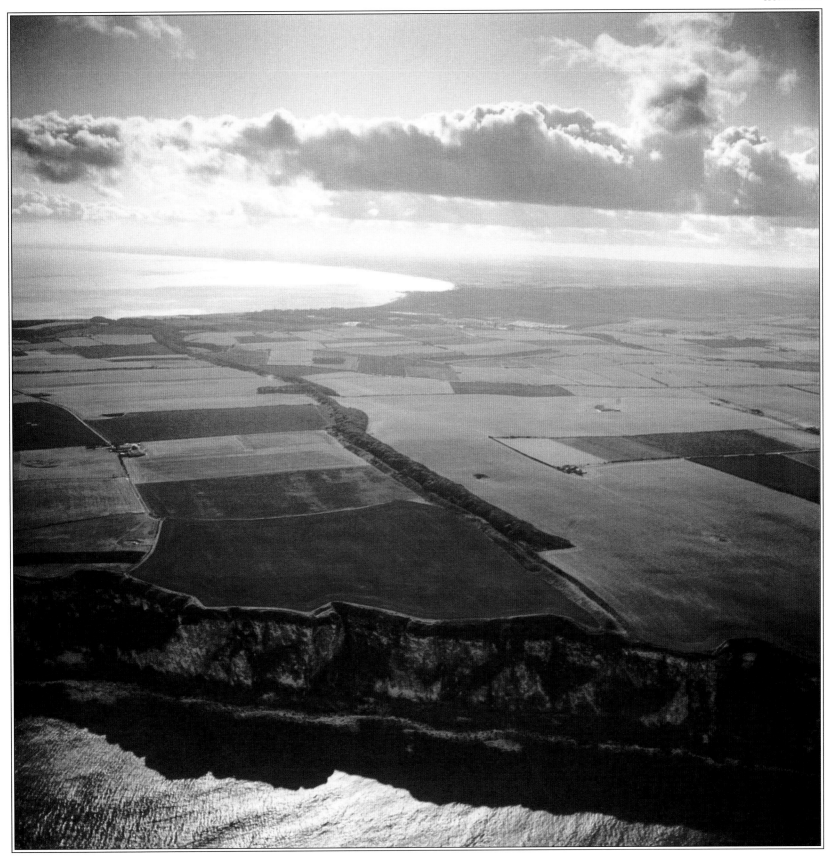

DANES' DYKE

*About two miles inland, a large ditch and bank runs across Flamborough Head,
cutting off some five square miles of the promontory. It is about two and a half miles
long and the northern part, seen in the foreground here, is some 20 feet deep and 60
feet wide. There has been a great deal of argument about the age of this defensive ditch
– it was probably begun around 300 BC although it has been ascribed to the Danes.*

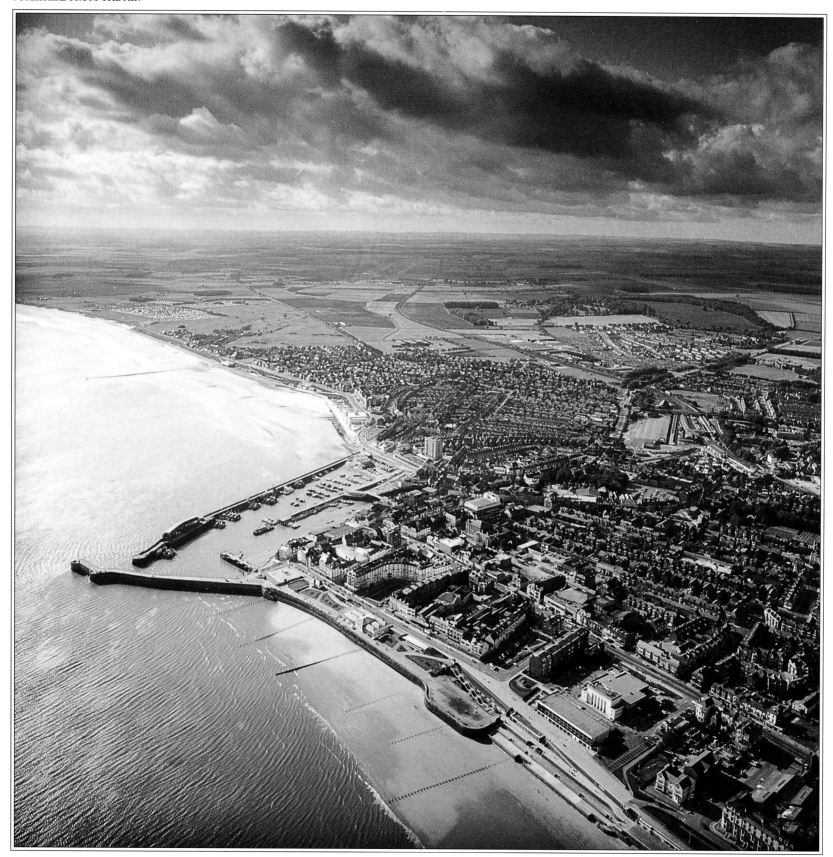

BRIDLINGTON

The old town of Bridlington is about a mile inland, but a thriving modern offshoot has
grown up by the sea. The harbour is the home of the Royal Yorkshire Yacht Club,
which holds a regatta here every summer; it is also the starting point for boat trips to
view the spectacular cliffs at Flamborough Head, five miles to the north. The sea walls
running along the North Sands are testimony to the erosive action of the sea.

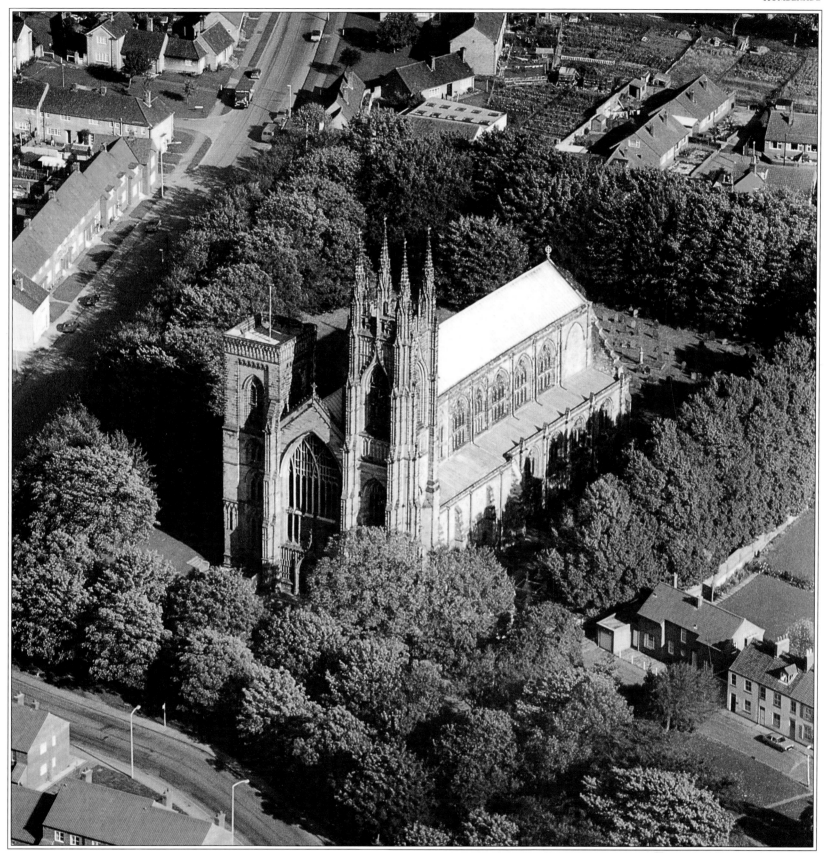

BRIDLINGTON PRIORY

The focal point of the old town of Bridlington is its priory church, all that remains of a
monastery of Augustinian canons, founded in 1113, that was once one of the
wealthiest and most powerful of Yorkshire's religious houses. The building was spared
at the Dissolution of the Monasteries because it was in use as a parish church, but was
much neglected until a massive restoration was undertaken by Sir Gilbert Scott.

LONDESBOROUGH

The green patchwork of the countryside around Londesborough, on the western edge of
the Wolds, is typical of this fertile chalk escarpment, which produces both good
grazing and arable crops. This is land which has been farmed since the Bronze Age,
although increasingly the old field divisions are being swept away to create
ever bigger expanses of wheat and barley.

 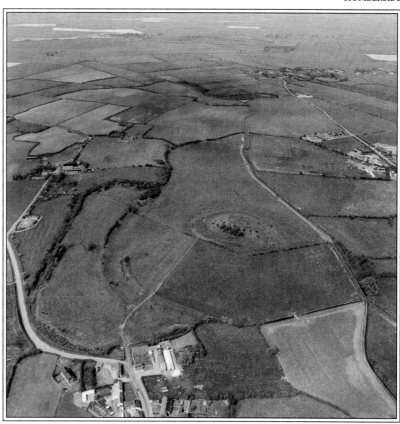

BURNBY HALL GARDENS, POCKLINGTON

Rather improbably squeezed in next to Pocklington's football field and cricket pitch are
water gardens containing the largest collection of water lilies in Europe. The two lakes
at Burnby Hall were originally built on concrete bases 70 years ago as trout ponds;
today they contain 5000 plants of nearly 50 varieties of water lily, making a
breathtaking show from late June to mid-September. There is also a rose garden,
which makes a neat pattern in the centre of the picture.

SKIPSEA CASTLE

To the west of Skipsea, a seaside town on the Plain of Holderness, the eagle eye of the
airborne camera picks out the motte and bailey of an important castle.
It was built by a Flemish soldier named Drogo, who came to England
with William the Conqueror. Drogo later married William's niece but, tiring of her,
murdered her, and was forced to flee the country. The castle was eventually destroyed
during the reign of Henry III.

FARMLAND NEAR HOLME-UPON-SPALDING

Between the western edge of the Wolds and the Vale of York the land is flat, but the
patchwork of crops and their different colours make it anything but monotonous when
seen from the air. The soil is mixed: on the sandy, loamy ground and on the peat,
sugar beet is grown; on the heavier clay, wheat and barley predominate. Much of the
wheat is sold for seed crop; the barley is malted and sent to the breweries.

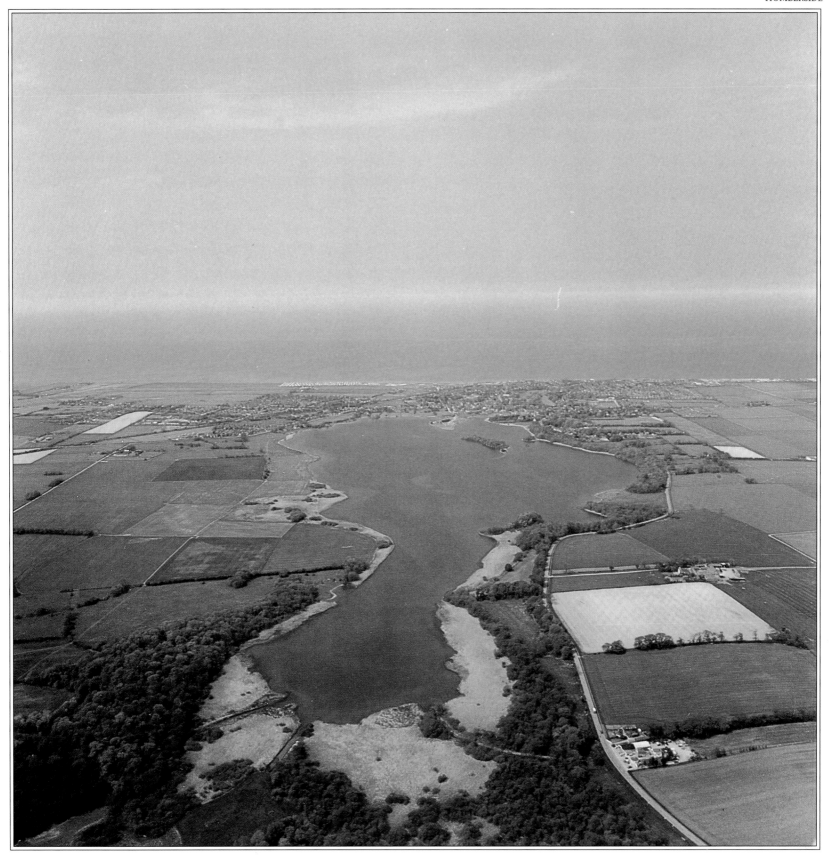

HORNSEA MERE

The paler blue of the nearby sea, the rich greens of the woods and farmland and the
flashes of brilliant yellow added by the occasional field of oilseed rape set off Hornsea's
famous Mere to perfection. Two miles long and a mile wide, it is the largest freshwater
lake in Yorkshire. Many fishing records have been set here in the past, and the wooded
landward end is a sanctuary for cormorants, waterhen, coot and heron.

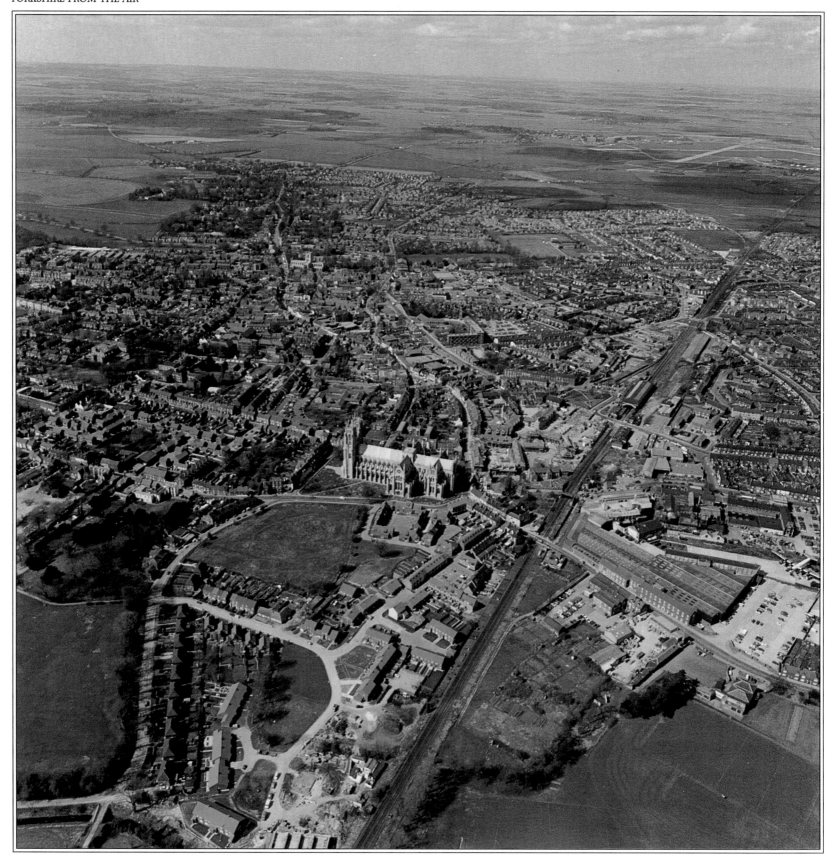

BEVERLEY

Beverley's first charter dates from 1129 and it is strange to think that the sprawling
city of Hull was once an unimportant suburb of this ancient market town. It has the
distinction of possessing two magnificent churches; as well as the famous Minster in
the foreground, there is the even older Church of St Mary, dating from the twelfth
century. The town takes its name from Beaver Lea (Lea means meadow).

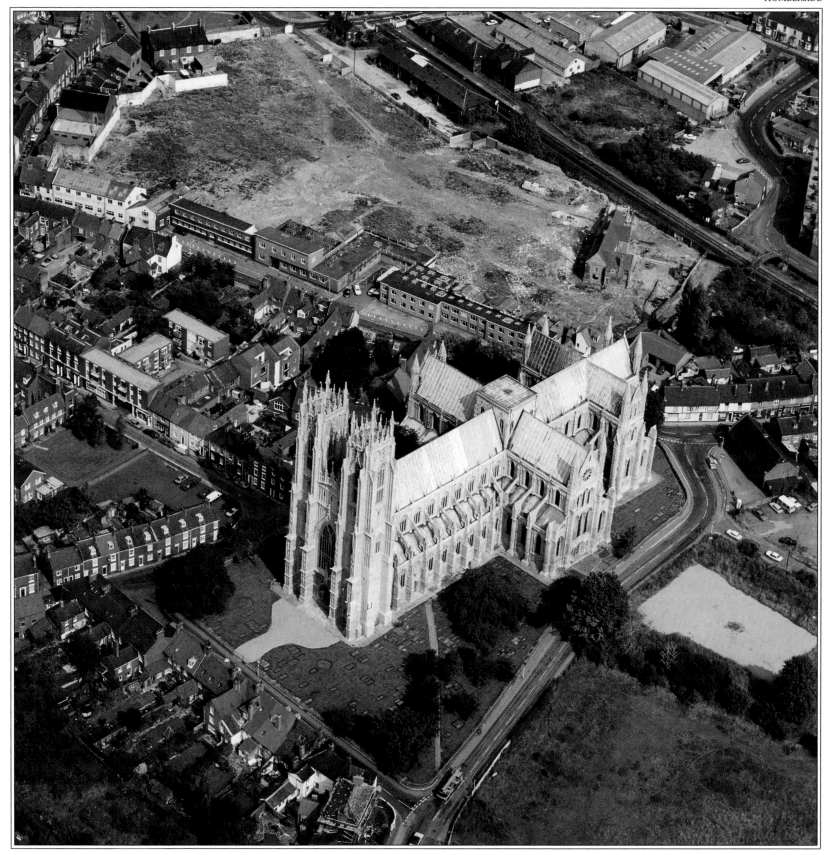

BEVERLEY MINSTER

One of the most beautiful Gothic churches in Europe, Beverley Minster incorporates a
mixture of early English, Decorated and later English architecture that took two
centuries to complete and yet has a marvellous feeling of unity and harmony. There
was a monastery on this spot as early as AD 700, but the present building dates from
1220-60, when the choir and transepts were built.

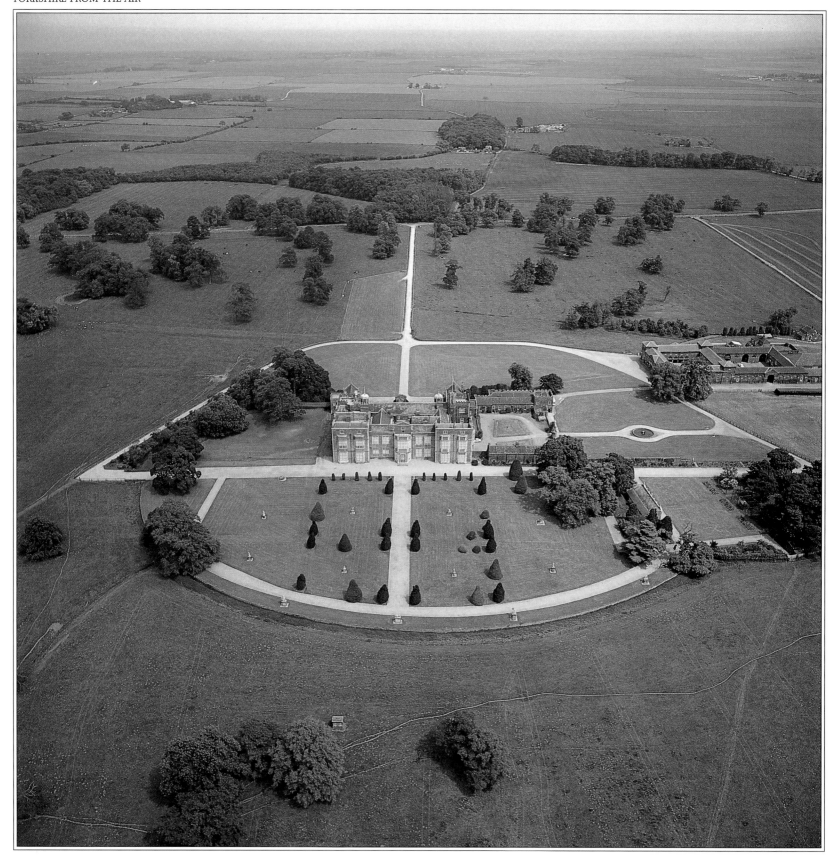

BURTON CONSTABLE

On the Plain of Holderness, set in 250 acres of park landscaped by 'Capability'
Brown, Burton Constable is a hugely successful combination of the Elizabethan and
the Georgian. Building in the characteristic red brick began in 1571; in 1759-60 the
top storey was added by Lightoller, who also designed the stable block. Although open
to the public for part of the year it is still a private house.

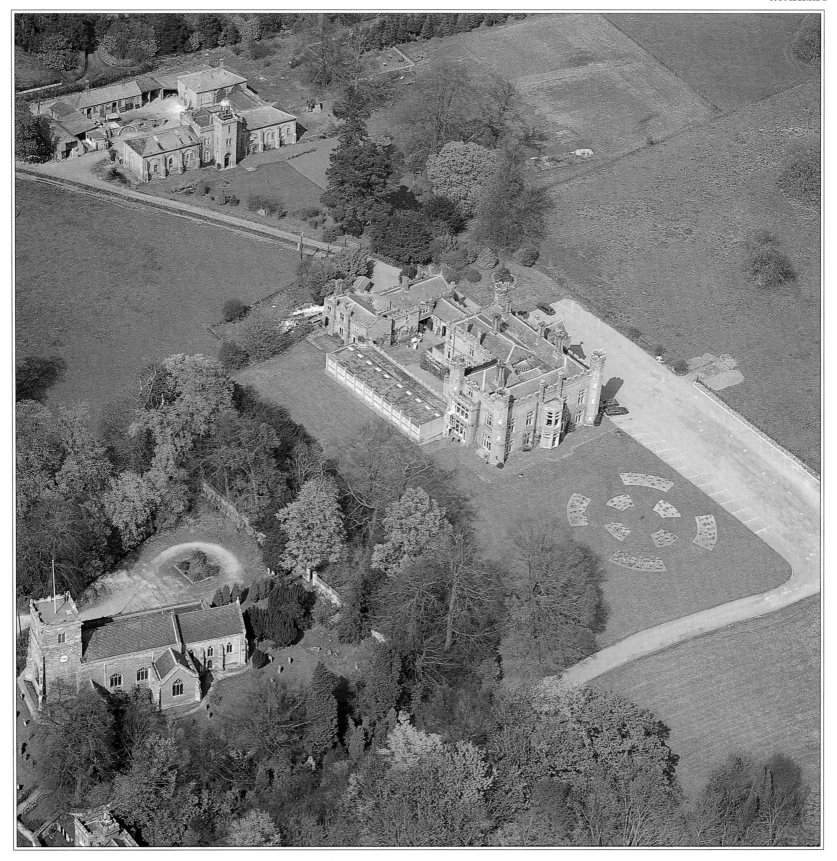

SOUTH CAVE

This castellated Victorian country house, at South Cave near the Humber, is now an
hotel. It was probably built on the site of a much earlier manor, and the parish church
stands in its grounds.

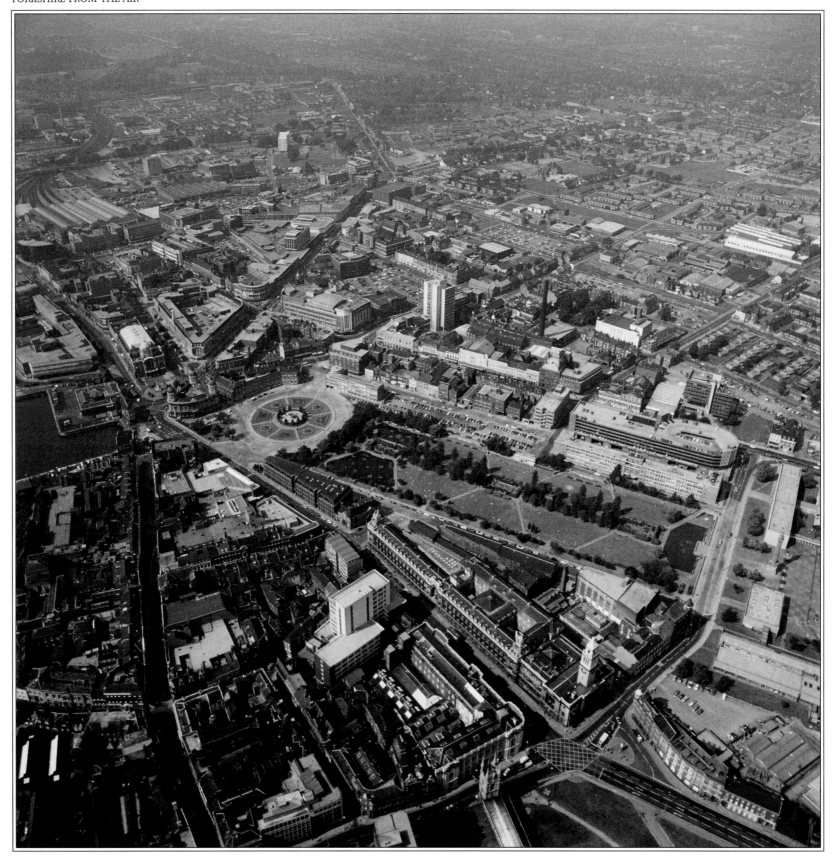

HULL

Hull, or Kingston-upon-Hull as it is properly called, has been a port since the end of
the thirteenth century, but came to prominence during the Industrial Revolution. It
was until recently the second fishing port in Britain in weight of fish landed, and the
attractive three-domed Town Docks Museum in the centre left of the picture
records the history of fishing, trawling and whaling here.

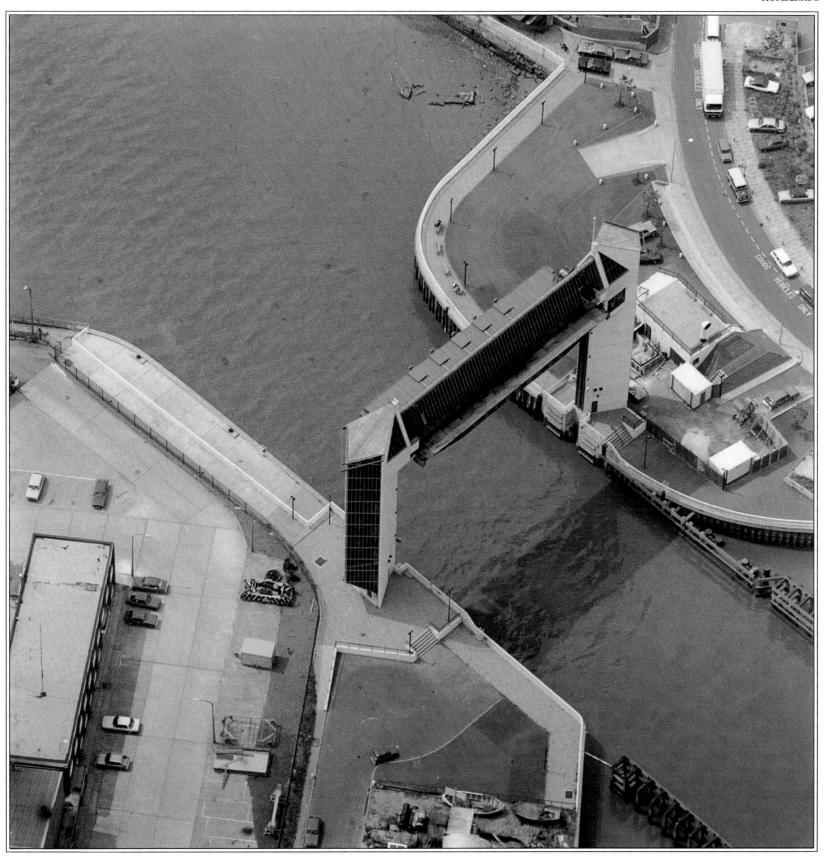

HULL

The sea, source of Hull's past prosperity, has now become a threat to the city's future.
Global warming has meant that the water level here is rising at about 2 feet 6 inches
every 100 years, and over 90% of the city is already below the highest recorded tide
level. Built between 1977 and 1980, this tidal surge barrier at the mouth of the
river Hull, when lowered, raises Hull's defences by a crucial 3 feet 6 inches.

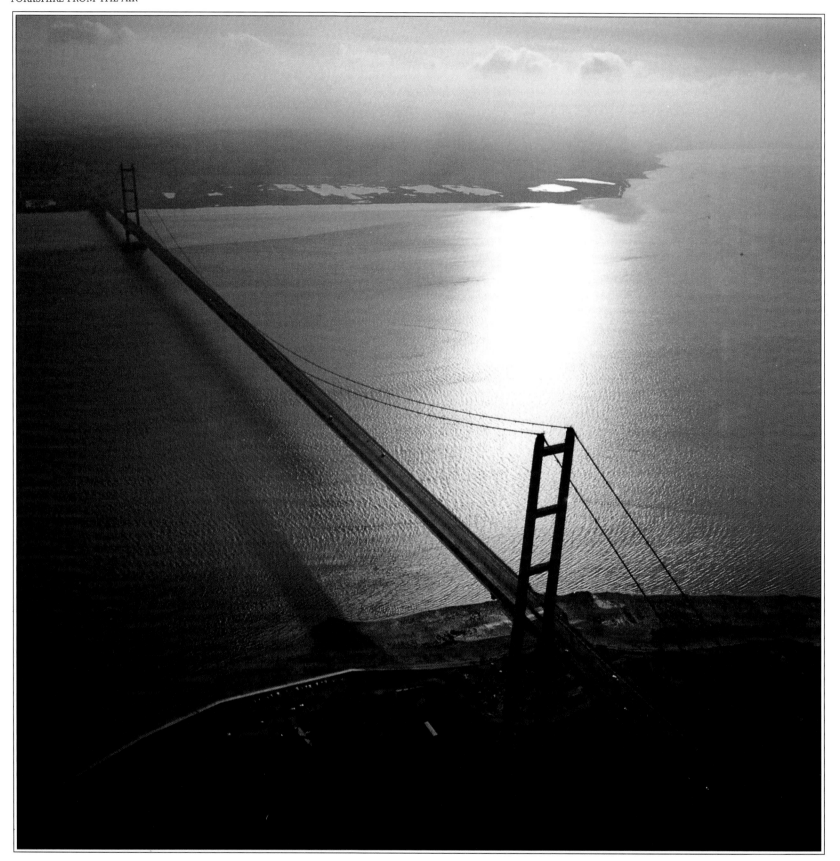

THE HUMBER BRIDGE

Five miles west of Hull, the largest single-span suspension bridge in the world stretches
its majestic arm across the gleaming waters of the Humber Estuary.
The bridge, which has dramatically improved Hull's communications with the
industrial cities of South and West Yorkshire and the Midlands, was begun in 1972,
took over eight years to build and cost £91 million. Its main span is 4626 feet.

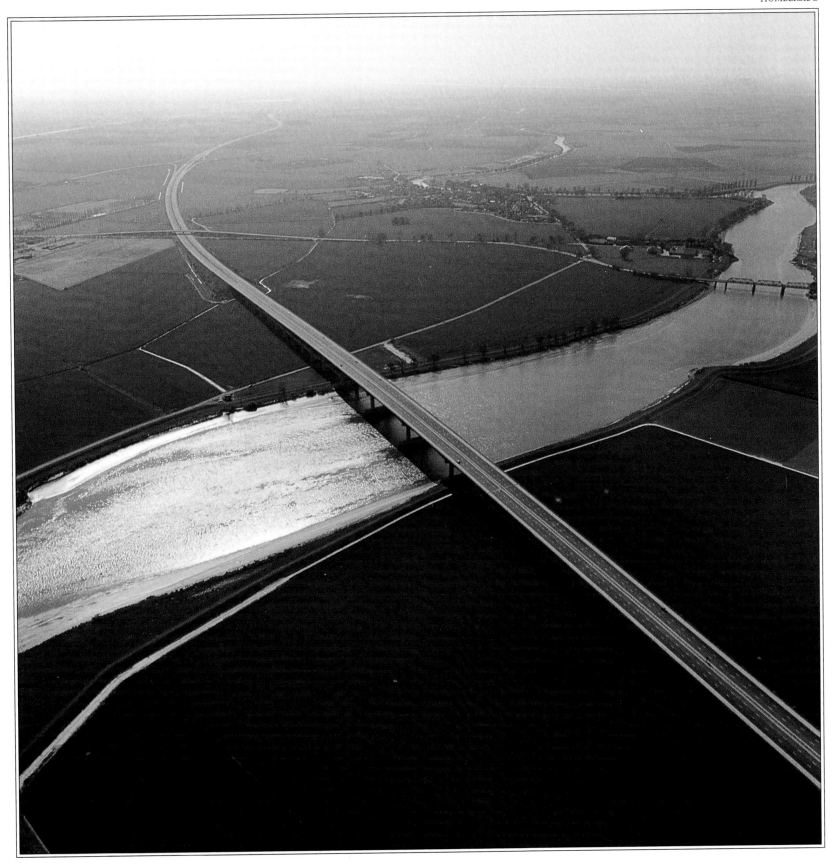

BOOTHFERRY

Before the Humber Bridge was built, the first bridging point on the Ouse was here at
Boothferry, more than eight miles upstream. The place takes its name from
the old ferry that plied its trade here, it is now also the point at which the M62
crosses the river. In the distance is the confluence of the Ouse (right) and Aire (left),
on the boundary between Humberside and North Yorkshire.

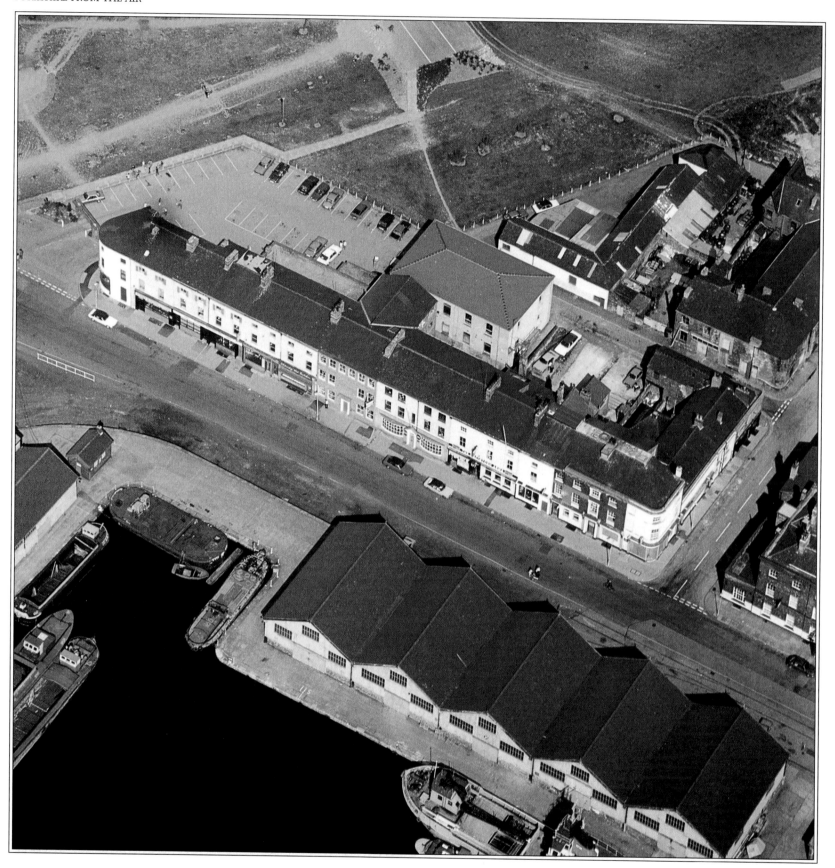

GOOLE

*Goole is an extraordinary monument to the industrial past: a port built in the 1820s
on the River Ouse, 50 miles from the North Sea, and connected to the interior by rail
and the Aire and Calder Navigation canal. It remains an active port today.*

MARKET WEIGHTON

On the western edge of the Wolds, between York and Beverley, stands the attractive old market town of Market Weighton. The Wolds Way which runs from Hessle Haven on the Humber up to the Cleveland Way in the north, passes through the town, which was also on a turnpike route in the past. Market Weighton's claim to fame is as the birthplace of Bill Bradley, who at 7'9" was Britain's tallest man.

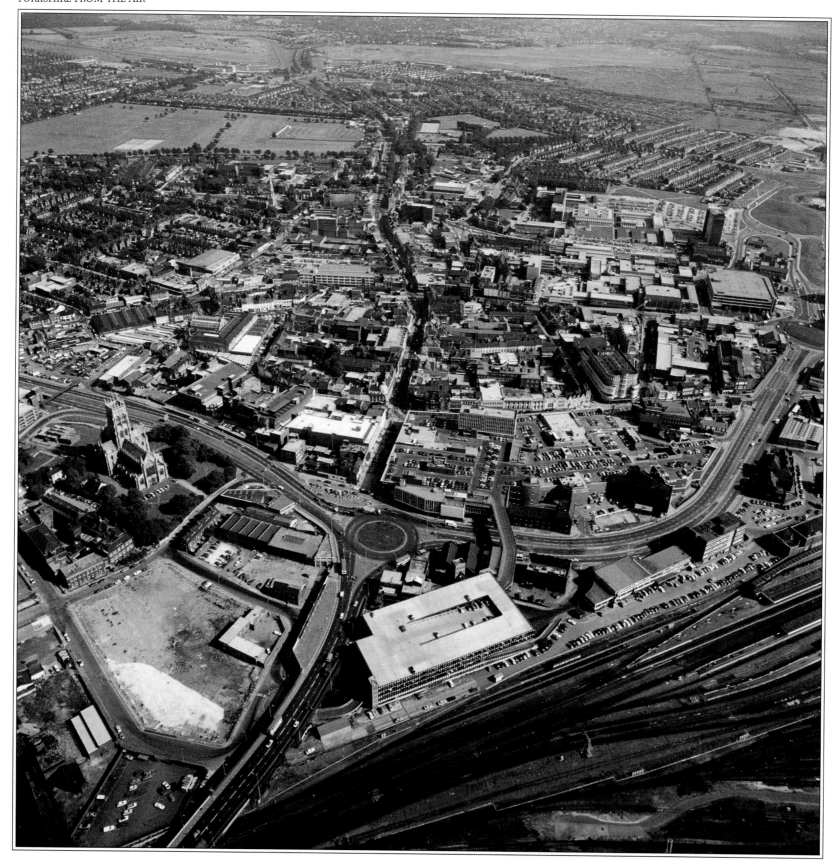

DONCASTER

Although it is now a major coal-mining town, Doncaster's origins long pre-date the
Industrial Revolution: the Romans had a fort here, on the Lincoln to York road, called
Danum. The racecourse, at the top left of the picture, is the home of the St Leger, first
run in 1776, and named after its creator, Colonel Anthony St Leger. The splendid St
George's Church, by Sir Gilbert Scott is in the left foreground.

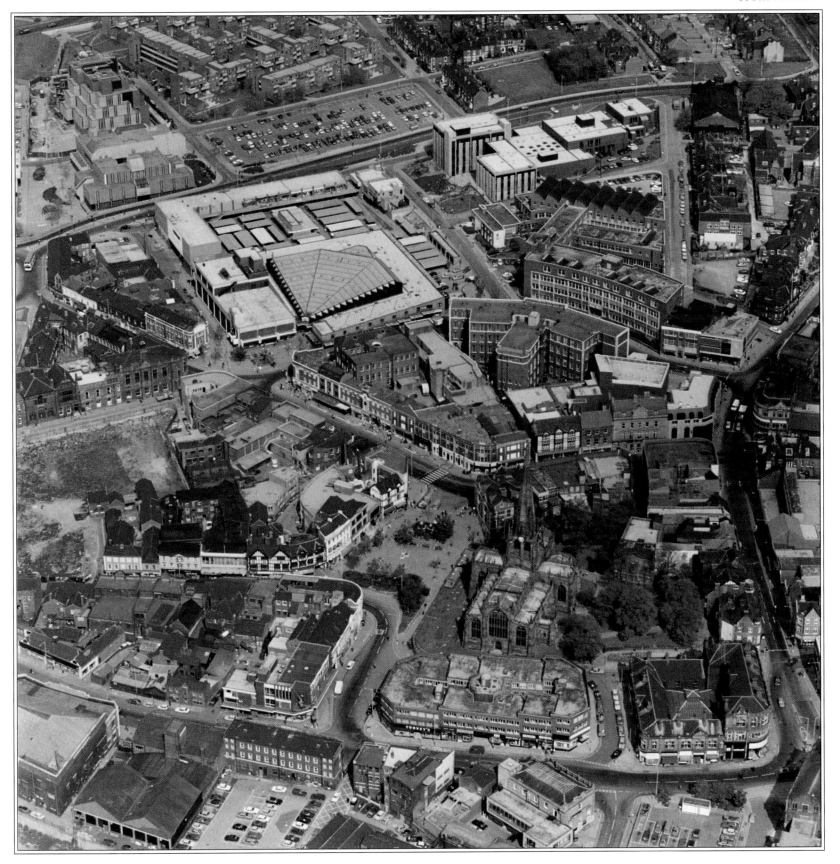

ROTHERHAM

*Almost a suburb of Sheffield nowadays, Rotherham has managed to retain a human
scale in its buildings, which are mostly nineteenth and early twentieth-century. The
most obvious exception is the famous All Saints Church in the foreground, a
masterpiece of Perpendicular architecture. The modern market, with its pastel-coloured
stall roofs, is the successor of an ancient one granted by a charter of King John.*

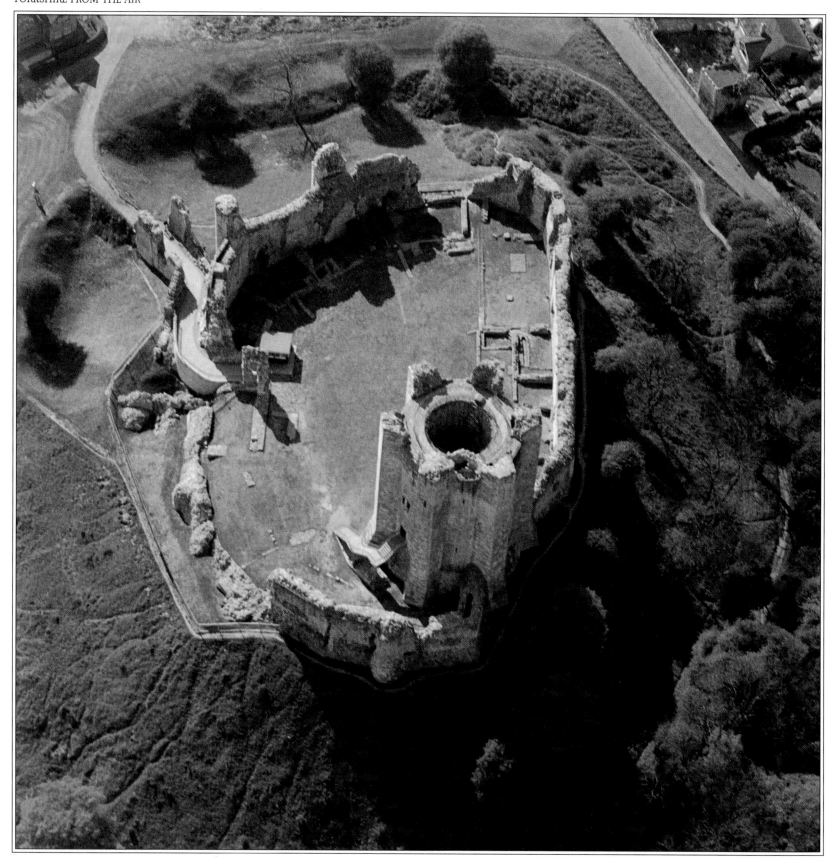

CONISBROUGH CASTLE

Vying for the aerial photographer's attention alongside rather more recent structures of
curiously reminiscent shape (see opposite) is Conisbrough's extraordinary castle. It
must have looked even more unusual when it was built c. 1180, for the six tapering
buttresses supporting the white limestone keep were each topped by turrets, and the
central cylinder by a conical roof.

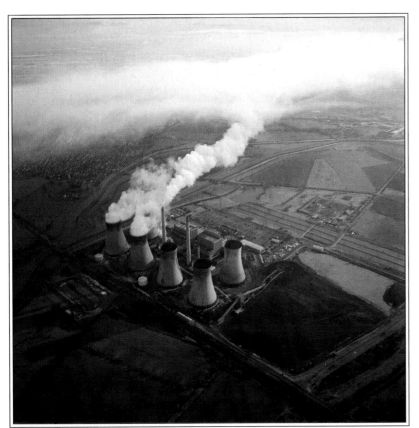 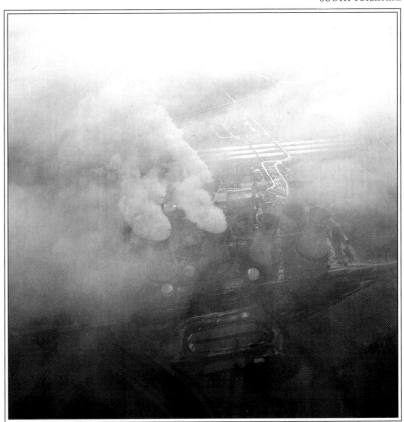

THORPE MARSH POWER STATION

A lingering mist and the steam rising from the giant cooling towers mingle together to produce an atmospheric portrait of a utilitarian object, one of the many power stations in the area profiting from abundant local coal and water. At Thorpe Marsh, just north of Doncaster, the CEGB has made special efforts to provide attractive surroundings with a large nature reserve on its land nearby.

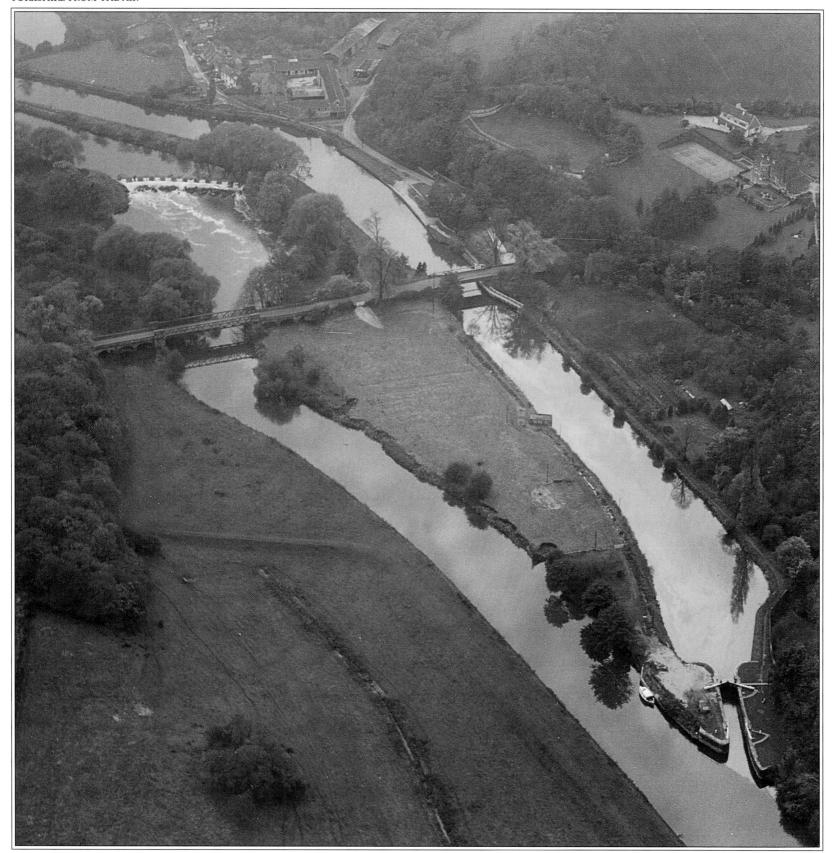

RIVER DON, SPROTBROUGH

Southern Yorkshire is one of the few areas of Britain still to make commercial use of
its man-made waterways, carved out in the late 18th and early 19th
centuries to transport bulk supplies of heavy goods for the new industries. Sometimes
new canals were dug; elsewhere improvements were made to rivers. At
Sprotbrough, a section with a lock guides the river round a weir and hidden shallows.

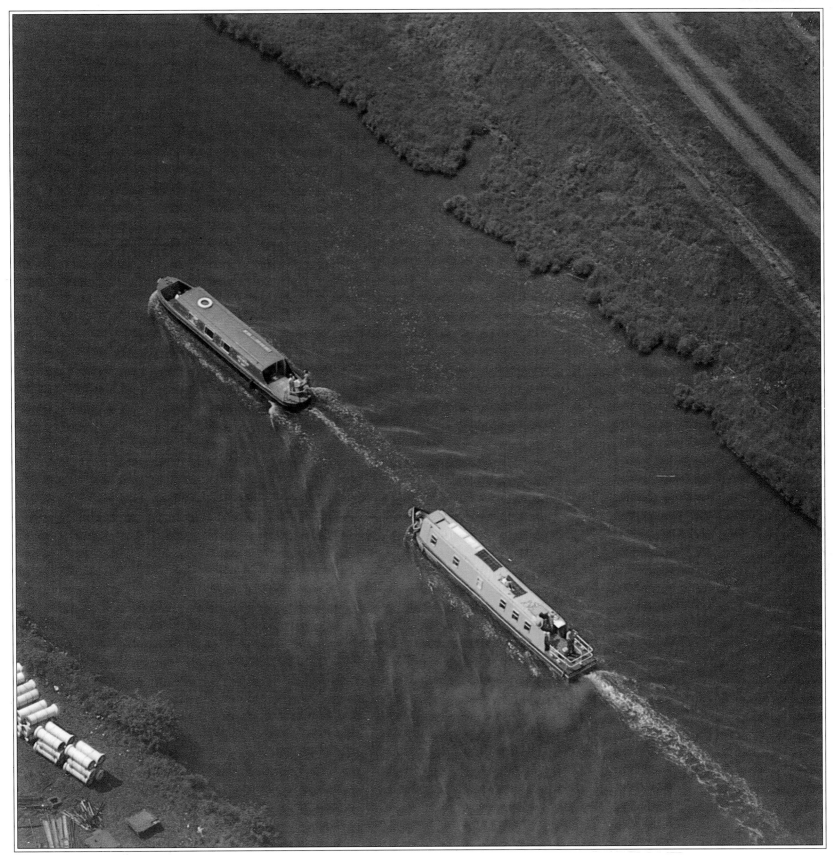

RIVER DON, DONCASTER

Coloured barges on the River Don near Doncaster. The canal is increasingly
used by leisure craft. Commercial traffic, meanwhile, includes limestone, wire and
steel. It is the Don's access to the Humber Estuary that has kept trade alive: the river
joins the Ouse at Goole by means of the artificial 'Dutch River', dug by Cornelius
Verminyden, nephew of the Dutch ambassador to Charles I.

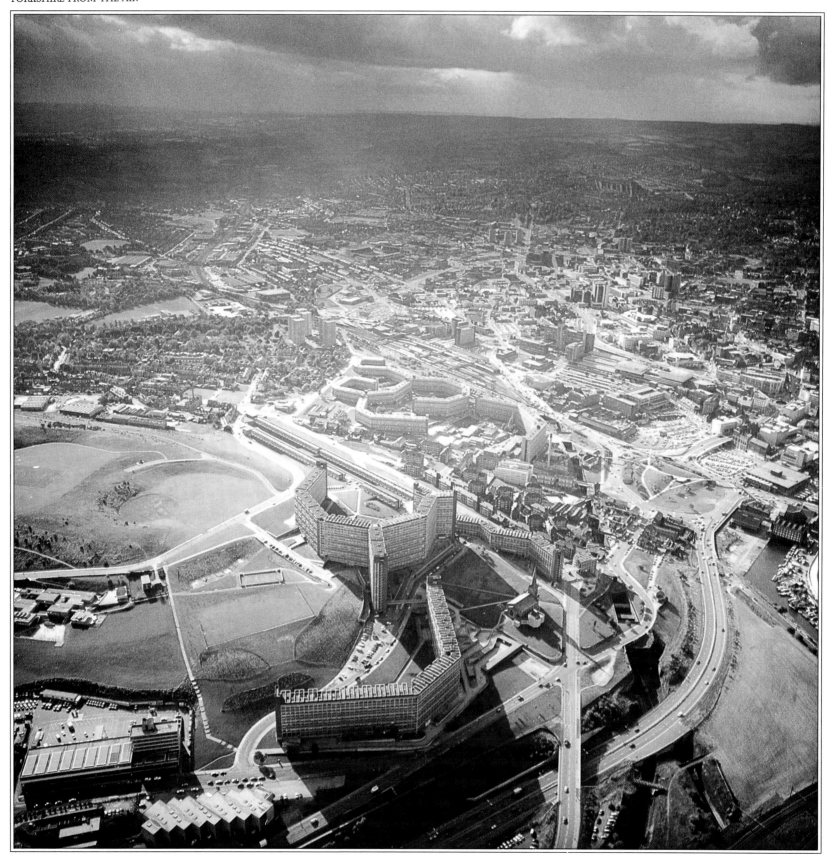

SHEFFIELD

This photograph of Sheffield under a lowering sky seems to confirm the old
unflattering description of the town, attributed to both Ruskin and Palmerston: 'a dirty
picture in a lovely frame'. Appearances are deceptive, however, for Sheffield is now
probably the cleanest industrial city in Europe. It has been a manufacturing centre for
over 500 years – its famous cutlery is mentioned in The Canterbury Tales.

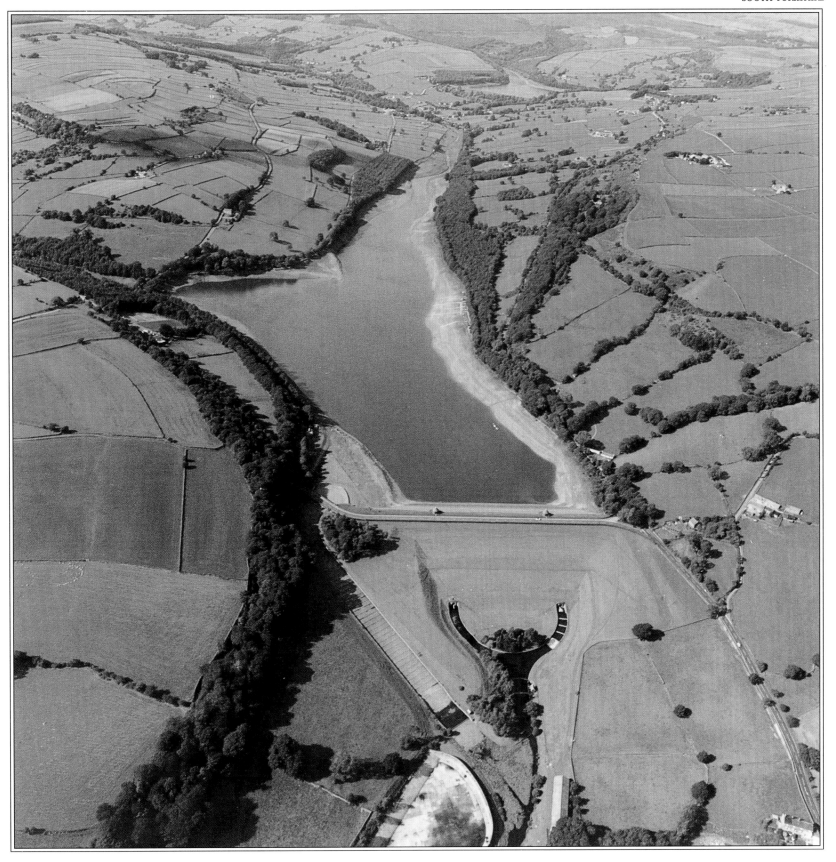

DAMFLASK RESERVOIR

The eastern edge of the southern Pennines are cut into deep valleys by rivers flowing
towards the North Sea, and many have been dammed to form South Yorkshire's
numerous reservoirs. As well as supplying soft water to the huge
industrial towns nearby, they provide welcome leisure areas. Damflask, in the
Loxley Valley on the northern outskirts of Sheffield, is avidly fished for trout.

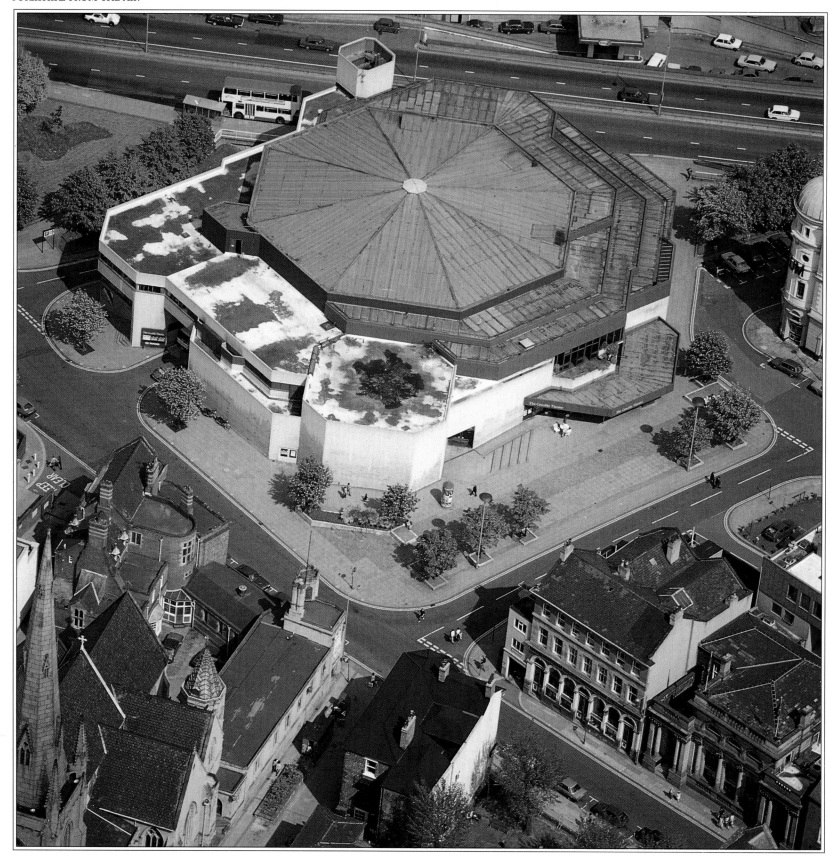

THE CRUCIBLE THEATRE, SHEFFIELD

Sheffield has no fewer than three theatres, but the famous Crucible, opened in 1971,
undoubtedly takes pride of place. With its 1000-seat main auditorium set round three
sides of a 28-foot 'thrust' stage, an idea brought back from Canada by its first artistic
director, Colin George, it was considered revolutionary when built. There is also a
smaller auditorium, the studio, seating 250, used for new and experimental plays.

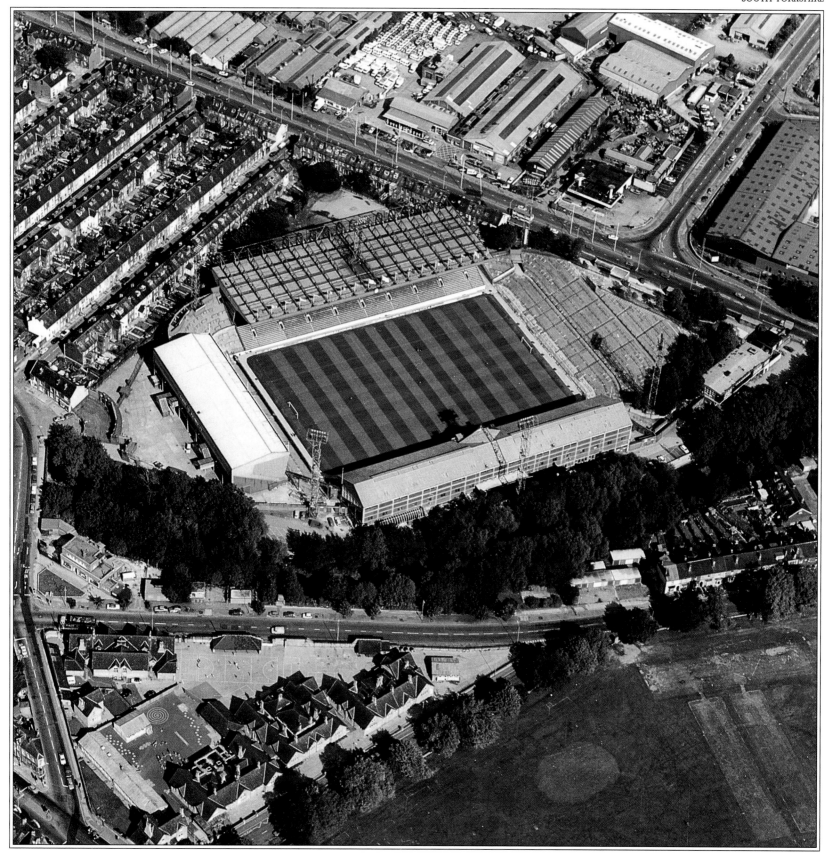

HILLSBOROUGH

Another famous form of Sheffield entertainment is football. Punters have the choice of
two clubs – Sheffield United at Branall Lane or Sheffield Wednesday here at
Hillsborough. Sheffield Wednesday's strange name comes from the fact that its
founders, the Wednesday Cricket Club, were local craftsmen whose weekly half-day
was on Wednesday. In 1986 Spion Kop, on the far side of the ground, was roofed.

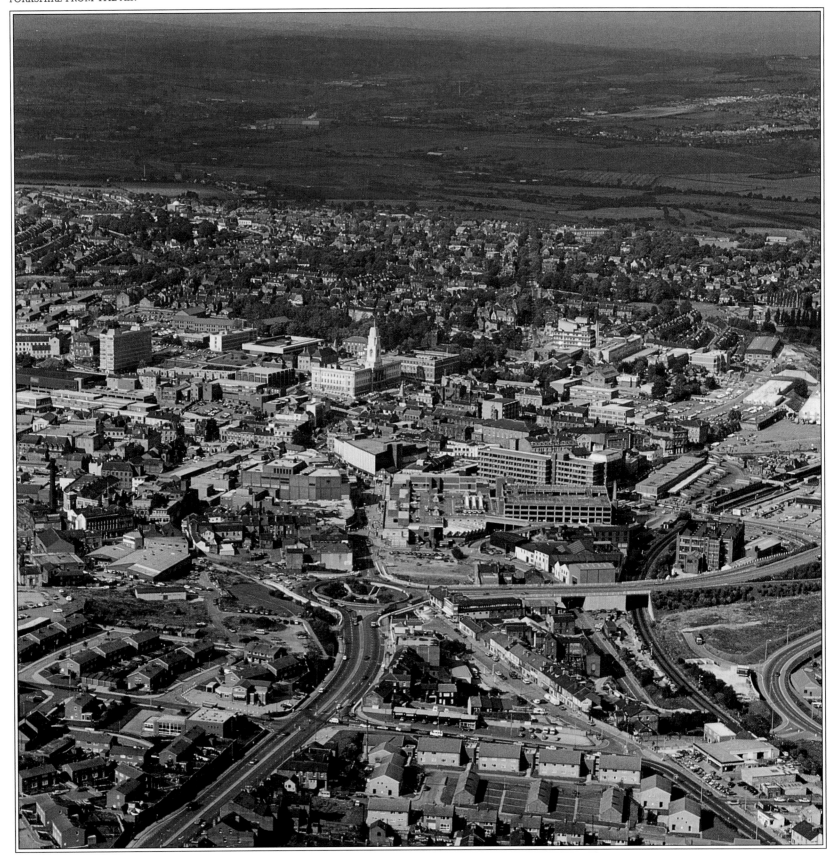

BARNSLEY

Barnsley, geographically in the centre of the South Yorkshire coalfield, has a past that
is inextricably bound up with mining. But although some pits are still working nearby,
and the town still houses the Yorkshire Area Headquarters of the NUM, there are no
pits in Barnsley any more: it has lost out to the new mines around Selby, Doncaster
and Rotherham. The town's most conspicuous building is the Town Hall.

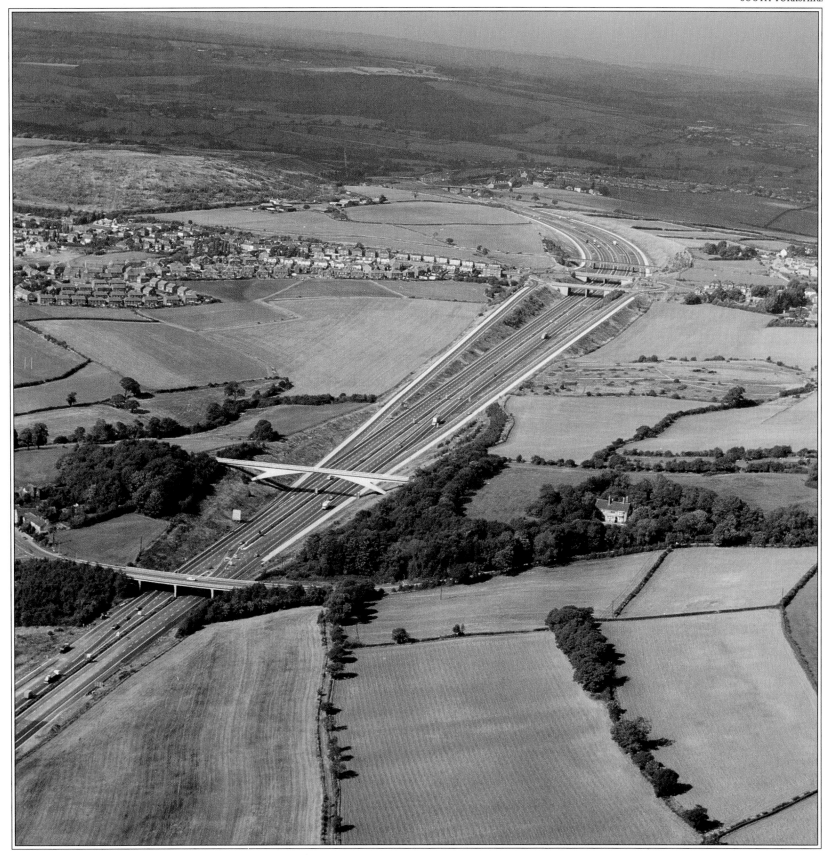

M1 MOTORWAY, WEST OF BARNSLEY

In the early twentieth century, the A1, linking London with Edinburgh, was designated
the prime arterial road in the country. However, it soon became apparent that its
route down the east side of Britain bypassed the industrial centres of West Yorkshire
and the Midlands. Hence, in 1957, Britain's first motorway was opened, linking
London with Birmingham and later continuing to Sheffield, Barnsley and Leeds.

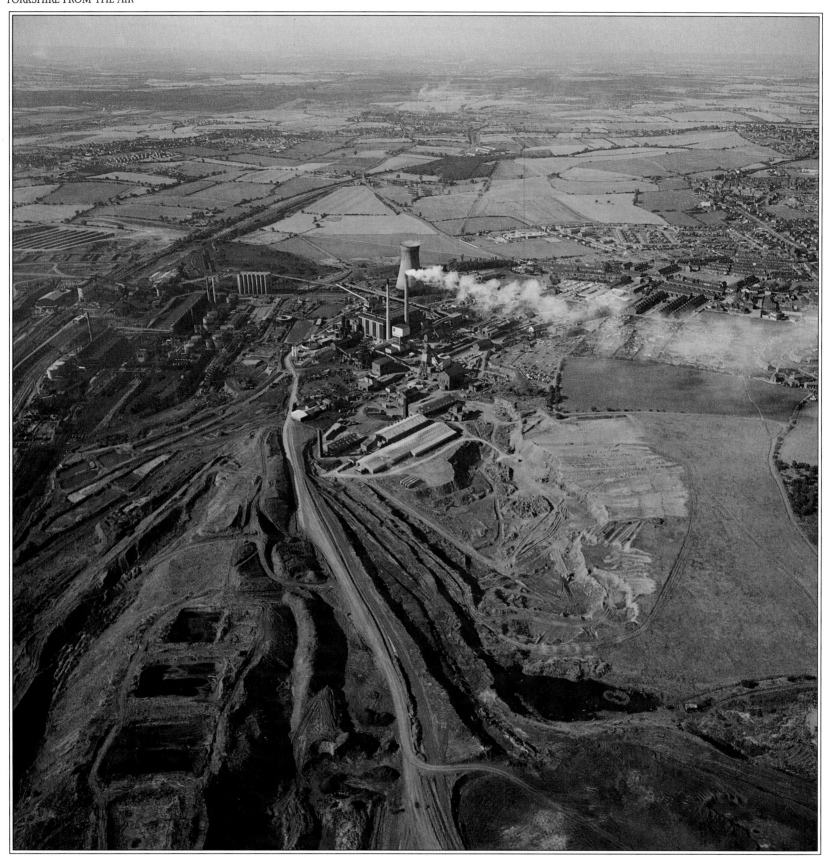

GRIMETHORPE COLLIERY

The Yorkshire, Nottinghamshire and Derbyshire Coalfield is the largest and most
important in Britain, producing about 53% of the national output, and Yorkshire is
pre-eminent among the three counties, accounting for 30% of Britain's coal on its
own. Grimethorpe, first mined in 1894, produces over a million tonnes a year from its
three coal seams and provides fuel for domestic and industrial uses.

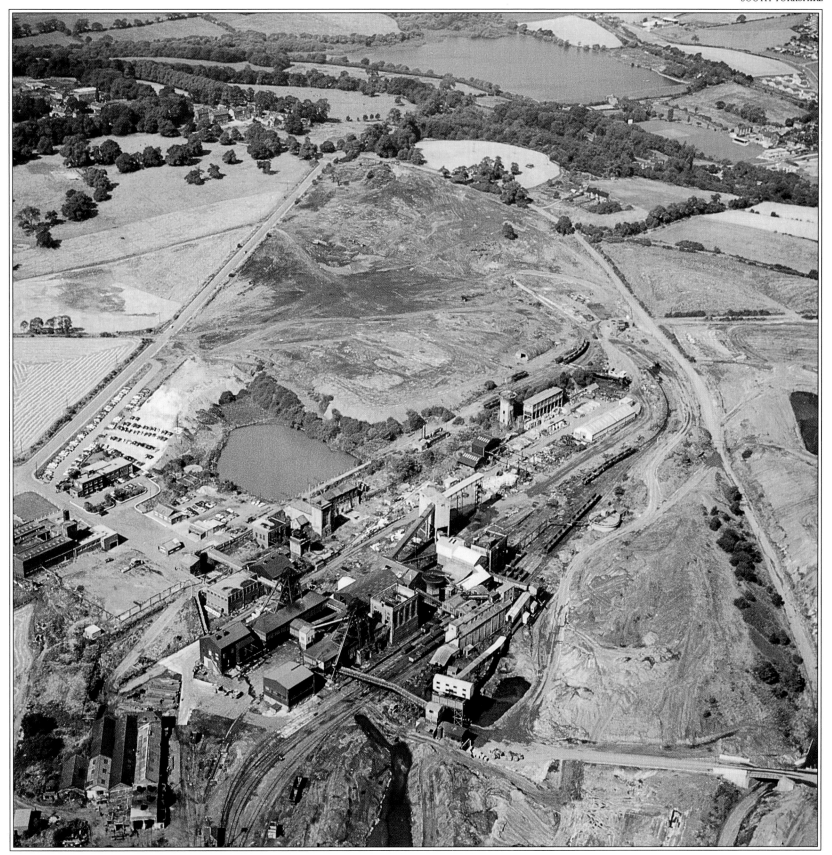

BARROW COLLIERY

The picture shows a typical deep-shaft mine, surrounded by its spoil heaps (often
erroneously called slag heaps), which are afterwards landscaped. Barrow Colliery is on
the Barnsley coalfield, which has a thick seam – it averages 6 foot – of good-quality
coal. Barrow was closed in 1985 but happily with no loss of jobs: the 1200 men
working there were transferred to Barnsley Main Collery.

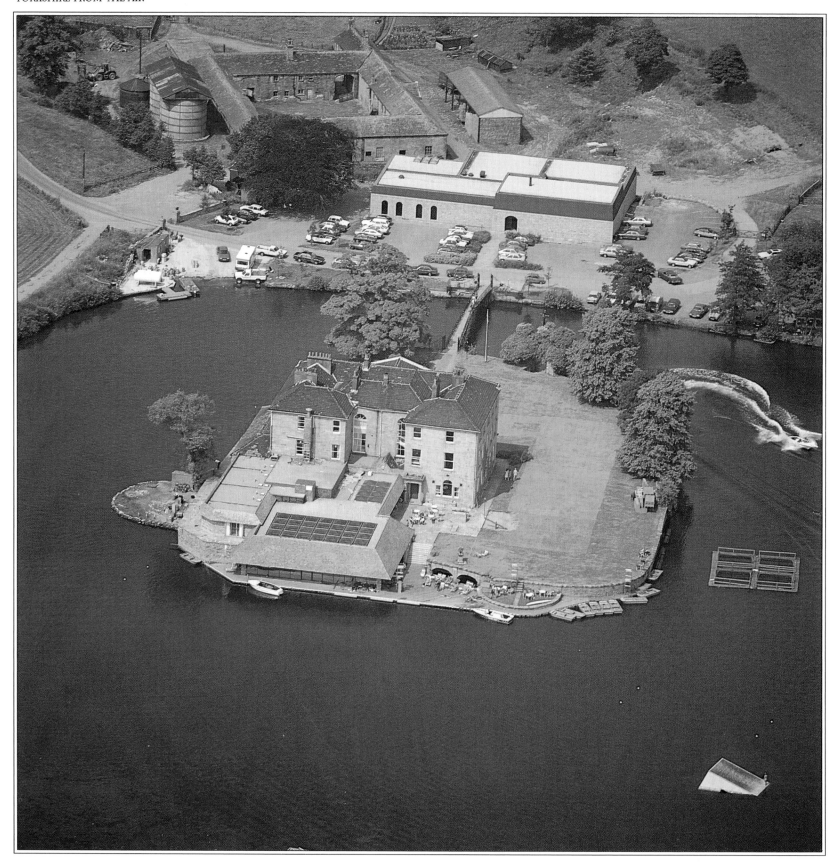

WALTON HALL

This estate in the heart of industrial Yorkshire was the somewhat unlikely site of the
first bird sanctuary in England, set up in the mid-nineteenth century by the
explorer and taxidermist Charles Waterton. The house, built in 1767-8 on an island
in the lake, and reached by a pretty iron bridge, has been through various incarnations
since, including a spell as a water-skiing centre as in the picture.

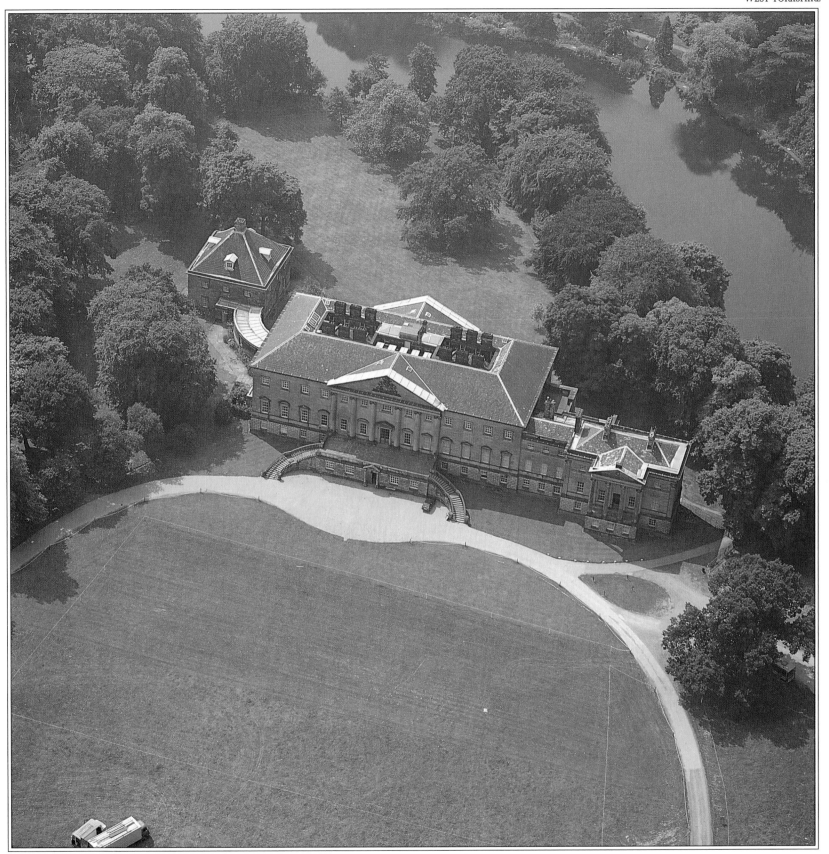

NOSTELL PRIORY

Nostell Priory takes its name from an Augustinian priory founded in the early twelfth
century that once stood nearby. By 1654 the estate had passed into the hands of
Richard Winn, a London alderman, and the magnificent house, begun in 1733, was
paid for out of the profits of the estate mines. Paine, the original architect, planned to
add four square pavilions to the main house, but only one was built.

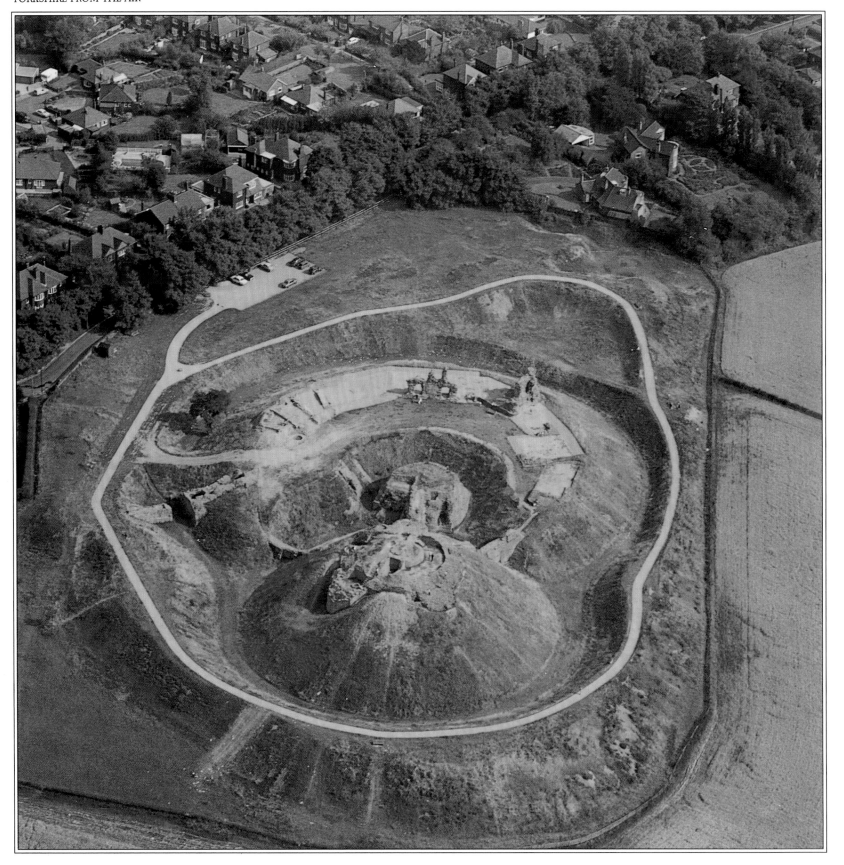

SANDAL CASTLE

Although only excavated comparatively recently, Sandal Castle was once a great
fortress, the headquarters of the Duke of York prior to his final defeat by the
Lancastrians at nearby Wakefield Green in 1460 and a favoured residence of Richard
III. The motte and bailey date from the eleventh century but the remains of the
buildings that have been found are all fourteenth century or later.

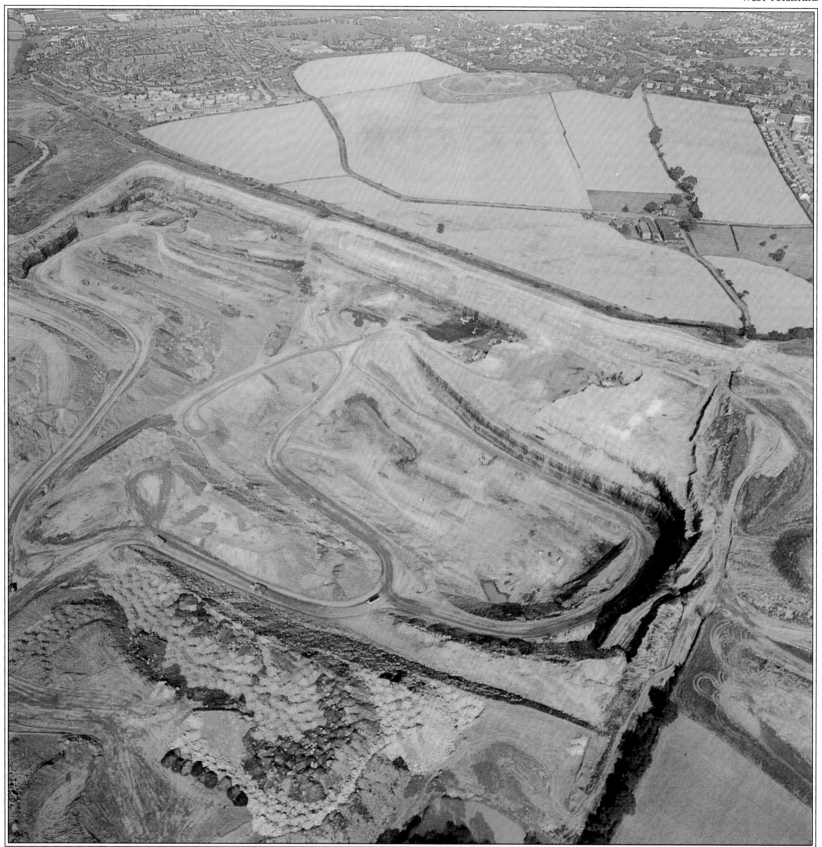

PUGNEYS OPEN-CAST MINE, DURKAR

Having begun life as a sand and gravel quarry, this open-cast site just south of
Wakefield produced over a million tonnes of coal a year from British Coal from 1972
to 1978. Its appearance today is a distinct improvement from that shown in the
picture – after the completion of mining the site was landscaped and turned into a
country park, with a lake for watersports.

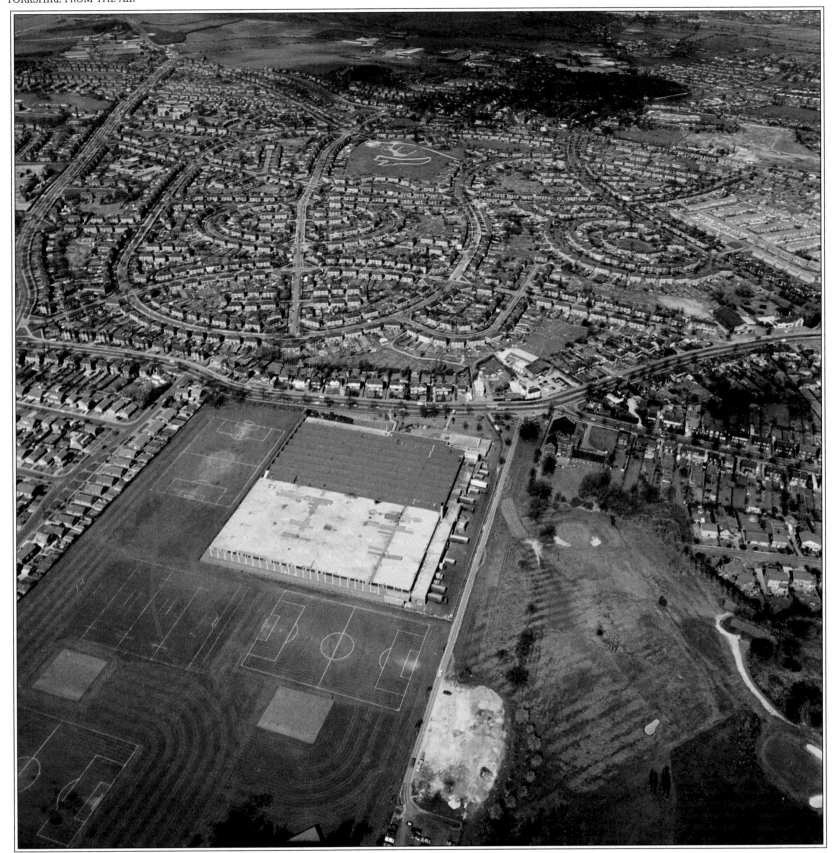

WAKEFIELD

Twentieth-century housing on the outskirts of Wakefield makes an interesting pattern
when seen from above, but Wakefield is in fact one of West Yorkshire's most ancient
towns. Mentioned in the Domesday Book, it was known for its weaving as early as the
thirteenth century and by 1400 was the largest cloth town in West Riding. Little
remains of medieval Wakefield apart from the chantry chapel (opposite).

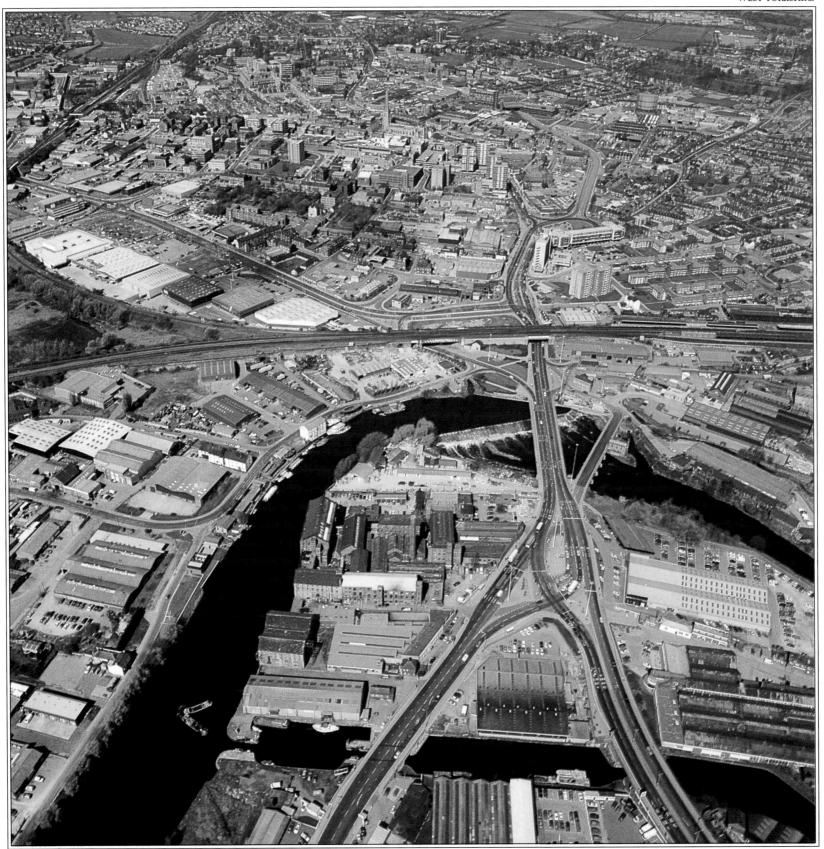

WAKEFIELD

Perched incongruously beside a maze of modern roads and railway lines in Wakefield's
industrial area is the fourteenth-century chapel of St. Mary, standing on a 600-year
old bridge over the River Calder. The chapel is one of only two or three chantry chapels
remaining in England; here prayers were said for travellers in exchange for money to
maintain the bridge. On the far side of the river is the town centre.

131

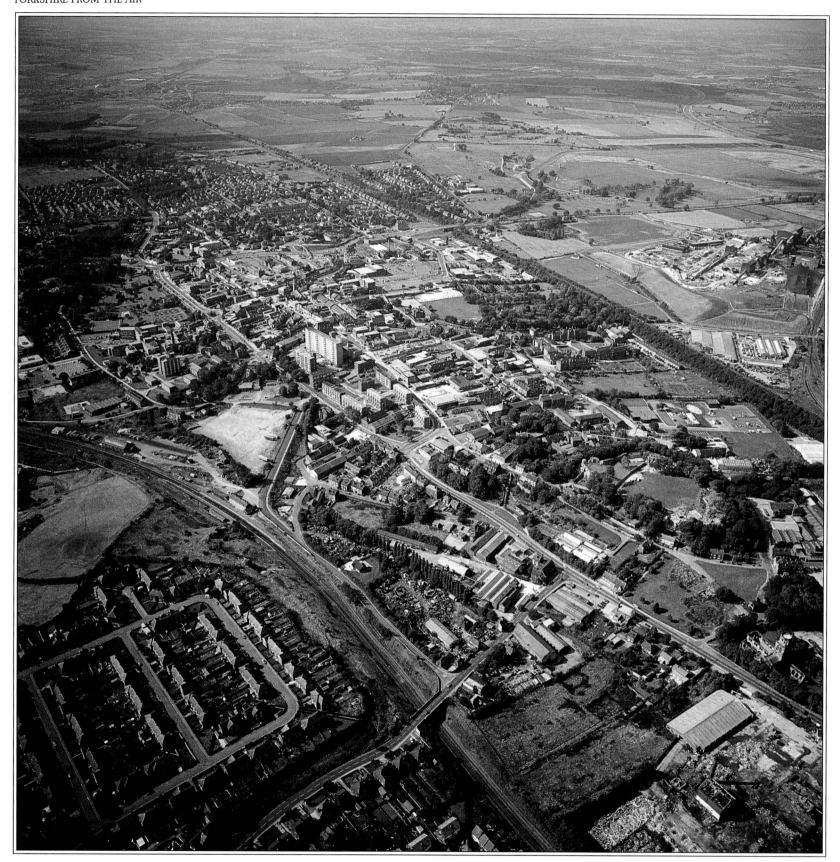

PONTEFRACT

*Although it may not be obvious from this picture, Pontefract, home of the delicious
liquorice Pontefract cakes, is one of the oldest boroughs in England, and was settled by
the Brigantes, the Romans and the Danes. The town grew up from three separate
villages. First came pre-Conquest Kirby, then the part shown here, around the castle
built by Ilbert de Lacy, and finally the thirteenth-century borough of West Cheap.*

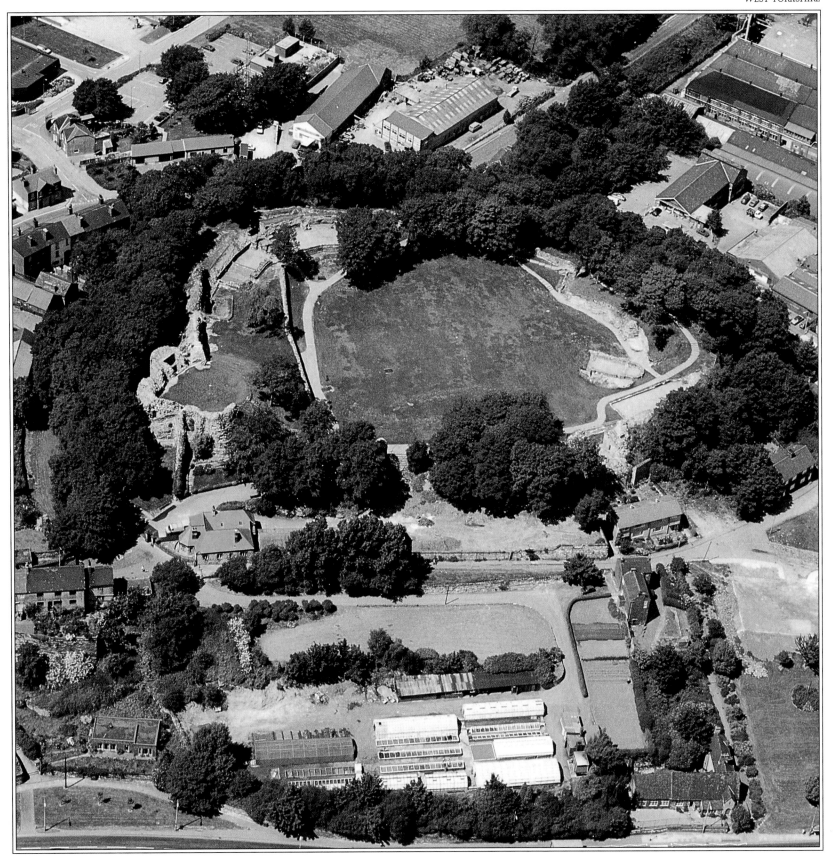

PONTEFRACT CASTLE

*A welcome green space and a few crumbling walls are all that remains of Pontefract's
mighty Norman castle, which once covered seven acres and guarded the main route
north and south. Its pastoral appearance belies a dark history. Richard II and
Archbishop Scrape both died here and James I of Scotland and Charles Duke of
Orleans were held prisoner. Cromwell had it demolished after besieging it three times.*

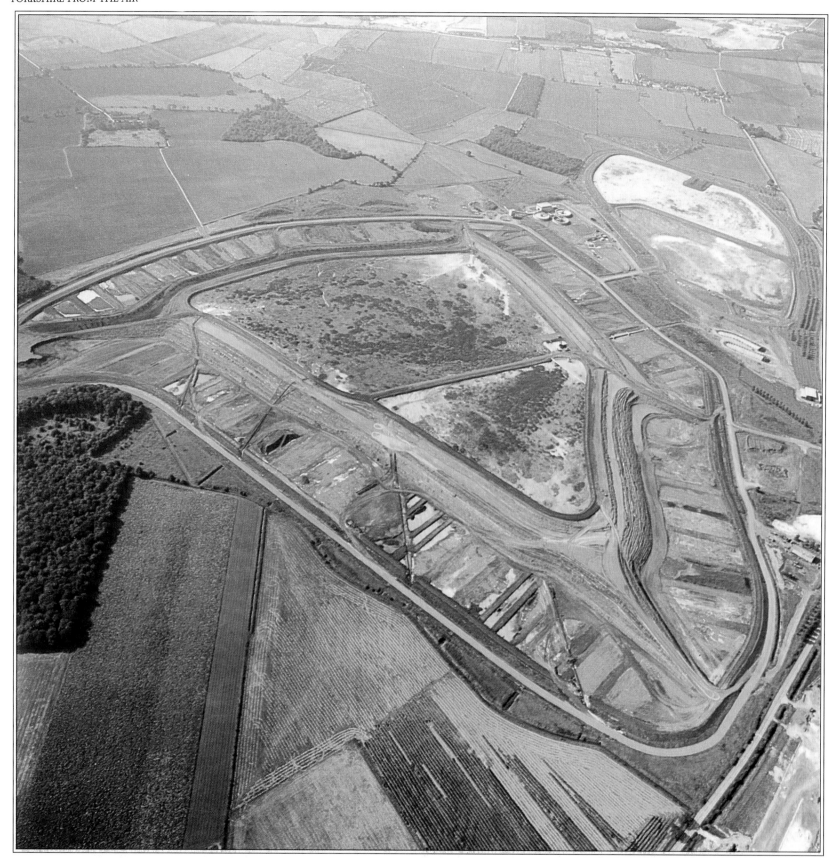

GALE COMMON

*A few miles east of Pontefract is a piece of man-made landscape that is frankly
unattractive at ground level but intriguing from the air. The Gale Common ash
disposal site takes ash from the nearby power stations Ferrybridge 'C' and Eggborough.
The ash is piped in, in a slurry. Eventually, top soil is added and the newly-created hill
is grassed over; this has happened at Gale Common since this picture was taken.*

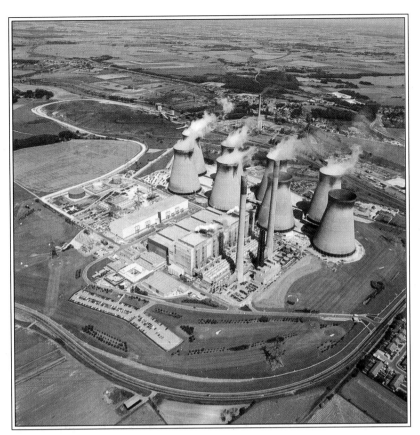
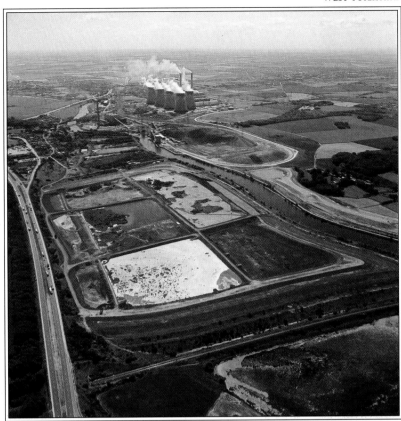

FERRYBRIDGE 'C' POWER STATION

On the west bank of the River Aire, just ouside Castleford, are the two Ferrybridge
power stations; only Ferrybridge 'C' can be seen in these pictures. The power station
achieved notoriety when in 1965, during the construction of the huge cooling towers,
three of them fell down in a gale; it became operational in 1966 and burns about 5
million tons of coal a year. The Great North Road can be seen passing by to
the east of this complex industrial scene.

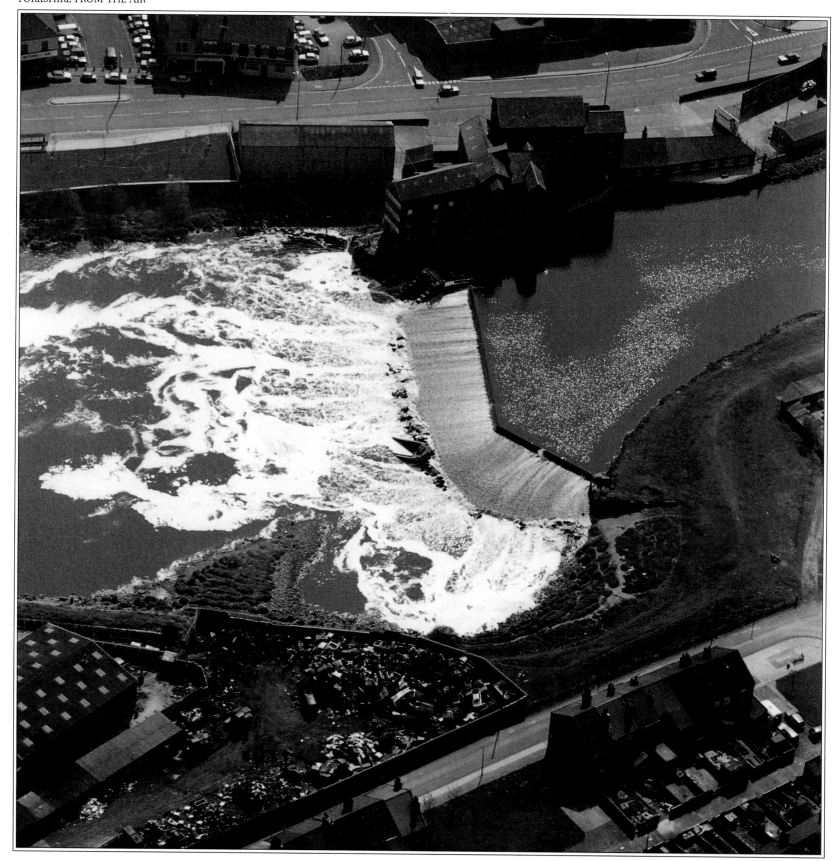

CASTLEFORD

Water froths and churns over a weir in the industrial town of Castleford, once an
important Roman station and birthplace (in 1898) of Henry Moore. Castleford used to
be a great coal-mining and glass manufacturing centre, but now only one pit remains
and the glassmakers have closed down, the newer industries are chemicals, clothing and
confectionery and the once grimy town has been somewhat spruced up.

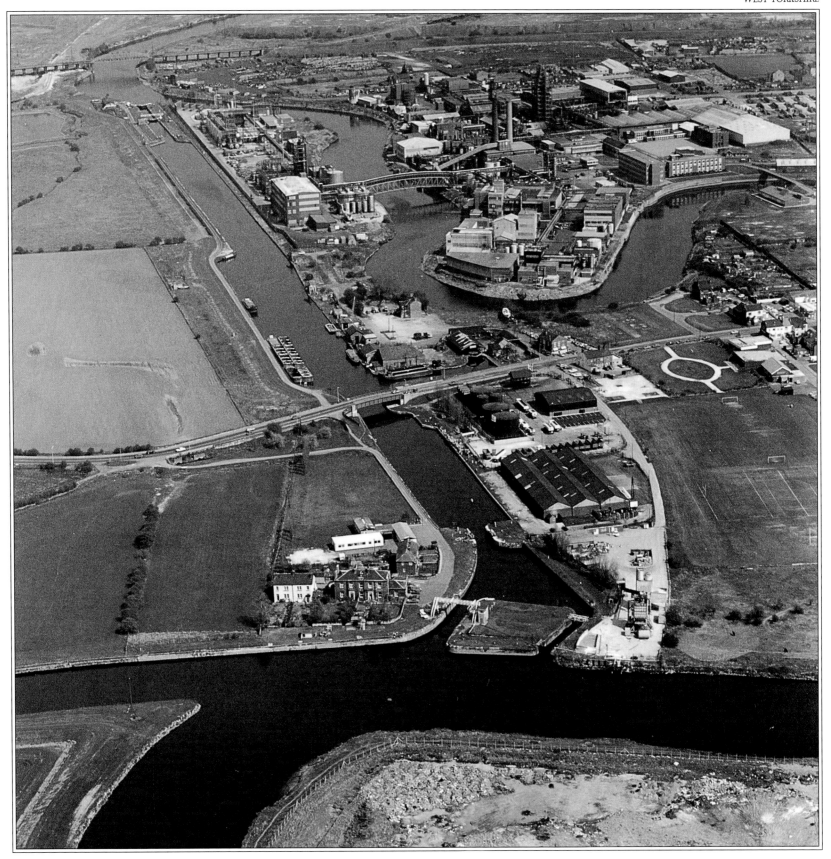

CASTLEFORD

When the River Aire meets the River Calder on the north western edge of Castleford,
an extravagant meander of the rivers has been cut short by a stretch of the Aire and
Calder navigation, one of the earliest canals to be built in England, dating to before
1700. It is still in commercial use, taking coal to nearby Ferrybridge power station and
bringing petroleum from the Humber port of Immingham to Leeds and Wakefield.

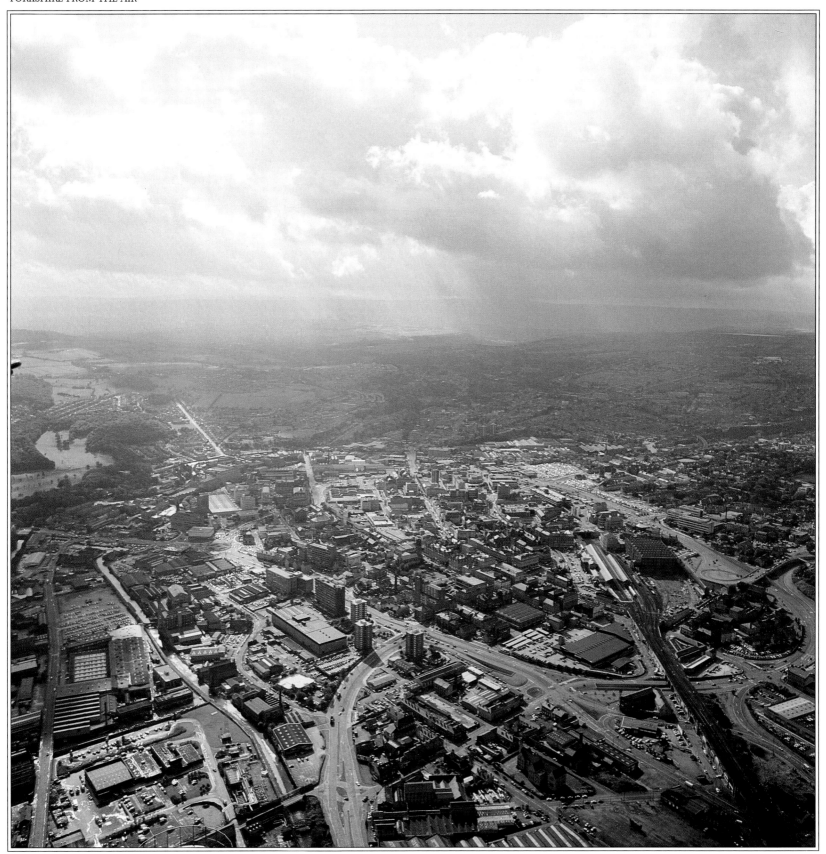

HUDDERSFIELD

Friedrich Engels described Huddersfield, centre of the worsted industry, as the most
handsome manufacturing town in the North of England. Unfortunately the twentieth
century has seen a certain amount of destruction but there are certainly some fine
buildings here: an Italianate Town Hall, a Greek-style railway station and numerous
nineteenth-century villas built by wealthy millowners.

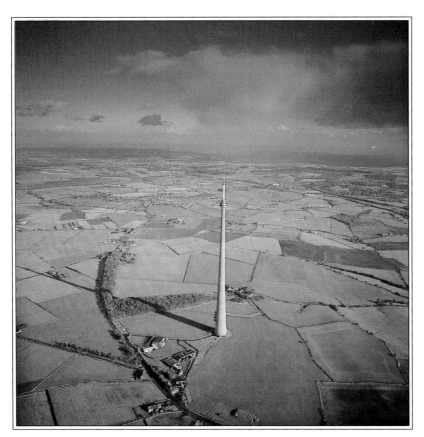

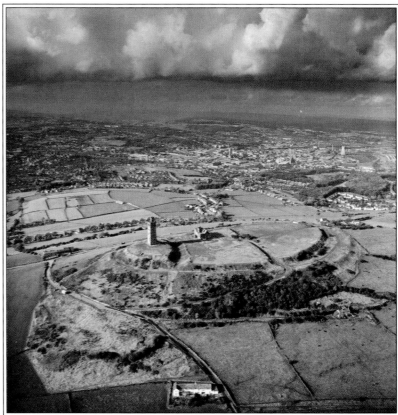

EMLEY MOOR

On the top of Emley Moor, south-east of Huddersfield, the white concrete finger of the television mast seems intent on piercing the clouds. The 900-foot tower topped by a 184-foot television mast is Europe's highest concrete building. It was built in 1970 to replace a steel mast which fell down under the weight of ice in winter and partly demolished a chapel. The moor is a bleak isolated place in spite of its proximity to industrial towns.

CASTLE HILL, HUDDERSFIELD

Apparently guarding the urban sprawl of Huddersfield from the south is Castle Hill, a flat-topped mound surrounded by a double bank of prehistoric earthworks which, as well as being the site of a Roman fort and later a Norman castle, is said to have been the capital of the Brigantes. On the site of the Norman keep now stands a tower put up to commemorate Queen Victoria's Diamond Jubilee: yet another age has left its mark on this ancient place.

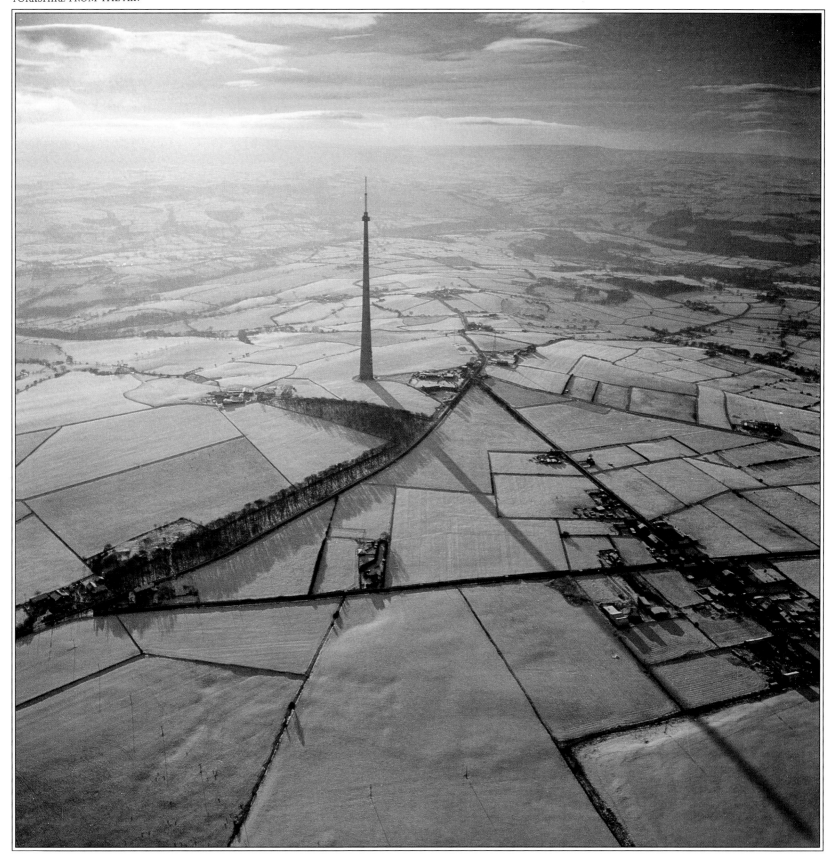

EMLEY MOOR UNDER SNOW

*Although at 726 feet above sea-level Emley Moor is not high compared to the hills and
moors of North Yorkshire, it is nevertheless just on the edge of the central Pennines. Its
glistening blanket of new snow reminds us that winters can be harsh throughout
Yorkshire's uplands; but here the winter sun, low in the sky and creating an
apparently endless shadow from the television mast throws a gentle light on the scene.*

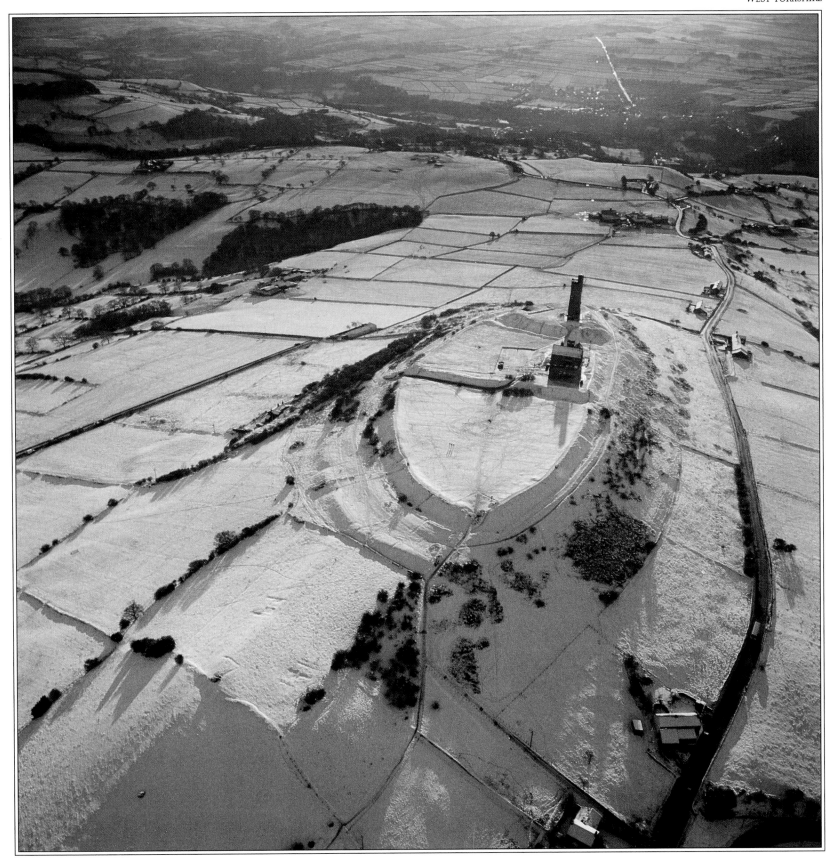

CASTLE HILL UNDER SNOW

This tendency of aerial views to 'flatten' the landscape perhaps gives a false impression
of the height of Castle hill. In fact it is the highest hill on a straight line west of Urals
– the top of the tower is at nearly 1,000 feet. This seems more believable when it is
seen, as here, carpeted with snow and with the road down into the Holme valley
beyond shining icily.

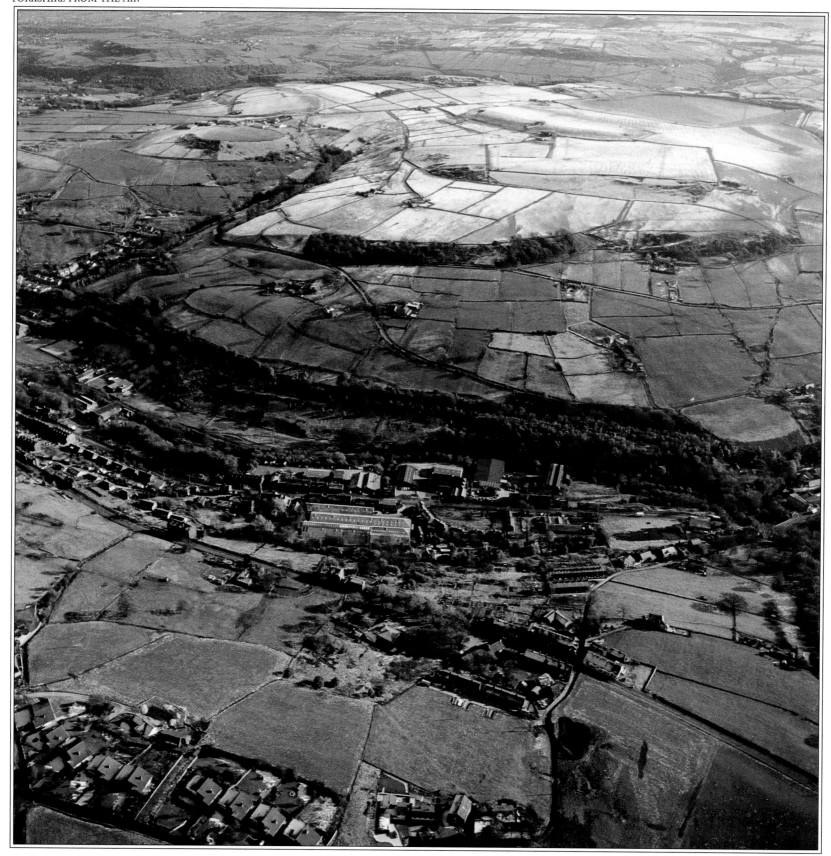

RIPPONDEN

A light powdering of snow covers Ringstone Edge Moor above the small mill town of
Ripponden in the Rybwn Valley. The somewhat bleak scenery is the product of the
underlying Millstone Grit that forms this part of the Pennines. Millstone Grit was also
the source of the area's wealth, however: the soft water running off it proved
ideal for washing, bleaching and dyeing wool.

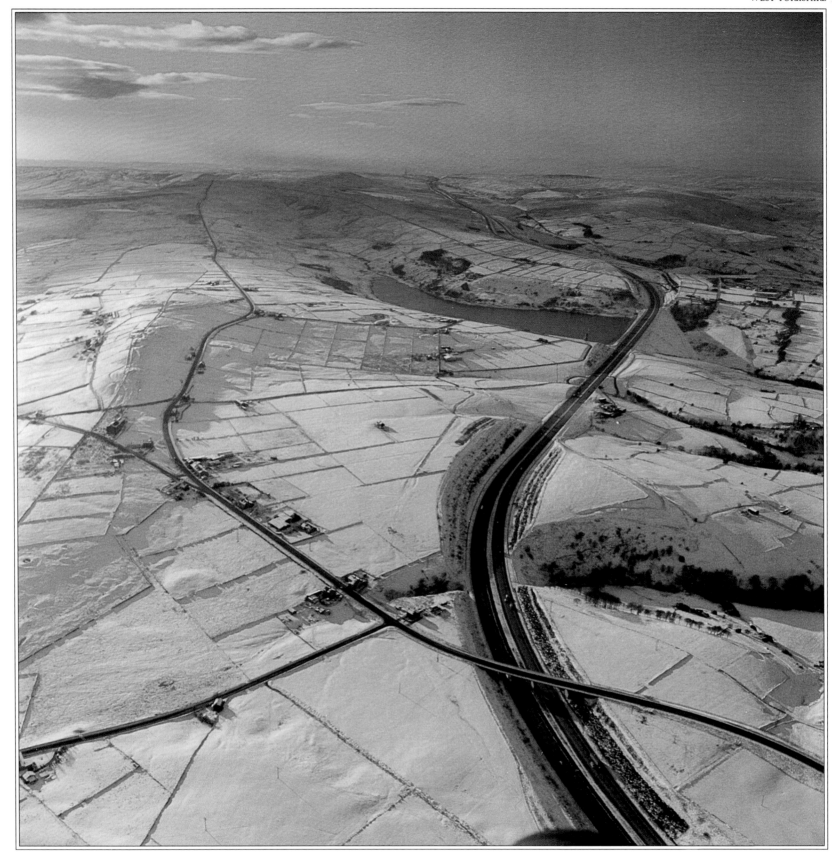

M62 MOTORWAY WEST OF HUDDERSFIELD

The M62, or trans-Pennine motorway as it is sometimes called, sets out on a
spectacular route across the snowy moors west of Huddersfield. This vital artery, the
highest of Britain's motorways, links Hull and the cities of West Yorkshire – Leeds,
Halifax and Huddersfield, with Manchester and Liverpool on the other
side of the Pennine 'backbone of England'.

First published 1989

1 3 5 7 9 10 8 6 4 2

Designed by Carol McCleeve
Map by John Beck

First published in the United Kingdom in 1989 by
Barrie & Jenkins Ltd
Random House, 20 Vauxhall Bridge Road, London SW1V 2SA

Random House Australia (Pty) Limited
20 Alfred Street, Milsons Point, Sydney,
New South Wales 2061, Australia

Random House New Zealand Limited
18 Poland Road, Glenfield
Auckland 10, New Zealand

Random House South Africa (Pty) Limited
Endulini, 5A Jubilee Road,
Parktown 2193, South Africa

Random House UK Limited Reg. No. 954009

A CIP catalogue record for this book
is available from the British Library

Typeset by SX Composing, Rayleigh, Essex
Printed in Italy by New Interlitho